The FLASH BOOK

How to fall hopelessly in love with your flash, and finally start
taking the type of images you bought it for in the first place

SCOTT KELBY

Author of the top-selling digital photography book ever—
The Digital Photography Book, part 1

THE FLASH BOOK

How to fall hopelessly in love with your flash, and finally start taking the type of images you bought it for in the first place

MANAGING EDITOR
Kim Doty

COPY EDITOR
Cindy Snyder

ART DIRECTOR
Jessica Maldonado

PHOTOGRAPHY
Scott Kelby

COVER PHOTOGRAPHY
Adobe Stock

PUBLISHED BY

Rocky Nook, Inc.
1010 B Street, Suite 350
San Rafael, CA 94901

Composed in Univers and Avenir (Linotype) by KelbyOne.

Trademarks
All terms mentioned in this book that are known to be trademarks or service marks have been appropriately capitalized. Rocky Nook cannot attest to the accuracy of this information. Use of a term in the book should not be regarded as affecting the validity of any trademark or service mark.

Photoshop is a registered trademark of Adobe Systems Inc.
Canon is a registered trademark of Canon Inc.
Nikon is a registered trademark of Nikon Inc.
Sony is a registered trademark of Sony Corp.
Phottix is a registered trademark of Phottix Ltd.
Yongnuo is a registered trademark of Shenzhen YongNuo Photographic Equipment Co. Ltd.

Warning and Disclaimer
This book is designed to provide information about flash photography. Every effort has been made to make this book as complete and as accurate as possible, but no warranty of fitness is implied.

The information is provided on an as-is basis. The author and Rocky Nook shall have neither the liability nor responsibility to any person or entity with respect to any loss or damages arising from the information contained in this book or from the use of the discs, websites, or programs that may accompany it.

ISBN 13: 978-1-68198-274-8

10 9 8 7 6 5 4 3 2 1

Printed and bound in Canada
Distributed in the US by Ingram Publisher Services
Distributed in the UK and Europe by Publishers Group UK

Library of Congress Control Number: 2017941598

www.kelbyone.com
www.rockynook.com

This book is dedicated to my dear friend and colleague Anne Cahill, who in the lobby of a small hotel in Vermont showed me how to use wireless flash for the very first time. I'll always be indebted to you for sharing your knowledge, for opening a whole new world to me, and for your friendship these many years.

Acknowledgments

Although only one name appears on the spine of this book, it takes a team of dedicated and talented people to pull a project like this together. I'm not only delighted to be working with them, but I also get the honor and privilege of thanking them here.

To my amazing wife Kalebra: You continue to reinforce what everybody always tells me— I'm the luckiest guy in the world.

To my son Jordan: If there's a dad more proud of his son than I am, I've yet to meet him. You are just a wall of awesome! So proud of the fine young man you've become. #rolltide!

To my beautiful daughter Kira: You are a little clone of your mom, and that's the best compliment I could ever give you.

To my big brother Jeff: Your boundless generosity, kindness, positive attitude, and humility have been an inspiration to me my entire life, and I'm just so honored to be your brother.

To my editor Kim Doty: I feel incredibly fortunate to have you as my editor on these books. In fact, I can't imagine doing them without you. You truly are a joy to work with.

To my book designer Jessica Maldonado: I love the way you design, and all the clever little things you add to everything you do. Our book team struck gold when we found you!

To my dear friend and business partner Jean A. Kendra: Thanks for putting up with me all these years, and for your support for all my crazy ideas. It really means a lot.

To Erik Kuna: Thank you for taking the weight of the world on your back, so it didn't crush mine, and for working so hard to make sure we do the right thing, the right way.

To Joe McNally: I owe a special debt of gratitude to my dear friend Joe McNally, who taught me more about flash than I ever thought I would know. Thank you, Joe, for helping me "see the light."

To Jeanne Jilleba: Thanks for jumping in to help out and keeping me from sinking from the weight of my daily work. Thanks for juggling my crazy schedule and making sure I have time to write.

To Ted Waitt, my awesome Editor at Rocky Nook: Thanks for helping bring this book to life, and for seeing why it could help a lot of folks. You can go ahead and order the next round of pizzas from Tony's Pizza Napoletana. I'll take a Honey Pie, a New Yorker, and a La Regina. :)

To my publisher Scott Cowlin: I'm so delighted I still get to work with you, and for your open mind and vision. Can you please help Ted pay for those pizzas?

To my mentors John Graden, Jack Lee, Dave Gales, Judy Farmer, and Douglas Poole: Thank you for your wisdom and whip-cracking—they have helped me immeasurably.

Most importantly, I want to thank God, and His Son Jesus Christ, for leading me to the woman of my dreams, for blessing us with such amazing children, for allowing me to make a living doing something I truly love, for always being there when I need Him, for blessing me with a wonderful, fulfilling, and happy life, and such a warm, loving family to share it with.

About the Author

Scott Kelby

Scott is Editor, Publisher, and co-founder of *Photoshop User* magazine, *Lightroom Magazine*, and host of the influential weekly photography show, *The Grid*. He is President of the KelbyOne online educational community for photographers, and is the founder of the annual Worldwide Photo Walk™.

Scott is a photographer, designer, and award-winning author of more than 80 books, including *Light It, Shoot It, Retouch It; The Adobe Photoshop Book for Digital Photographers*; *Professional Portrait Retouching Techniques for Photographers*; *How Do I Do that in Lightroom?*; and *The Digital Photography Book*, parts 1, 2, 3, 4, and 5. The first book in this series, *The Digital Photography Book*, part 1, has become the top-selling book on digital photography in history.

For six years straight, Scott has been honored with the distinction of being the world's #1 best-selling author of photography techniques books. His books have been translated into dozens of different languages, including Chinese, Russian, Spanish, Korean, Polish, Taiwanese, French, German, Italian, Japanese, Hebrew, Dutch, Swedish, Turkish, and Portuguese, among many others.

Scott is Training Director for the Adobe Photoshop Seminar Tour, and Conference Technical Chair for the annual Photoshop World Conference. He's featured in a series of online courses from KelbyOne.com, and has been training photographers and Adobe Photoshop users since 1993.

For more information on Scott, visit:

His daily blog at **scottkelby.com**

Twitter: **@scottkelby**

Instagram: **@scottkelby**

Facebook: **facebook.com/skelby**

Contents

Chapter 1 **1**
Flash Controls and Settings
Ya gotta start somewhere, right?

Seven Things You Need to Know Now.
If You Skip Them... _____ 2

Same Thing Over Here.
Skip Them at Your Own Peril! _____ 3

Here's Another Thing _____ 4

These Are the Last Two_____ 5

You're About to Learn a "System" _____ 6

You're Not Going to Mess with
the Back of Your Flash a Whole Bunch. Or at All _____ 7

Say Hello to "Mister Flash!" _____ 8

Why TTL Might Be Making You Hate Your Flash _____ 9

The Most Common Reason Flash Shots Look Bad_____ 10

Don't Put Your Flash on Top of Your Camera_____11

Don't Use Your Pop-Up Flash to
Try to Fire Your Hot Shoe Flash. Ever _____ 12

Why You Need a Wireless Controller _____ 13

Why You Don't Want Just a Wireless Trigger _____ 14

The Difference Between Optical and Radio Wireless _____ 15

What If Your Flash Doesn't Have Built-In RF Wireless? _____ 16

Troubleshooting: If Your Flash Doesn't Fire _____ 17

Understanding the Whole "Brightness" Thing _____ 18

What to Do When 1/2 Power Is Too Bright _____ 19

How to Change the Power (Brightness) of Your Flash _____ 20

Where to Set Your Power to Start _____ 21

Why I Recommend You Set Your Flash to Manual Mode_____ 22

Putting Your Flash Into Manual Mode _____ 23

Getting Your Flash to Refresh Faster _____ 24

Which Type of Batteries to Use_____ 25

Chapter 2 **27**
Next Level Flash Stuff
It's that stuff. At the next level

Using More Than One Flash? Then Using the
Group Feature Will Make Things Much Easier_____ 28

How I Assign My Groups _____ 29

Putting More Than One Flash in a Group_____ 30

Using Channels to Keep Other Photographers from Accidentally Firing Your Flash_____ 31

Slave Mode Lets You Fire a Second Flash without Wireless _____ 32

Contents

Getting More Power Than Maximum _____ 33

Want Your Beam Wider or Tighter? _____ 34

Your Flash's Modeling Light _____ 35

Want to Make the Light a Little Less Harsh?
Put on a Diffusion Cap _____ 36

When Diffusion Caps Don't Work _____ 37

Your Flash Has a Built-In Wide-Angle Diffuser... _____ 38

Using Your Flash's White Bounce Card _____ 39

Do You Need a Flash Meter? _____ 40

How to Wait Less Time Between Flashes _____ 41

Freezing Motion _____ 42

Getting Soft Blurry Backgrounds with Flash.
Spoiler Alert: You Use High-Speed Sync _____ 43

Chapter 3 45
Camera Settings for Working with Flash
This part is way easier than you'd think

Why We Need to Shoot in Manual Mode _____ 46

Shutter Speed Controls the Light in the Room _____ 47

F-Stop Controls the Brightness of the Flash _____ 48

ISO Makes Everything Brighter or Darker _____ 49

Where to Set Your Shutter Speed (and Why) _____ 50

When to Change Your Shutter Speed _____ 51

Which f-Stop to Start With _____ 52

Where to Set Your ISO _____ 53

Here's Your Camera Settings Checklist _____ 54

The Big Secret: Balancing the Light _____ 55

Chapter 4 57
Using Flash for Portraits
How to make people look awesomer

Get It Off Your Camera _____ 58

Make It Soft and Beautiful _____ 59

This Helps a Little, but It's Not a Softbox _____ 60

My Favorite Softbox for Flash _____ 61

You Can Make Beautiful Light for Just $20 _____ 62

No Friend to Help? Get Out Your Debit Card _____ 63

Use a Strip Bank Softbox on Your Second Light _____ 64

Get a Tighter Focus and More Drama by Using Grids _____ 65

Use Metal Grids to Get Tightly Focused Beams _____ 66

Contents

Using an Umbrella to Soften the Light
(It Works, but Don't Do This)_____ 67

Big, Beautiful Light Comes
from Big Softboxes _____ 68

If You Need Really Big Light
on a Budget _____ 69

Instant Headshot Setup _____ 70

The Most Popular Place to Position Your Flash _____ 71

Getting More (or Less) Shadows_____ 72

If You Need Even Softer Light, Feather It _____ 73

How High Up to Position Your Flash _____ 74

How Close to Put Your Softbox_____ 75

Lighting to Make Your Subject Look Thinner _____ 76

Bounce Flash Can Save the Day _____ 77

Adding a Second Flash _____ 78

Use Fall-Off for More Professional-Looking Portraits _____ 79

Creating Fall-Off Manually by "Flagging" _____ 80

Three-Flash Edge Light Setup_____ 81

Chapter 5 83
Using Flash On Location
This is truly terrifying stuff, so maybe you should skip this

Why We Need to Put Gels on Our Flash
When Shooting on Location _____ 84

How to Deal with Problem Room Light _____ 85

How to Attach a Gel to Your Flash _____ 86

Pre-Cut, Pre-Sized Commercial Gel Setups _____ 87

Easy Location Flash
Step One: Positioning Your Subject _____ 88

Easy Location Flash
Step Two: Metering _____ 89

Easy Location Flash
Step Three: Underexposing _____ 90

Easy Location Flash
Step Four: Positioning Your Flash _____ 91

Easy Location Flash
Step Five: Adding an Orange Gel _____ 92

Easy Location Flash
Step Six: Flash Settings_____ 93

Easy Location Flash
Step Seven: Adding More Gels _____ 94

Flash with a Reflector as Your Second Light_____ 95

Getting Some Fill Light Outside without a Softbox _____ 96

Contents

On Overcast Days, You Can Use Wide-Open
f-Stops to Get Soft Backgrounds _____ 97
Awesome Trick for Simple, Clean Backgrounds _____ 98
Shooting Interiors with Flash _____ 99

Chapter 6 101
How to Light Backgrounds
Baby got back!

Lighting Backgrounds without a Second Flash _____ 102
Before You Aim a Flash at Your Background,
You Have a Decision to Make _____ 103
Inexpensive Backgrounds _____ 104
Which Color Background to Order First _____ 105
Using Canvas or Painted Backdrops _____ 106
Light Stands for Lighting Backgrounds _____ 107
Why the Distance You Place Your Flash
from the Background Is So Important _____ 108
Turn Off Any Front Lights While
Lighting the Background _____ 109
How to Light for a Solid-White Background _____ 110
Lighting a Wider Solid-White Background _____ 111
How to Avoid Spill on Your Background _____ 112
Keeping the Background Flash from
Spilling onto Your Subject _____ 113
Creating a Graduated Background Look _____ 114
Getting a Tighter Background Spot Light _____ 115
Color Gels for Backgrounds _____ 116
Adding Color to Your Background _____ 117
Changing the Color of Your Background _____ 118
Spotlight Gradient Background Effect _____ 119

Chapter 7 121
Using Flash at Weddings
Here comes the bright...

Simple One-Light Bridal Portrait Setup _____ 122
Shooting the Bride Getting Ready _____ 123
Reception Option #1: On-Camera _____ 124
Reception Option #2: Serious Diffusion _____ 125
Reception Option #3: Lighting the Room _____ 126
Reception Option #4: Seeing Flash in the Frame _____ 127
Lighting the Group Formals _____ 128

Contents

Rotating Your Head for Bounce Flash _____ 129

Flash Behind the Bride _____ 130

Add a Gel to Match the Room Lighting _____ 131

Chapter 8
How to Mount Your Flash
That sounds bad, but you know what I mean

Which Type of Light Stand to Use for What _____ 134

Why You Need a Tilt Bracket _____ 135

Using Your "Little Foot" to Hold Your Flash _____ 136

My Favorite for Location Shoots:
Mounting Your Flash on a Monopod _____ 137

Mounting Second Flashes:
Clamp It _____ 138

Mounting Second Flashes:
Joby Flash Clamp _____ 139

Mounting Second Flashes:
Tether Tools RapidMount SLX with RapidStrips _____ 140

Mounting Second Flashes:
Platypod Ultra _____ 141

Mounting Second Flashes:
Manfrotto Magic Arm _____ 142

Holding Multiple Flashes _____ 143

Chapter 9
Flash Tricks
Getting your flash to beg, roll over, and fetch light

A Studio Portrait Look without the Studio _____ 146

Hiding the Flash and Light Stand _____ 147

Sunset Look on Location _____ 148

Dragging the Shutter for Effect _____ 149

Three Lighting Looks without Moving Your Flash _____ 150

If You Can't Bounce Off the Ceiling _____ 151

If You Want to See Background Shadows _____ 152

Using Your Flash as a Prop _____ 153

Fix Ground Spill with a Double-Tap _____ 154

Special Effects Gels _____ 155

Using White Balance as a Second Color _____ 156

Pan Blur and Freeze Effect _____ 157

Chapter 8 heading page number: **133**

Chapter 9 heading page number: **145**

Contents

Stroboscopic Effect _____ 158
The Classic Hollywood Dramatic Look _____ 159
Dramatic Profile Portrait _____ 160
Two-Color Split Back Lighting_____ 161
Removing Reflections from Glasses _____ 162
Simple Two-Flash Product Lighting Setup_____ 163

Chapter 10 165
Flash Workflow
If you've got an indoor, outdoor, or
wedding shoot, then here's what to do!

Indoor Portrait Workflow
Step One: Put Your Flash on a Light Stand _____ 166
Step Two: Put a Softbox in Front of It _____ 167
Step Three: Use These Settings on Your Flash _____ 168
Step Four: Position It Up High, at a 45° Angle_____ 169
Step Five: Use These Camera Settings _____ 170
Step Six: Take a Test Shot and Evaluate _____ 171

Outdoor Portrait Workflow
Step One: Put Their Back to the Sun_____ 172
Step Two: Set Your Correct Exposure First _____ 173
Step Three: Now Make Everything Darker _____ 174
Step Four: Use These Settings on Your Flash _____ 175
Step Five: Get Your Flash Off Your Camera _____ 176
Step Six: Put an Orange Gel on Your Flash _____ 177
Step Seven: Make the Light Soft and Flattering _____ 178
Step Eight: Position It Up High, at a 45° Angle _____ 179
Step Nine: Turn Your Flash On and Take a Test Shot _____ 180
Step Ten: Balancing with the Natural Light_____ 181

Wedding Workflow
Step One: Make Ready Flash _____ 182
Step Two: The Bridal Portraits _____ 183
Step Three: The Ceremony _____ 184
Step Four: The Group Formals _____ 185
Step Five: Reception, One Flash _____ 186
Step Six: Reception, Two Flashes _____ 187

INDEX_____ 188

Flash Controls and Settings

Ya gotta start somewhere, right?

If you bought this book, I can already tell a few things about you: (1) You have impeccable taste. (2) You're thoughtful intelligent, you're kind to small animals, and people are inexplicably drawn to you. It's why birds suddenly appear every time you are near. And, (3) you're probably fairly new to flash. You probably own a flash already, but you got this book so you would finally fall in love with your flash. You did the right thing. But, as the author of the book, of course I would say that, right? So, to be fair, let's ask a random person on the street and see if they agree. [slight pause] Yup, they said you did the right thing, too, so it's not just me. Anyway, I want to make sure your transition into the wonderful world of flash is as painless as possible, and that begins with understanding that using flash is a lifestyle. Pretty soon, you'll be hanging out with your cool new flash friends, and you'll be going to flash parties, and flash raves and flash protests, and flash parole hearings, and I want to make sure you don't embarrass yourself at these events by giving away the fact that you're not yet a flash ninja (which will occur about 10 chapters from now, when you'll get presented with the black outfit and all that). But, for now it's likely that at one of these parties, some total flash nerd will try to trip you up by asking you where the term "flash" even comes from. This is a trick question. Most folks would answer something like, "Because it creates a flash of light?" at which the nerd will annoyingly roll their eyes, because they know the real answer, which is: flash is actually FLASH— an acronym, created by Eastman Kodak back in the late 1890s, which stands for "Focused Lumens Aligned to Sensor Head." Now, if you believed any of that, even for a second, if you had a moment of doubt that it could be true, you need to align your sensor head. Welcome to the chapter intros (which I warn you about in the book's intro ;-).

Seven Things You Need to Know Now. If You Skip Them…

…something really bad will happen. (1) Stuff like not knowing that there's a special page with some videos I have for you that you'll need along the way, or that you should, or shouldn't, read the chapter intros, or how to avoid breaking out in red, itchy hives when reading about flash settings (I recommend the yellow itchy hives, which are much more manageable). It'll only take two minutes to read these four pages (yup, you'll need to read the other three, too), but you'll be glad you did (hey, it's possible). By the way, here's the link to watch the bonus videos and stuff: **kelbyone.com/books/flashbook**. Okay, so let's get on with the other six riveting things (stop snickering).

(2) I don't refer to them as "Speedlights" —I just call them "flashes." Some companies call theirs an "external flash unit," some call them "Speedlights," some people call them the "Space Cowboy." Some call them the "Gangster of Love." So, since we can't all agree (and it would be painfully clunky to reference one each time as a "speedlight/flash/external flash"), I'm just going with "flash" —just so ya know.

Same Thing Over Here. Skip Them at Your Own Peril!

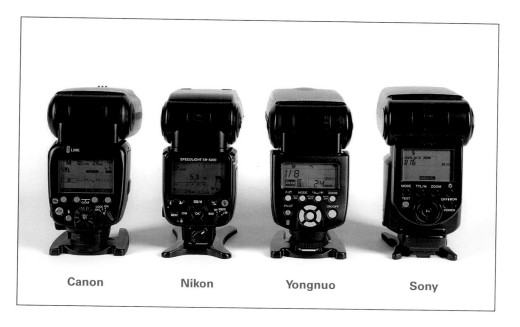

Canon Nikon Yongnuo Sony

(3) Flashes are flashes. And they all do essentially the same thing. They produce a bright flash of light. If I took a $600 flash and a $60 flash, and put them (and you) in a dark room and fired each one separately, it would be impossible for you to tell which one was which—they both make a bright flash of white light. The difference may be in the features, or the build of the unit, or whether it has a built-in wireless radio transceiver, but as far as what they create (a bright flash of light), any flash can do that, and they're pretty much indistinguishable from that standpoint.

(4) Lots of companies make flash units. I couldn't include every model of flash in the book, so I went with the flashes most folks use these days, which are from Canon, Nikon, Phottix, Sony, and Yongnuo. Luckily, all flashes pretty much work the same, so if you don't see your make and model in the book, don't sweat it—especially since we don't do much on the flash units themselves besides turning them on and a few initial settings for the most part.

Here's Another Thing

(5) Should you read the intro page to each chapter? Just a heads up: I have a tradition in all my books that either delights my readers or makes them spontaneously burst into fits of anger. It's how I write the introduction to each chapter. In a normal book, these brief intros would give you some important insight into the coming chapter. But, mine…um…well…don't. These quirky, rambling intros have little, if anything, to do with what's actually in the chapter. They're designed to simply be a "mental break" between chapters, and a lot of folks really love them (we published a whole book of nothing but chapter intros from my various books. I am not making this up), but some folks hate them with the passion of a thousand burning suns. Luckily, I've delegated the "crazy stuff" to just those intro pages—the rest of the book is pretty regular. But, I had to warn you, just in case you're a Mr. Grumpypants and all serious. So, if that sounds like you, I'm begging you, please just skip the chapter intros altogether.

These Are the Last Two

(6) Sometimes you have to buy stuff. This is not a book to sell you stuff, but before you move forward, understand that to get the kind of results you're looking for, sometimes you have to buy some accessories—everything from light stands to tilt brackets to a diffuser or softbox. I use low-priced gear myself, so I always keep an eye on the budget throughout, and I search out great deals on stuff (it probably goes without saying, but the prices you see here in the book were the current prices on bhphotovideo.com or the manufacturer's website when I wrote this and may have changed).

(7) What's that Workflow chapter in the very back? Read that last. After you've read everything else. It's more of a resource for you to refer back to next time you're going out for a shoot and want a step-by-step setup for indoor, outdoor, and wedding shoots. Okay, bunky, it's time for you, and me, to head out and tame this wild world of flash together, on a journey, a bold journey, blah, blah, blah....

You're About to Learn a "System"

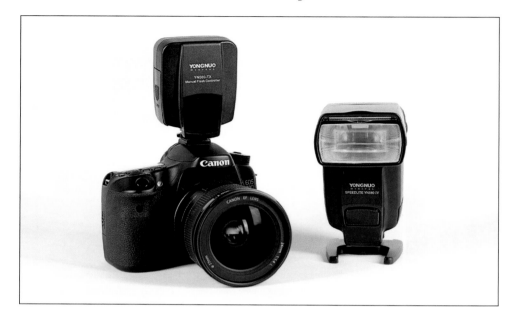

I have good news, and I have good news. Which do you want first? Okay, we'll start with the good news. You're not going to learn everything about your flash in this book. You're not going to have to learn a bunch of geeky flash stuff, and you're not going to have to do math, and you're not going to need a light meter, or have to do any of that nerdy stuff (in short, you're not going to learn everything about flash—it's not that kind of book). Instead, you're going to learn a system—a really simple one, and one that I've been using for years—and I'm going to teach it to you the same way I would teach it to a friend (luckily, I've had a lot of practice because I've taught it to a lot of my friends). Okay, that's the good news. Now, for the other good news: I know that the method I'm going to teach you works, because I've received literally hundreds of emails, comments on Facebook, forum comments, social media messages, you name it, from my students telling me that they are finally taking the kind of images with flash that they always dreamed they would. After years of struggling, they are finally falling in love with their flash. I think the best thing about this system is that it's so darn easy, but it's definitely different than what you might have tried before. So, if you read stuff and you think, "That's not like what I read on the Internet," it's because I don't do it that way. But, this system does work, and once you try it, you'll become a believer. Or a "Belieber," if you like the system, and you're a fan of Justin Bieber (even though I'm not sure he uses flash at all, and if he does, it's probably on his phone). Just wanted you to know this stuff now, before we dig in.

You're Not Going to Mess with the Back of Your Flash a Whole Bunch. Or at All

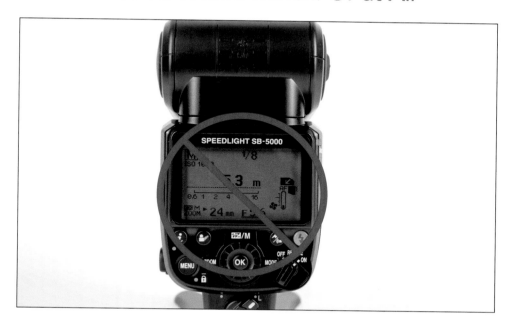

An interesting part of this "system" is that you won't actually mess with the controls on the back of your flash very often, or at all for that matter. In fact, once you start your shoot, you probably won't push a single button, rotate a dial, or even touch the back of your flash to change anything! So, why is there a chapter on the flash settings? It's because I get paid by the chapter (that's not entirely true). The reason is, when you first get your flash, you'll need to set a few things up, just like you do when you buy a new TV—you start by going through a setup phase, where you choose some settings and preferences. But, from then on, what do we really change on our TVs? We change the volume, and we change the channel. Well, it's kinda the same thing with your flash. You'll need to set up a few things at first, but after that, all we pretty much change is the brightness of the flash. (Spoiler Alert: We don't do it by walking over to the flash. We'll talk about how in just a minute.) We don't have to mess with all that other stuff once it's set up. In fact, probably the only thing you'll do on the back of your flash is literally turn it on at the beginning of the shoot and turn it off at the end. That makes your flash life really easy (basically, with this system, you can stop messing with all those buttons and dials on the back of your flash, and instead concentrate on making a great picture).

Say Hello to "Mister Flash!"

Don't let all those buttons and menus intimidate you because today's flashes all pretty much work the same—they usually have a screen, four buttons below that, and a dial below those. Some might have a couple of extra buttons (like a power button or test flash button), but for the most part, they all pretty much look and work the same way. Well, especially in the way we're going to use flash in this book, because we're not going to nerd-out and look at esoteric features only a small percentage of users ever touch (and then only when they're tired of playing Dungeons and Dragons). Since all flashes pretty much look and work the same, I didn't want to throw you off by showing a Canon flash on one page, and a Nikon flash on the next, then a Sony flash, and so on, so we went down into our semi-terrifying, secret sci-fi lab and created the non-brand-specific flash unit you see above, which we lovingly call "Mr. Flash" (when we're in an international mood, we call him either Señor Flash, Monsieur Flash, or Flash-san). Don't get too attached to Mr. Flash (yes, ladies, he's single and available) because you'll only really get to see him in these first few chapters, with a simplified LCD screen for which setting you're supposed to adjust at that point, but I also, at times, include written instructions for the most popular flashes in the text. By the way, the text on the tiny screens on the back of real flash units are size-rated for teens with 20/20 vision, and even they have to squint to read them. You'll often see teens passing flashes back and forth asking, "Can you read what that says?" and then they talk about the weather, reminisce about when you used to be able to smoke on airplanes, and complain about cuts to Social Security. True story.

Why TTL Might Be Making You Hate Your Flash

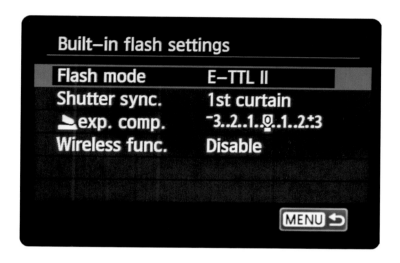

A number of years ago, the flash industry touted a breakthrough called TTL (an abbreviation for Through The Lens metering—some companies call their brand of it E-TTL, i-TTL, etc.), which uses your camera's built-in metering to automatically adjust the amount of power your flash puts out. Sounds good, right? In some cases, it actually works. However, when it doesn't work (and it has been my experience that it doesn't work all that often, or simply isn't consistent from shot to shot), then what? I've seen so many people using TTL quickly get to the point where they just say to themselves, "Well, I must not be any good at flash because this looks like [insert your favorite term for 'poop' here], so I'm giving up on flash." It's my contention that TTL is actually one of the leading causes of "I hate my flash" syndrome, which is suffered by most of the photographers I've polled over the past year. But, luckily, you don't have to fall victim to this flaky technology. Now, I know what some of you must be saying at this point: "Well, Joe McNally uses TTL and his flash shots look amazing!" This is true. They absolutely do. But here's the problem: you're not Joe McNally. Joe could take a 9-volt battery, a stick of gum, and a spare bulb from a camping lantern and light a portrait that would make Rembrandt rethink using window light. Joe's not like you and me. All comparisons or references to Joe are somewhat invalid because he is the magical unicorn of flash, sired by an enchanted leprechaun, and swaddled in a four-leaf clover. In short, he is not of this earth. For the rest of us mortals, using TTL isn't the answer (in fact, I kind of think of it as the enemy). Instead, we need something really simple and reliable that works every time. Spoiler Alert: That's coming on page 22.

The Most Common Reason
Flash Shots Look Bad

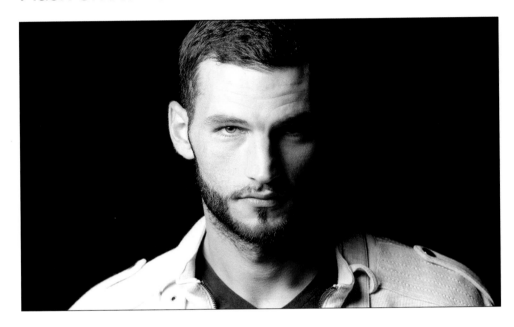

If you're unhappy with the results you're getting from your flash photography, and you showed me an example of a shot you didn't like, it's almost a lock that I'd say the problem is simply that your flash is too bright (like this shot above). It is the most common problem I see, and it's a pretty significant problem because the whole idea behind using flash is not to make it look like you used a flash—it's supposed to mimic natural light. When your flash power is up too high, it looks like you went to Home Depot, bought a Black & Decker Ultra Bright LED Spotlight, and shined it right on your subject. That flashlight is designed to light things up, not make them beautiful, but that's the look I see again and again. When you see hot shoe flash done really right, you're not sure that they used a flash at all, and a big part of that process is using the right amount of light—setting the power of your flash so it looks natural and blends in with the existing light (more on exactly how to do this in the camera settings chapter). But, for now, if you do nothing more than just start to pay attention to the power of your flash—in particular, that it's not too bright (in other words, the power setting isn't too high)—just that one thing, you're already on your way to much better photos using flash.

Don't Put Your Flash on Top of Your Camera

There are one or two exceptions to this rule (see Chapter 7), but for the most part, the worst possible thing you can do with your hot shoe flash is to actually put it in the hot shoe mount on the top of your camera. That is a recipe for awful-looking, harsh, unflattering shots. It's basically what we do to get even with someone "who done you wrong!" (say that last line with a country drawl). Think of it this way: the pop-up flash that is a feature on some consumer cameras (notice that it's not on professional-level cameras from either Nikon or Canon) creates the most miserable, harsh light on earth (to give you an idea of how harsh it is, it's where they put the flash when they take your driver's license photo, so expect similar results). It's just a mean thing to do to someone that you're not trying to present with a license to drive. A big part of the problem is its location right on top of your camera, where it can blast straight into your subject's face. So, if that pop-up flash light is so awful (and it is), what are you doing when you put a larger, more powerful flash right on top of your camera? You're simply creating a larger and more powerful, harsh, miserable light. It's like you're entering the Super Bowl of driver's license photo lighting. If you want a chance to create beautiful images with your flash, you must, must, must, must, must (there is not a number of "musts" that would be too many here) get your flash off the top of your camera and over to the side, so your photos have shadows, depth, and dimension. Without it, your portraits will look flat, washed out, and awful (but at least your subject will be able to use your photo to buy beer and get into nightclubs).

Don't Use Your Pop-Up Flash to Try to Fire Your Hot Shoe Flash. Ever

You can use the pop-up flash that's built into your camera to fire your flash once it's off your camera. I'm going to tell you how to do it, but just know now, up front, that you should never ever do it. Never! It's a trap that has brought down stronger men than me. While technically it should work, it absolutely will *not* work when your client shows up, or when you're shooting a wedding, or when it simply just matters that it actually fires. It has a reliability quotient that lies somewhere between a men's room hands-free faucet and a Fiat 500L. The idea is simple: You switch your built-in pop-up flash to a special mode where it doesn't actually emit enough power to light anything. Instead, it just sends out a small pulse of light, and that tiny pulse triggers the other flash to fire. It does fire occasionally—mostly, when you're testing it, and rarely when it matters. Did I mention the sensor on the flash has to be clearly visible to that light pulse? Ugh. I know what you're thinking, "But, I've seen Joe McNally fire eight flashes with it!" Those flashes simply fire out of respect. The rest of us are hosed. I could tell you a dozen embarrassing stories about how that "line-of-sight, pulse-of-light crap" has failed me and my colleagues ($10 word), but you can sidestep this whole nightmare by simply using a real wireless transmitter system. They are simple and work every time. If your flash doesn't fire consistently, you are never going to love it, and you're never going to use it, so the whole thing's setting you up for failure. But, it doesn't have to be that way—just get a real wireless transmitter. They're cheap now (see the next page). It's time to do it the right way and get the results you've always dreamed of.

Why You Need a Wireless Controller

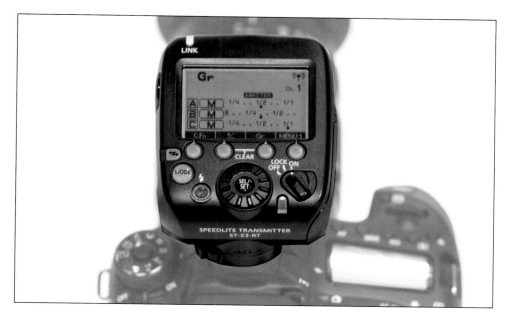

One big key to this system is that you control your flash (or flashes), including turning them on/off and changing the brightness, all from right where you're standing—at your camera position. No walking over and changing the power on the back of the flash—you're going to do it all from right on top of your camera (these controllers sit right in your camera's hot shoe mount—they slide right in just like they were a flash themselves, but thankfully they're much smaller). They have a screen on the back where you can choose which flash you want to adjust, they have a dial or an up/down button for changing the power, and you can turn any flash on or off with a simple press of a button. Luckily, these controllers are far cheaper than the flashes themselves. For example, the Yongnuo YN-E3-RT controller for Yongnuo flashes is just $75 (at B&H Photo). The Canon ST-E3-RT Speedlite Transmitter for Canon flashes is $270, but it's probably best in class (build-wise and feature-wise). You'll need the Nikon WR-R10/WR-T10/WR-A10 Wireless Remote Adapter Set ($199) to wirelessly fire the Nikon SB-5000. These controllers make controlling one (or more flashes; more on this later) a breeze. In fact, you'll now do everything from the controller, instead of on the flash, except for actually turning the flash on when you start a shoot.

Why You Don't Want Just a Wireless Trigger

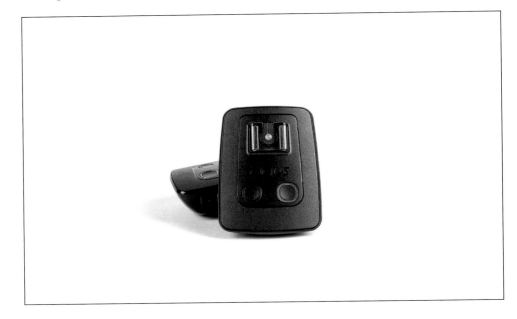

You can buy inexpensive wireless triggers (like the Cactus triggers you see above, which run around $60 for the pair), which use a real RF (radio frequency) wireless transmitter system, and they will definitely fire your flashes wirelessly every time. However, they don't let you control the brightness of your flash from right on top of your camera. So, each time you want to change your brightness, you have to walk over to the back of the flash unit itself and change the power manually. Now, you might have just read that and thought, "Aw, heck, I can walk over just a few feet and change the power—it's good exercise. So, I'll just save the money and buy a cheap trigger instead." Don't fall into that trap. Here's why: (1) Every shoot will take longer. In the time it takes to put down your camera and walk over to the back of the flash unit, you could have already changed the power and taken another test shot. (2) Leaving your camera position interrupts the flow of your shoot, your connection with your subject, and takes your attention off the important stuff. (3) At some point, you'll get tired of walking over there again and again, all shoot long. You'll see on your LCD screen that you should change the power, but you'll just skip it because it's a pain to do it every time. So, you'll take shots that are just a little bit off, but it's easier than walking over to the back of the flash. Now, if you're the type of person that refuses to use a TV remote, and prefers to walk up to the TV and change the channel old-school-1960s style, then maybe you should just get a trigger after all. For everybody else, I promise you, you'll thank me that you got a full controller, and not just a trigger. It's money well spent.

The Difference Between
Optical and Radio Wireless

I want to make sure, early on, that you understand the difference between "optical" wireless for your flash and "radio" wireless, because this is really important stuff. In short, an optical controller works like the remote for your TV. You know how when you point the remote at your TV, if it sees the infrared beam from your remote, it changes the channel or raises/lowers the volume? But, if there's anything blocking that beam—anything in the way of that "line of sight" from the remote to the TV—it doesn't work? So, you keep moving your TV remote around, aiming it at different angles, until you finally get it to work. Now imagine that same, frustrating experience as you try to get your flash to fire. You take a shot and the flash fires, then the next shot your flash doesn't fire, then it doesn't fire again, then it finally fires, then not, and so on. Or, worse yet, you can't get it to fire at all because optical wireless is even more flaky than your TV remote. That's optical wireless and why I'm pleading with you *not* to use it, and to use a real radio transmitter instead. Radio trans-mitters don't need a "line of sight"—it's real wireless. You could stick your flash inside a box, put it in the trunk of your car, and with a radio transmitter, it would still fire. It's very consistent, predictable, and there's no more positioning your flash at just the right angle in hopes that it can see a tiny pulse of light from your camera, so it will fire. That's a miserable way to work, and you'll never love your flash if it only works from time to time. Imagine doing a shoot with a client, like a family portrait or a wedding, and you can't get the flash to fire (it has happened to me, and after the last time, I said, "Never again—I'm going with real radio wireless!" I've never looked back). So, get the real thing. It'll be the start of a great romance with your flash.

What If Your Flash Doesn't Have Built-In RF Wireless?

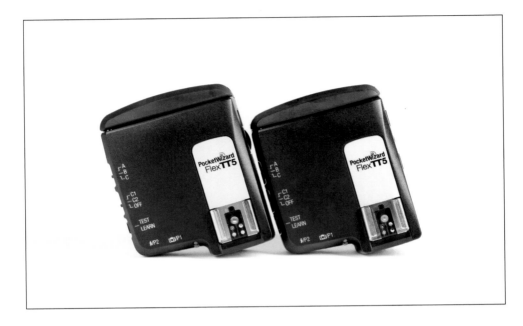

If you have an older flash, or if you bought a new one from a big camera company but it's one of their entry-level flashes, it probably won't have built-in radio frequency wireless. Instead, it will have that dreaded, and fairly unreliable, optical "line of sight" type of wireless. If that's the case, no problem, just pick up a third-party radio wireless controller that not only fires the flash wirelessly every time, but nearly as important, lets you control the brightness from right on top of your camera. It takes your flaky line-of-sight wireless flash, and makes it a fully controllable radio wireless flash that works every time. For example, Phottix makes a real radio wireless trigger called the Laso—slide your older flash (or new one that doesn't have radio wireless) into the Laso flash receiver's hot shoe, and then you can use the Phottix Laso wireless flash transmitter to operate (change brightness and turn flashes on/off) your Nikon or Canon flash wirelessly. PocketWizard also makes a line of wireless transmitter/receivers called "Flex" that fire your flash wirelessly, but you'll also need their AC3 ZoneController to control the brightness of your flash and to turn your flashes on/off from the camera position. There's also Yongnuo's YN-622N i-TTL Wireless Flash Transceiver & TX Controller Kit (for around $80) for both the transmitter/controller that goes on your camera's hot shoe and the receiver, which goes under your flash unit itself. There are other radio controllers out there, too, but just make sure you get a transmitter and receiver that work with your particular brand of flash, and you're off to the races.

Troubleshooting:
If Your Flash Doesn't Fire

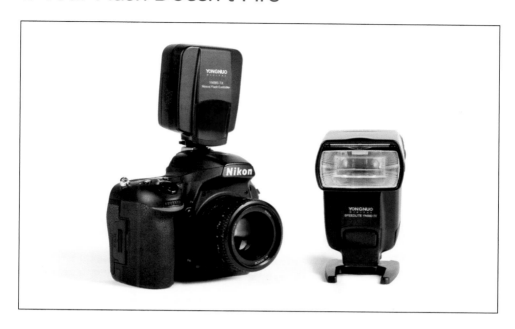

Once you have a radio controller for your flash, you put it in the hot shoe mount on top of your camera, and turn it on. Now, turn on your flash unit, press the test button on your controller, and the flash should fire (sometimes the test button is the power on button, and on some flashes, the test button is backlit, to help you find it in the dark). If you press the test button and it doesn't fire, here's what to check: (1) As "duh" as this sounds, make sure both the flash and the controller have the power turned on. It's easy to forget to turn one or the other on, or to forget you turned one off at some point. (2) Make sure your controller is set to On for that flash. Since you can turn flashes on/off temporarily from this controller, it's possible that you have your flash turned off on the controller (you'd still see the power light on the flash unit itself, but if you have that flash set to Off temporarily on the controller, it won't fire). (3) Check to see if both the flash and the controller are set to the same channel (see page 31, but in short, they have to be on the same channel, or it won't fire the flash). (4) Check to see if your flash controller is fully seated in the hot shoe mount on the top of your camera (technically, the flash should still fire using the test button whether it's fully seated or not, but this is just a good thing to check once the shoot is going and your flash stops—good chance it's not fully seated if that happens).

Understanding the Whole "Brightness" Thing

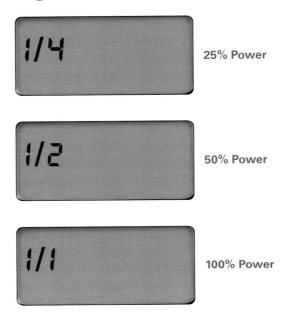

1/4 25% Power

1/2 50% Power

1/1 100% Power

Flashes use a slightly weird term for adjusting how bright (or dark) their light is. They don't call it "brightness" (that would make too much sense), but instead, refer to the brightness amount as "power." As in, "Want your flash to be brighter? Turn up the power setting." So, it's helpful to know that up front. The higher you set the power, the brighter the flash.

Full power (maximum brightness for your flash) is called "1/1" (one to one). This is pretty darn bright, and you probably won't use that full-power setting very often (if at all). More on why later, but just know that using your flash indoors at 1/1 power is kind of like tossing a flashbang grenade into the room—it blinds and disorients everyone just long enough to steal their valuables. Anyway, from here on out, if I say "full power," you'd see 1/1 on the back of your flash. In fact, if I say "power" at all, I'm referring to how bright your flash is.

If you turn your flash down from full power, the next stop is 1/2, which is obviously 1/2 power. The next big notch down is 1/4 power, then 1/8, 1/16, and if you need to turn your flash down even lower, most flashes have 1/32 and 1/64, and some even have 1/128 power. I live my life avoiding math like the plague, but it's helpful to do a tiny bit of 3rd grade math at this point. If you're at 1/4 power (25% of full power), and you turn up the power to 1/2 power, you just doubled the brightness. Now that you're at 1/2 power (50% power), if you turned up to 1/1 (100% power), you would have doubled it again. Wouldn't it be easier if they used percentages for power? Like 25% power, 50%, and 100% power? Yes it would, but if they did that, we'd easily get how it worked and then nobody would need to buy flash books, so I'm thankful they introduced fractions to keep me employed.

What to Do When 1/2 Power Is Too Bright

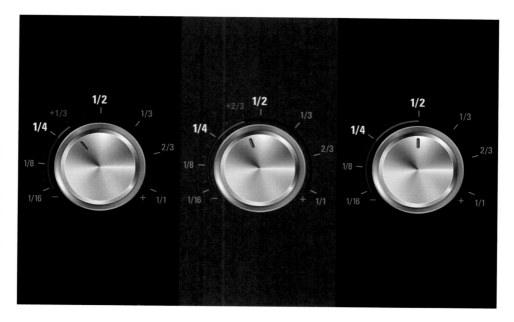

You know how life is—1/4 power is too dark, but then 1/2 power is too bright. Too bad there isn't some setting in between, right? Actually, there is. This is where the weird part of controlling the brightness (power) of your flash comes in. Between 1/4 and 1/2, there are 1/3 increments (in most flashes anyway). So, you can have your flash set at 1/4 power and turn it up by +1/3 (which means, you're at 1/4 power, plus you're 1/3 of the way to 1/2 power). So, what this means is that there are two power settings between 1/4 and 1/2 (and between all the lower power settings, as well). For example, let's say you're at 1/4 power:

(1) Turn it up one click to add +1/3 more power (at this point, you're 1/3 of the way to 1/2 power, as seen above on the left).

(2) Turn it up another click to add another +1/3 more power (at this point, you're 2/3 of the way to 1/2 power, as seen above in the middle).

(3) The next click takes you fully up to 1/2 power (as seen above on the right).

Inconsistency alert: Once you go above 1/2 power, there are just two clicks between it and full power (there is no 3/4 power on most flashes—you go from 1/2 power to +1/3, then +2/3, and boom, you're at full 1/1 power. Weird, I know).

This is how you fine-tune the exact amount of brightness you want.

How to Change the Power (Brightness) of Your Flash

Power Setting

Every flash does it a little differently, but for the most part, flashes either use a dial to crank up/down the power or an up/down button, and you'll see a readout of the current power setting in the LCD window on the back of your flash. Here are some examples for how you turn the power up/down on your flash:

Canon: Press the Select/Set button on the back of the flash, then turn the dial to the right to increase power or to the left to lower it.

Nikon: Highlight the power field, then turn the dial to the right to increase the power or to the left to decrease it.

Yongnuo: Press the Up button to increase the power of the flash; press the Down button to decrease it.

Sony: Press the right side of the dial to select Level, then turn the dial to the right to increase the power or to the right to decrease it.

Phottix: Press the Set button, then press the Up Arrow button to increase the power or the Down Arrow button to decrease it.

Keep in mind: to control your flash this way, you have to set it to Manual mode first (see page 22).

Where to Set Your Power to Start

Power Setting —————— 1/4

This really surprises a lot of photographers, but your power setting (the brightness of the flash) will probably be fairly low most of the time. In fact, I'm rarely at full power, unless I'm shooting with flash outside on a bright, sunny day. Otherwise, I'm at 1/4 power or less nearly all the time. The 1/4 power setting is my go-to starting amount anytime I set up my flash. In fact, in the system I'm teaching here, I pretty much always start with the same flash power, f-stop, shutter speed, and ISO, and that's part of what makes this system so easy—you nearly always start with the same settings (more on all those other settings in Chapter 3). So, for now, I thought it would be helpful for you to know that you're probably not going to use a ton of power and 1/4 power will be your normal starting place for any shoots you do indoors, or outdoors, unless it's really bright outside (then we have to crank it way up). Easy enough.

TIP | **FIRING TEST FLASHES**

Most flashes, and flash controllers, have a test fire button right on them (they're usually backlit in red or green), and the main reason to use them is simply to see if they're working. Press the button and the flash should fire.

Why I Recommend You Set
Your Flash to Manual Mode

Instead of relying on that flaky TTL, we're going to do something that sounds hard but is actually way easier. We're going to switch our flash to Manual mode, which simply means that now we control the power (brightness) of the flash (instead of the power being controlled by an autonomous AI that will one day connect itself to Skynet and turn against us, as all robots eventually do once they become self-aware, but I digress). So, once you switch your flash to Manual mode, what does that mean? It simply means this: If you take a shot, and the flash looks too bright, you turn the power of the flash down a bit, and take another test shot. If it looks too dark, you turn it up a bit. That's it. Don't overthink it.

Could using a flash actually be that easy? That simple? Yes—absolutely! That's what I do at every shoot, and it has made my life immeasurably better (well, my flash life anyway). "I had no idea it could be this easy!" (That's you talking.) "Why didn't you just tell me this right up front?" "I did." (That's me responding.) "This is only the first chapter in the book." So, that's our plan. We set the flash to Manual mode, and all we do pretty much from here on out is turn the flash power up/down as needed. Next, let's look at getting your flash into Manual mode.

Putting Your Flash Into Manual Mode

Manual Mode Icon ——————→ **M**

There are very few things that are consistent from flash brand to flash brand, but one thing that for some reason they all pretty much agreed on was that the letter "M" would mean "Manual mode," so you just have to figure out where it is on your particular flash's make and model. Most folks today use one of five flashes: a Canon, Nikon, Sony, Phottix, or Yongnuo flash (they're the new kid on the block and photographers are gobbling them up because the prices of their flashes are ludicrously low—about 15% of the price of a Nikon or Canon—but their quality is still pretty decent). Here's how to switch to Manual mode on "most" Canon, Nikon, Sony, Phottix, or Yongnuo flashes:

Nikon: Press the Wireless Settings button, then press the right side of the dial to select the flash mode, and then rotate the dial until an "M" appears in the LCD window.

Canon: Press the Mode button, then turn the dial until an "M" appears in the LCD window.

Yongnuo: Press the Mode button until an "M" appears in the LCD window.

Sony: Press the Mode button, then select Manual.

Phottix: You still set the flash to TTL mode on the flash itself, but on the Phottix transmitter, on top of your camera, you set that to Manual mode.

The good news is: now that you've set that, you won't have to change it or mess with it again. Your flash is now in Manual mode. Rejoice! By the way, changing your flash to work in Manual mode totally gives you the right to snicker a bit when you see some poor sucker still shooting in TTL. Just sayin'.

Getting Your Flash to Refresh Faster

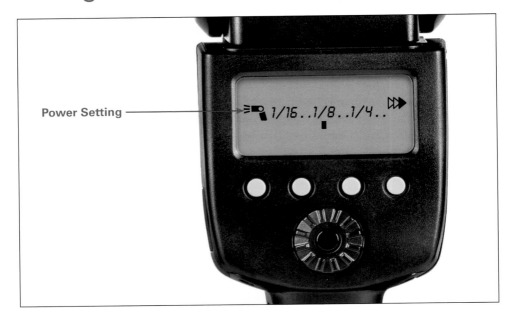

Power Setting

There's a very tight relationship between the power setting on your flash and how long it takes for the flash to refresh, so it's ready when you take the next shot (it won't fire while it's refreshing between flashes). In short, the lower the power setting on your flash, the faster it refreshes. This is awesome indoors, where we're often at 1/4 power or lower—you can pretty much fire away without really having to wait too much on the refresh (not at high-speed continuous mode speed, but a flash every second or so), at least until the batteries start getting low, but they won't get as low as fast at lower power. If you're near full power (1/1), you can expect to wait a bit between flashes, especially after a few minutes into the shoot. Basically, the higher the power, the longer the wait. So, if you're worried about managing your recycle time, you might consider changing your f-stop to something more open, so you're using less power on the flash and it will recharge faster. For example, if you're shooting at f/11 at 1/2 power, you might open up that f-stop to f/5.6, and then lower the flash power to 1/8 (these are rough numbers, of course, depending on your flash).

Which Type of Batteries to Use

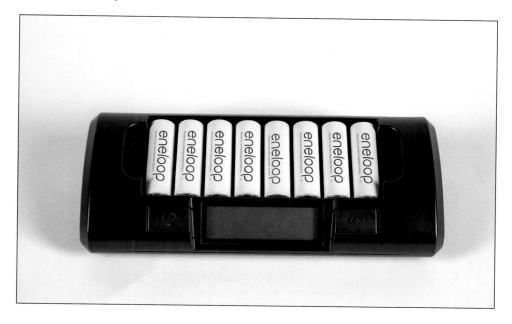

This is an easy one—rechargeable ones. Here's why: you're going to go through batteries quicker than a bag of Cheetos® at a Weight Watchers™ meeting. Plus, you always want to be using nice fresh batteries because as your batteries wear down, it takes longer and longer for your flash to be ready to take the next shot (when you first put them in, fresh batteries let you crank out the shots with only about a second or so between flashes to recharge. As the shoot progresses and the batteries wear down, that one or two seconds becomes three or four or longer, and you spend a lot of time waiting for the flash to recharge, which pretty much kills the energy on the set and the patience of your subject). So, you're either at Costco buying pallets of batteries, or you're using rechargeable batteries, so you always have some on hand. If you're not sure which ones to get, the pros use Panasonic's Eneloop rechargeable NiMH (nickel-metal hydride) high-capacity batteries (you can find them, and their charging stations, at B&H Photo). You can literally recharge these hundreds of times, and they still hold a full change. They're not cheap, but they are way cheaper than buying regular alkaline batteries every time you do a shoot.

Next Level Flash Stuff

It's that stuff. At the next level

If you're a longtime student of the art of flash, you already know this, but if not, it's important to note that much of the next level flash stuff uses a lot of Latin phrases, since the first flash unit was actually created in Rome around 1559. Of course, back then, they didn't have the luxury of rechargeable lithium batteries like we do today, which is why they coined the Latin phrase, "*Barba tenus fraus durante*," which loosely translated means, "Barbara, I need 10 fresh Duracells." Many people are surprised when they learn that the Duracell company chose their brand name based on ancient Latin texts, which included the phrase, "*Alis corpus beatae*," which roughly means, "alkaline Coppertop battery." True story. Anyway, one thing that the flash companies have learned is that people learn to use flash quicker if, at any point in their life, they were a Catholic priest—possibly because of the extensive use of Latin in the Catholic religion, or perhaps it's that photographers just generally like flowing robes and cool hats. It could go either way. But, I'm leaning toward the robe/hat theory because in popular flash circles, there's a phrase you often hear at strobist meetup groups, which is, "*Celerius cor habent ad rorate Pontifix comitem speculorum*," which means, "I wish I had a cool hat and robe like that priest with the Canon Speedlite." Of course, the deeper you get into using off-camera flash, the more Latin you'll wind up using. For example, here are a few handy Latin flash phrases: "*Facilius est multa facere quam diu*," which means, "The flash didn't fire," or "*Nec gaudia ut faciam*," which means, "I need a gel on this flash," or "*Malum quo communius eo peius*," which roughly means, "I borrowed this flash from a communist Toyota Prius owner." Hope you find those helpful.

Using More Than One Flash? Then Using the Group Feature Will Make Things Much Easier

Group Setting

Let's say you're using two flashes—one on your subject, and one on the ground, angled up to light the background. You do a test shot and decide you want the background light to be brighter, which is kind of a pain because now you have to walk over, get down on your knees, and change the power on the back of the flash. Ugh. There has got to be an easier way, right? Absolutely! This is why your flash's Group feature was born. For example, you can assign the front flash to Group A, and the background flash to Group B, and now you can control them each separately (including changing their power settings or turning either one on/off), all right from the wireless controller sitting on top of your camera. No getting down on your knees (and no making what my wife calls "old-man sounds" while you stand back up) and no interrupting the flow of your shoot. You start by going to the flash that's lighting your subject and assigning it to Group A (you can find out how to assign a flash to a group on the book's companion webpage at **www.kelbyone.com/books/flashbook**). Then, go to your background flash and assign it to Group B. Now, when you want adjust the background flash, on your controller, choose Group B, and now you're controlling that flash. You can raise/lower the power or turn it on/off any time. Want to raise the brightness of the light on your subject? Switch to Group A, then raise its power setting. What if you want to add a third flash? Well, I'd assign that to Group C. :)

How I Assign My Groups

Group Setting ——————→ Group A

So I never have to wonder during a shoot which flash is assigned to Group A, and which to Group B, and so on, I assign my groups in the order I set up the flashes. So, whichever flash is the main flash to light my subject, that is always Group A (it's usually the first flash I set up). If I add a second flash behind my subject (maybe a hair light or a fill flash), then I put that one in Group B. If I add a flash on the background, that of course, goes in Group C. That way, I never have to walk over to any of the flashes to figure out which flash is in which group.

Also, if you don't mind picking up a few thin rolls of colored gaffer's tape, you can put a small piece of colored tape on the back of each flash so you always know which flash is assigned to which group (that way, you'll only have to assign a particular flash to a group once). For example, you might put a small piece of green tape on the flash that's assigned to Group A, and then a small piece of yellow tape on the flash set to Group B, and red on the Group C flash. That way, when you take them out for a shoot each time, you won't have to go and check which flash is assigned to which group.

Putting More Than One Flash in a Group

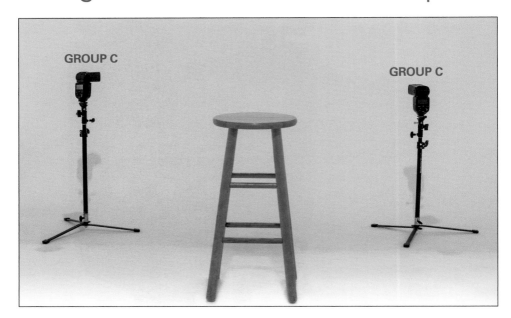

One of the big benefits of groups is that you can assign more than one flash to the same group. For example, let's say you have two flashes lighting the background (one from the left side; one from the right). You could assign both of those flashes to the same group (setting them both to Group C, for example). Now, when you choose Group C on your transmitter and change the power, it affects both flashes at the same time. Same with turning them both on/off at the same time. Super handy.

Now, if you're thinking to yourself, "But what if I want to control the left and right background flashes independently?" Well, if that's the case, don't put them in the same group—put one in Group C and the other in Group D (that is, of course, if your flash transmitter lets you have more than three groups), and then you can control each one separately.

Using Channels to Keep Other Photographers from Accidentally Firing Your Flash

Channel Setting

Let's say you're one of three photographers shooting a corporate party. The other two photographers are walking around taking photos of the "meet-and-greets," and you set up a white, seamless paper backdrop and a flash for portraits of the party guests. You have a couple move onto your "set," and while you're chatting with them, suddenly your flash fires. Then it fires again. You're not even holding your camera, and it fires a third time. What's happening?!! Well, one of the other photographers is accidentally firing your flash. When she takes a shot over by the entrance to the ballroom, it fires her flash, but it's also triggering your flash, as well, because you are both on the same wireless channel. This happens a lot because the default channel for most wireless transmitters is Channel 1, and if you didn't change the default setting, you're both on Channel 1, and you're both going to be firing each other's flashes all night long—unless you simply change your flash to Channel 2. That's it. Go on the back of your flash, go to the Channels function and change yours to Channel 2. Fixed. Unless, of course, that third photographer had his already set to Channel 2. Yes, it happens. So, you use Channel 3—no biggie. To avoid all of this, the next time you find yourself shooting with other flash photographers nearby, simply ask each one what channel they're on, so you can all choose your own separate channels and nobody fires anybody else's flash. Then, you can do an uncomfortably long group hug. That's optional (but it shouldn't be).

Slave Mode Lets You Fire a Second Flash without Wireless

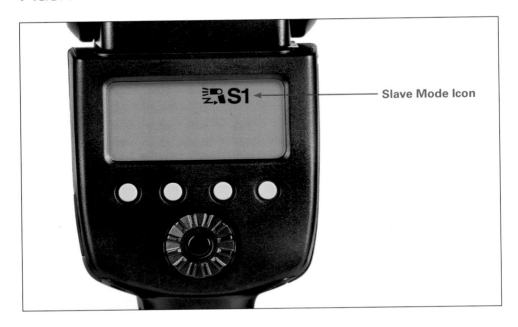

Slave Mode Icon

Sometimes you need to set up a quick flash, and you don't want to mess with any settings—you just want it to fire. That's when you use Slave mode. When you switch your flash to Slave mode, here's what you're telling it: "If you see anything else flash, you fire immediately." You don't need to set up a wireless transmitter, or put it in a group, or a channel, or any of that stuff—you put it on Slave mode, it sees a flash, and it fires. Done deal. This is great for those situations where you don't have another wireless transmitter for this flash, or if you just need to "run and gun," where maybe you want to quickly put a flash behind the bride—you just set it on Slave mode, place it anywhere, and you know it's gonna fire when you fire your main flash. If it can see the light from your main flash, it will fire. Another place you can use Slave mode is when you're using studio lights, and you also want to use a flash—maybe to light the background or something in the background. Just put it on Slave mode and when you fire your studio strobes, it will detect that flash and fire right along with them, just like it was one of the big boys!

Getting More Power Than Maximum

So, what do you do if you're shooting outdoors, you have your flash powered all the way up, and it's just not enough light? You don't change your shutter speed (that doesn't control the brightness of the flash at all), but instead, you start by lowering your f-stop. If you were at f/8, try f/5.6 and see if that does the trick. If not, then it's time to raise your ISO, which helps tremendously when you're trying to get more power from your flash. Since we normally shoot with flash at our lowest, cleanest ISO (see page 53), you probably have plenty of headroom to crank up the ISO without introducing a lot of noise, especially since this "I need more power than full power" phenomenon wouldn't normally be happening at night—this would be happening during a bright, sunny day. So, increasing the ISO for a daytime shot will probably introduce little noise (even if you have a somewhat noisy camera).

Want Your Beam Wider or Tighter?

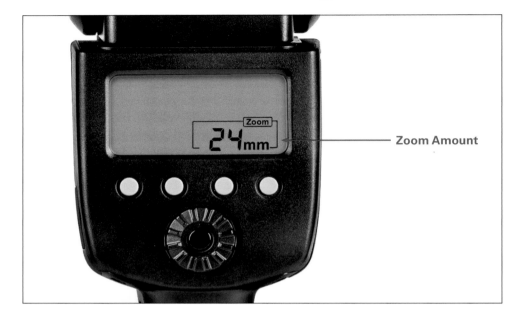

Zoom Amount

This is something that most flashes take care of automatically for you—it varies the width of the beam of the flash (or "zoom amount," as it's called by flash street gangs) to match the lens you're using, so if you're using a wide-angle lens, the flash covers a wide area (it would be weird if you took a wide-angle shot, but only the center of the image was lit, and the sides were all dark, right?). It also works with a zoom lens. So, if you zoom in tight on your lens, it makes sure the width of your flash beam zooms in, too. For example, if you were using a 24–120mm lens on your camera, when you're zoomed all the way out to 24mm, you'd see 24mm appear right on the back of the flash, and as you zoom to 120mm, you'll see that the zoom amount changes until it gets to 120mm when you're zoomed all the way in. So, since this all happens automatically, why am I telling you this? Well, it's because you can override the automatic setting and set that beam to whatever you want. For example, if you were shooting a wide shot, and you just wanted the center lit, you could change the zoom amount from, say, 24mm (very wide) to 120mm (creating a much tighter beam). You'd just go to the Zoom control on your particular flash (of course, it's in a different place depending on your flash's make and model) and use the dial (or up/down buttons, if your flash has those) to change the amount of zoom. By the way (and, in case you care), the flash head inside your flash physically moves forward or backward inside the flash casing as it zooms, so this isn't some software trick—it's doin' it "old school" (ain't no school like the old school).

Your Flash's Modeling Light

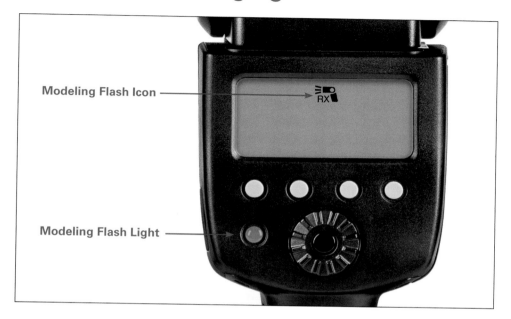

Modeling Flash Icon

Modeling Flash Light

When you shoot in a photo studio, the regular room lights in the studio are generally very low, so most studio lights come with what's called a modeling light. This is usually a separate, low-wattage, continuous light bulb that does two things: (1) it stays lit all the time to give you a preview of how your lighting and shadows will look on your subject before you actually fire the flash, so it's really helpful when positioning the lights; and, (2) it helps you focus your camera in what would be an otherwise very-low-light situation (most cameras don't lock focus very well in really low light). Well, some flashes have a built-in modeling light feature, too, but they work in a very different (and not nearly as helpful) way. When you enable the modeling light on your flash, it fires a quick series of flashes at your subject, so you can stand back and see how the light will fall. It's "kind of" helpful, but you need to be careful not to overheat your flash (in fact, Canon warns that if you fire too many modeling light flashes in a row, you need to let the flash cool down for 10 minutes before using it again). So, in short, just let it pop a few times—two or three flashes—not 10. Check your flash's manual to find out if your particular make and model has this modeling light feature. By the way, I included this modeling light feature here because I thought you'd want to know about it, but I don't use this feature myself. Try it once, and you won't want to use it either. It's like a momentary bad drug trip (or so I've been told by some flash hippies in Colorado).

Want to Make the Light a Little Less Harsh? Put on a Diffusion Cap

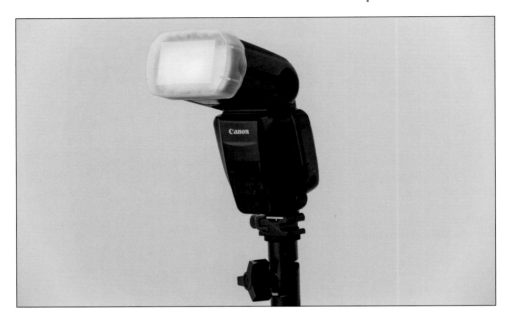

Chances are your flash came with a frosted white, plastic diffusion cap (sometimes called a diffusion dome) that snaps right on over your flash head (if your flash didn't come with one, you can buy one that fits your particular make and model of flash—a company named Vello sells 'em for like 10–12 bucks at B&H Photo). These make your flash "slightly less harsh," as they take the normally direct beam of light from your flash and spread that beam out pretty much everywhere, and that helps take some of that nasty edginess (hard shadows) off your flash, especially if you're already bouncing your flash off the ceiling (see page 77). However, this does not, by any means, replace a softbox, but it at least helps a bit if you don't have one. (BTW: I know a number of photographers who put on the diffusion dome, and then still attach a softbox in front of their flash to get it a little bit softer.) Most of the time, you're better off using it, unless you're trying for some hard, edgy light. So, it's a good accessory to have, especially since they're so affordable, and it is less harsh than using just a bare flash.

When Diffusion Caps Don't Work

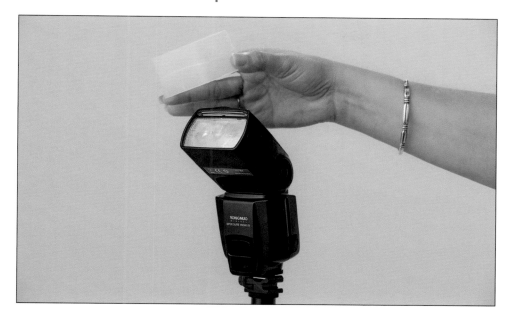

When you fire your flash through anything, it eats up a little of the power of the light, and while a diffusion dome can help when you're shooting up close to your subject indoors, or bouncing your flash off the ceiling (again, see page 77), they don't really do anything meaningful outdoors because there aren't walls, a roof, or any other large surfaces to bounce off. Same thing when you're shooting far away from your subject, or when you're in a really big room. That's when I would take the diffusion dome off the flash, so it doesn't eat up any power and helps your batteries last longer.

Your Flash Has a Built-In Wide-Angle Diffuser...

...and it's not awesome, but once again, it's better than nothing if you don't have any-thing else to diffuse the light from your flash, so your shadows are less harsh. This wide-angle diffuser is built into your flash (it's right beside the built-in bounce card on most Canon, Nikon, Sony, Phottix, and Yongnuo flashes). You slide it out from that lit-tle slot in the back of your flash head, right between the flash itself and the body of the flash unit, and you tilt it down so it covers the flash head (as seen above). These wide-angle diffusers have a repeating pattern etched into the plastic to spread the light out wider, and while that sounds helpful, overall, these built-in diffusers are not awe-some. Like I said, they're "better than nothing," but that's probably not the quality level you've been searching for. In fact, while I would spend the $10 or $12 to buy a diffusion dome, I wouldn't spend 30¢ to get a plastic wide-angle diffuser, but I still thought it was important for you to know what it does and why you shouldn't waste your time using one (it's definitely a "use in emergency situations only" type of diffuser).

Using Your Flash's White Bounce Card

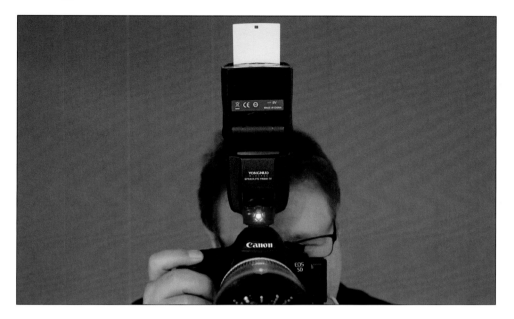

If you're going to be putting your flash directly on top of your camera (and there are some instances where this is, well, kind of acceptable, like while shooting the bride-to-be in her suite, while the bridesmaids are hanging out, getting the bride ready, etc.), I'm hoping that you are aiming your flash straight upward (like you see above), rather than directly at your subject (which is a recipe for awful flash). If that's the case, you can take some of the light from your flash that is aiming upward and redirect a tiny bit of it back to your subject in front of you, using your flash's built-in bounce card. This is the tiny white card that slides up/down right behind the flash head itself. So, look down in the little crack between the flash head and the outside body of your flash, and you should be able to pull out that tiny card. You'll really only use this card in the situation I mentioned above (your flash is on top of your camera, aiming straight up toward the ceiling—don't angle it even a bit), but it does make a nice difference, especially when you're standing reasonably close to your subject, and it also helps to add a little catchlight to your subject's eyes (which is why it's sometimes referred to as a "catchlight card"), which is a bonus. BTW: If, for some reason, your flash doesn't have a bounce card built in, you can find third-party bounce cards at B&H Photo from Rogue, Honl, and MagMod, among others, or you can just make your own with a white index card and a rubber band.

Do You Need a Flash Meter?

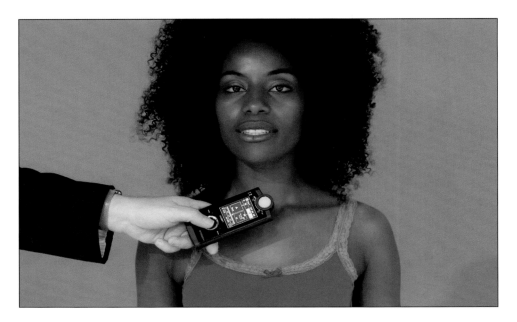

Flash meters simply measure the light coming from your flash, and tell you what to set your f-stop at so you have a proper exposure. Let's do a quick Q&A: **Q. Scott, do you own a light meter?** A. Yes. In fact, I own two. **Q. Do you use them?** A. No, never. **Q. Why not?** A. Two reasons: (1) I have a monitor on the back of my camera that shows me how the lighting looks. I take a test shot. If the light looks too bright, I turn it down a bit. If it's too dark, I turn it up. It usually takes just two or three test shots, and I get it looking like I want. (2) I generally don't like a perfect exposure. I like to either underexpose by a stop or so, or overexpose by like two stops. So, to me, perfect exposure is perfectly boring. Plus, I can never decide where to aim the white dome. **Q. Aren't you supposed to aim it at the flash?** A. Oh yeah, that's right—you aim it at the light source. It has been so long since I used a flash meter I forgot. Thanks. **Q. No problem.** A. That's not a question. **Q. I know.** In case you're wondering, here's how flash meters work: If you're doing a portrait, position the flash meter just under your subject's chin and aim the little white dome on the flash meter toward the flash (some folks argue that it should be aimed toward the camera, instead, but it's easier to find people who agree on gun laws than it is to find two photographers who agree on where to aim the dome. In fact, the only thing you can get two photographers to agree on is that the third photographer isn't a very good photographer. But I digress). Anyway, aim that stupid dome somewhere, have a friend (or assistant) fire a test flash, and you'll see a reading right on the display: f/8 or f/11, etc. Now, calmly walk over to your camera (so as not to upset the other photographers on set still arguing about the angle of the dome), set your f-stop to match whatever it said on the meter, and there you have it—the boring, yet proper, flash exposure.

How to Wait Less Time Between Flashes

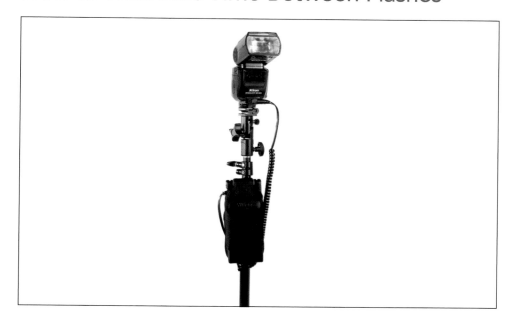

When you take a shot using your flash, you have to wait a second or two (when your batteries are fresh, or a few seconds or more when they're not), until your flash "refreshes," and it's ready to fire again at whatever power setting you have it set at (the higher the power setting, generally, the longer it takes to refresh). By the way, if you take a shot before your flash is fully refreshed, one of two things happens: (1) your flash just doesn't fire at all, or (2) it fires, but not at the amount of power you have it set at, so it looks much darker than it did on the shot before. Luckily (depending on your make/model of flash), you might be able to dramatically speed up its refresh time using an external battery pack accessory (like Nikon's SD-9 Battery Pack [it's $199] or the much more affordable Bolt CBP-N2 Battery Pack, for around $75 [ahhh, that's more like it]. Canon has a similar battery pack accessory, at a price similar to Nikon's, and Bolt makes a Canon version, too [for a similar price]. Sony makes one [sadly, no Bolt version at a lower price], and it's $211). These external packs (which plug right into your flash) do two things: (1) they greatly speed up your refresh time, so you can fire off shots a lot quicker, and (2) they let you fire the flash a lot more times without having to change batteries. The only downside is: they use a lot of AA batteries (you can get away with four, but to really get the benefits, you need to use eight). These packs usually come with a strap, so I just hang mine from a knob on the light stand that's holding my flash (they're not very heavy—it's mostly just the weight of the AA batteries).

Freezing Motion

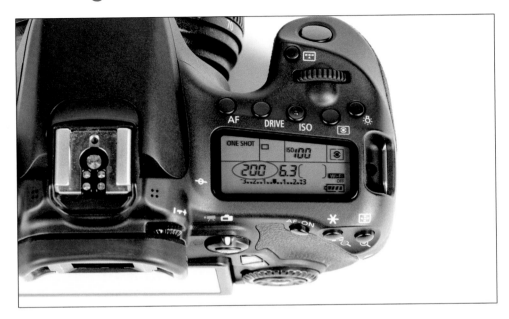

Flashes are pretty great on their own for freezing motion—that sudden burst of light does wonders for freezing whatever is in front of you. But, there are a few scenarios where that doesn't work as well as you'd think. If the thing (or person) you're shooting with flash is moving, and you see a blurring from the motion, the first thing you can try is to simply lower the power of your flash. That increases the speed of that tiny burst of flash big time, so it'll freeze stuff like you can't believe when you set your flash to a low power setting. If you were at 1/1 power (full power) and lowered it to 1/4 power, your freezing motion issue will probably instantly go away thanks to that massively increased flash duration. Another thing to try is raising your shutter speed. If you get your shutter speed up to around 1/200 of a second, that will probably do the trick (many flashes can go to 1/250 of a second and still stay in sync [see page 50], and some can go much, much higher [see the next page], but all of them go to 1/200, and that's probably all you will need). If you shoot with your shutter speed at 1/30 or even 1/60 of a second, it won't always freeze motion, even with a flash. Lastly, it's the light from the flash that freezes your subject's motion, not the existing light in the room or outdoors. So, raising the shutter speed like this lets in less existing light to your camera, and then your photo relies on your flash to freeze your subject.

Getting Soft Blurry Backgrounds with Flash. Spoiler Alert: You Use High-Speed Sync

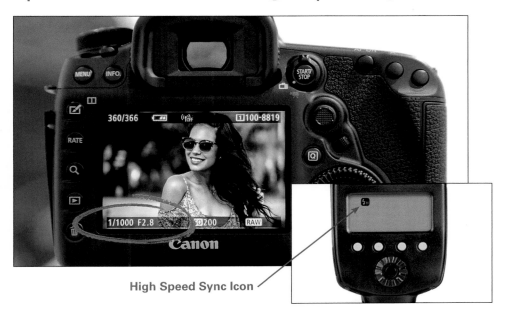

High Speed Sync Icon

The secret to getting an out-of-focus background with flash outdoors is to get your shutter speed high enough so you can shoot with wide-open f-stops, like f/2.8 or even f/1.8, which (when paired with a nice zoom lens, like a 120mm or a 200mm) gives you that soft, out-of-focus background. The problem is, when outdoors on a bright, sunny day, to get a proper exposure, we'd have to use an f-stop like f/11 or f/16, which makes the entire background sharp and in focus, and generally, isn't awesome for location portraits (to say the least). The solution? High-Speed Sync, which lets you use as high a shutter speed as you want (rather than being limited to just 1/250 max), so now you can use really low f-stops, like f/2.8. Why isn't this on by default? Because turning on High-Speed Sync chews through batteries like a Castor beaver through a cottonwood tree (and that, folks, is a metaphor you just don't hear enough these days. #sad). High-Speed Sync (enable it from your flash's menu) eats up power, and that eats up batteries, so we only turn it on when we need it (and when we have extra batteries nearby). But, now you can crank your shutter speed up to 1/1000, 1/2500, pretty much whatever you need, to get those wide-open f-stops and gloriously out-of-focus soft backgrounds when using flash. There are two more downsides to High-Speed Sync: (1) you lose around a full stop of power from your flash, and (2) its light doesn't travel nearly as far (High-Speed Sync isn't actually just one pop of flash, but a super-fast series of flashes firing in a row). This is why some pros use a cluster of multiple flashes firing from the same position at once to add more light and distance (see page 143). So, High-Speed Sync is awesome when you need it, but like everything else in life, it has its downsides (well, everything but pizza. There is no downside to pizza. Or tater tots. They're the perfect food. They were probably invented by unicorns).

Camera Settings for Working with Flash

This part is way easier than you'd think

I know what you're thinking, "Wait! I had to learn flash settings, and now I have to learn camera settings, too?" Yes, my little lighting buckaroo. But, not only that, you have to learn so many complex mathematical computations that you'll find yourself holding a Texas Instruments TI-83 Plus Graphing Calculator far more than you will an actual camera or flash on your shoots. Well, that and a logarithmic slide rule (I recommend the Nestler Rietz 23/52 original German version), which any flash photographer will tell you is an indispensable tool on all shoots—right up there with a roll of gaffer's tape, a few sheets of CTO gel, and of course, a Northwest Instrument NETH503 Theodolite for precisely measuring angles in horizontal and vertical planes, which you'll be spending a fair amount of your time doing, so make sure you get a good one. If that sounds like a lot to carry around on a shoot, it is, and that's why I always recommend hiring an assistant for these types of shoots—one with a strong back and a fully paid up short-term disability plan, with a low deductible—because at some point, they're going to tumble down a flight of stairs with all that gear, and it's not going to be pretty. Surely, they just tripped over their own feet (assistants are so clumsy), or maybe they were pushed; it's really hard to say. But, as the photographer, you're never to blame, which is precisely why we hire assistants in the first place—to take the heat for any incident, camera malfunction, or accidental death that may occur at on-location shoots with flash. See, having to learn how to use the Nestler Rietz 23/52 logarithmic slide rule doesn't sound all that bad now, does it?

Why We Need to Shoot in Manual Mode

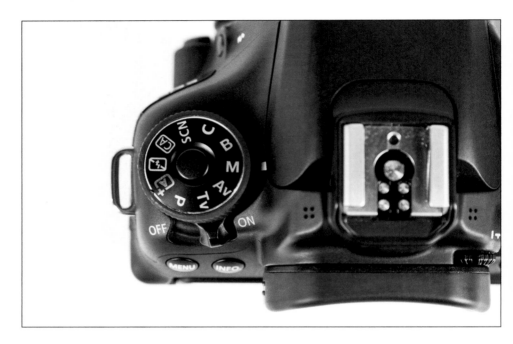

For my everyday photography (travel, sports, portraits in natural light, etc.), I generally shoot in aperture priority mode (A or Av mode on most cameras), where I pick the f-stop and my camera automatically picks the proper shutter speed for me. But, when it comes to using flash, this is when I switch to manual mode because, believe it or not, it's easier. That's right, it makes using flash a breeze, and what we do in manual mode is so easy, even if you've never shot in manual mode before, you'll totally "get" this. One big reason it's easier is that, with the flash system I'm teaching you, you'll have a starting place (a specific shutter speed setting and a starting f-stop) each time you use your flash (in fact, if you're shooting indoors, you might not even change these settings at all—you just dial 'em in and those are your settings for the shoot. They'll stay the same the whole time. The only thing you'll do is take a test shot, and if you think the flash looks too bright, you'll turn down the brightness setting of the flash. If you think it's too dark, you'll turn it up. How simple is that?). So, even if you've never shot in manual before, you will have absolutely no problem doing the simple stuff we need to do using the flash system this book is based upon. Okay, let's start with what controls what. There are three controls on your camera that affect your flash photography, and we'll start with shutter speed on the next page.

Shutter Speed Controls
the Light in the Room

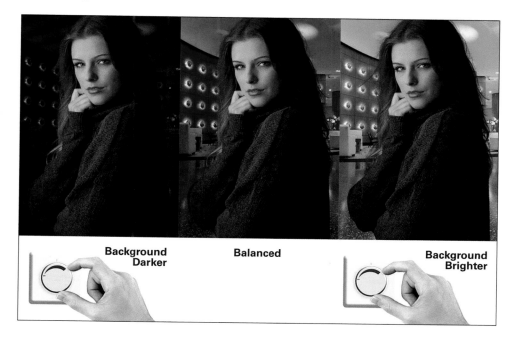

Background Darker | Balanced | Background Brighter

Take a look at the image above, in the center. The flash on her is pretty balanced with the light in the room behind her, but if I decided I wanted that light in the room darker, in real life, I'd walk over to the dimmer switch on the wall and turn down the lights, right? That wouldn't affect the flash, it would just affect the lighting in the room, right? Well, that's exactly how shutter speed works. If I wanted the background behind her darker, I would raise the shutter speed, maybe up to 1/200 of a second or even 1/250 (if my flash allows me to go that high and still stay in sync). Doing that darkens the room light behind her, just like turning down the dimmer switch on the wall. The problem with this awesome metaphor is there's no dimmer switch when you're shooting outside, but that is precisely why this technique is so awesome: because it works outdoors, too, making the background behind your subject darker, even outside. (I know. Mind blown!) Now, just so you totally get this, take a look at all three photos above. Notice that even when I change my shutter speed, and the background gets darker (by raising the shutter speed to a faster amount), or brighter (by lowering my shutter speed to maybe 1/60 of a second, or 1/30 of a second, or even less), the amount of light from my flash hitting my subject doesn't change. It's the same amount of light on her in all three shots. That's why you can think of shutter speed as the dimmer switch for the existing light whether you're inside or outside.

F-Stop Controls the Brightness of the Flash

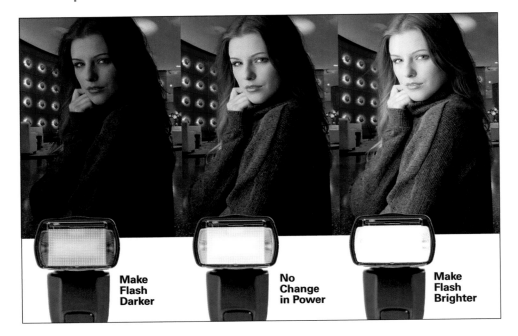

Make Flash Darker **No Change in Power** **Make Flash Brighter**

You already know there's a power control on the back of your flash, and you can turn the brightness (power) up or down using that control. But, what if you're just an incredibly lazy person, and you don't want to change the power of your flash using the up/down control? Well, then you're going to love the fact that you can change your f-stop to brighten and darken the flash without affecting the existing room light much at all (or the natural light outdoors). Take a look at the three shots above. The one in the middle is pretty balanced between the room light, and the amount of flash I'm using, but if I raise my f-stop (let's say my current f-stop is f/5.6, and I raise it numerically to f/8 or f/11), the flash goes down in brightness but the background pretty much stays the same. Why? Because only my flash is lighting my subject (the background is lit with the room lighting indoors or the sun outdoors). Look at the shot on the right. That's what happens if I lower my f-stop (let's say it's still at f/5.6) down numerically to f/4 or f/2.8. My flash gets brighter on my subject, but notice that the room light, in all three shots, never changes. (Pop-quiz: What changes the light in the room? That's right, the general manager of the hotel. Or, if he's not available, you can use your shutter speed.) "So, Scott, I just want to make sure I have this correct, are you saying that I can change the brightness of my flash by either: (a) changing the power setting on the flash, or (b) by changing my f-stop?" Yes, that's what I'm saying. Boom! (Drops mic.) "That is incredibly helpful to know." Sorry, I can't comment any further, I already dropped the mic.

ISO Makes Everything Brighter or Darker

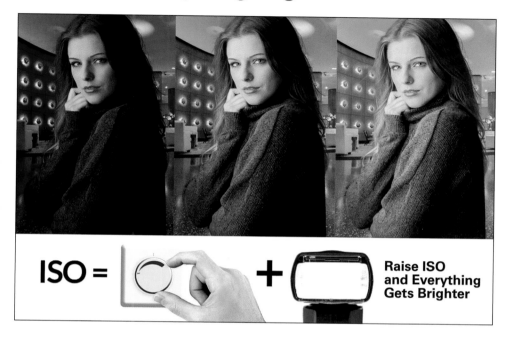

What if you want everything brighter—the room light (or the light outside) *and* your flash? Then, you'd increase your ISO (let's say, for example, we're at 100 ISO, so maybe you'd move it up to 400 ISO, or even 800 ISO), and you'll see everything get brighter, because (nerd alert) your camera is more sensitive to light. So, see that little formula above? That's telling you that ISO equals turning up the dimmer switch, and the brightness of your flash—you're turning up everything at once. Needless to say (but, I'll say it anyway because I heard a rumor once that authors get paid by the word, but apparently that was a long time ago, and then it only applied to newspaper and magazine articles, and one can't be too careful when it comes to 3¢ a word), if you're already at 400 or 800 ISO, turning down your ISO would make everything darker (those 17 words just brought in a cool 51¢. Cha-ching!).

Where to Set Your Shutter Speed (and Why)

Set your shutter speed at 1/125 of a second. Okay, why 1/125? Because that's a good, safe shutter speed to use on almost any camera to make certain that your flash and the shutter on your camera stay in sync—you press the shutter button and it fires at exactly the right time. What happens if they get out of sync? Well, that's what you see above. If your shutter speed gets too high (above 1/200 of a second for Canon, 1/250 for Nikon, or depending on which Sony camera you have, it could be 1/160, 1/200, or 1/250, which is why 1/125 is so perfect), you start to get a dark gradient that appears over the bottom of your image, like you see above. The higher you go over that "maximum flash sync speed," the higher that gradient gets. But, of course, you can avoid that entirely by just doing what I do and use 1/125 as your shutter speed. There will be a time (as you'll learn shortly) where you might want to change it, but usually it will be to lower the shutter speed, and that's perfectly fine. It's when you go above 1/200 of a second that things get dicey, so that's why I recommend 1/125 of a second. I'm doing my best to not nerd out here and go into how the "curtains" work in your shutter, and their relation to the focal plane, and all that stuff, so instead just know that (a) you want your camera and flash to stay in perfect sync, (b) if you set your shutter speed at 1/125 of a second, you'll never have to worry about them being out of sync, and (c) if you see a gradient appear on your photo, check to see if you accidentally increased your shutter speed, 'cause ya probably did (I've done it dozens of times myself). So, set the shutter speed back to 1/125.

When to Change Your Shutter Speed

If you're doing indoor portraits or headshots, where your subject is photographed against a backdrop, or a roll of seamless paper, etc., you won't need to change your shutter speed off that 1/125-of-a-second setting. You can "set it and forget it." So, when would you ever change your shutter speed? Well, here's the really cool thing: the shutter speed doesn't affect the power of your flash, whatsoever—you can raise it, lower it, etc., and the brightness of the flash doesn't change a lick. As you learned back on page 47, the shutter speed controls how much of the existing light in the room (or outdoors) makes its way into our photo. We call this existing light "ambient light" because, in photography, we like using fancy words (it makes us feel important). So, for example, if you walk into a restaurant, the lights that are already on in the restaurant would be the ambient light (the light that is already in the place where we're shooting). If you take a photo of someone in that restaurant, and the background behind them looks really dark (maybe so dark you can't even tell they're in a restaurant), then you could lower your shutter speed (from 1/125 of a second down to 1/60 of a second, or even 1/30 of a second), and that would let more light from the restaurant into your shot.

Which f-Stop to Start With

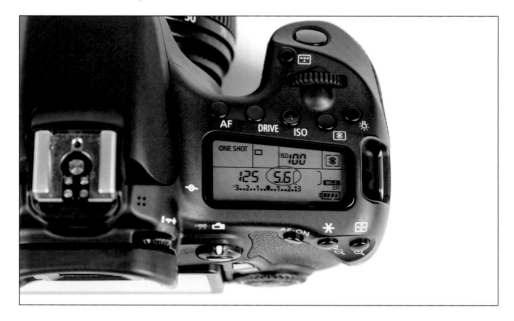

That's easy: f/5.6. Why f/5.6? Well, why the heck not? It's a lovely f-stop this time of year. Okay, actually, everybody needs a starting place and f/5.6 is what I always use as my starting f-stop when I'm working with flash. It's a good, solid starting place, and I like it for a number of reasons, with one being that if I use a long lens (like my trusty 70–200mm) at f/5.6, when I zoom in on my subject, the background behind them goes a little bit soft and out of focus. Also, it allows me to keep the power of my flash pretty low (and, as I mentioned back in Chapter 1, my starting place for the power setting on my flash is just 1/4 power), and if the power of my flash is pretty low, that means my flash recharges faster, so I can shoot to capture moments when, otherwise, I'd be standing there just waiting for the flash to recharge. It also means, I won't burn through batteries as fast. It's all good. So, in short, that's my starting f-stop—f/5.6. Of course, you could start with a different f-stop, if you really want to, like f/8 (even though it may possibly be the most boring of all possible f-stops), but you'll probably just have to turn up the power of your flash a bit, maybe to 1/2 power, which just means your flash will take longer to recharge, and you'll go through batteries faster, and your background won't be soft behind your subject, and your images won't look one bit better. Just sayin'.

Where to Set Your ISO

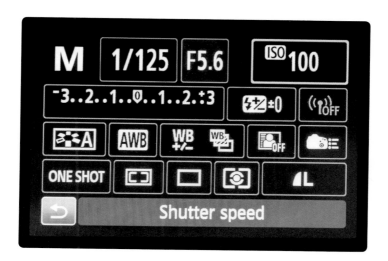

Your flash is going to illuminate your subject (five bonus points for using a $10 word there. Say it with me, "illuminate!" Now, use it in a sentence: "Your flash is going to illuminate your subject." Illuminate. Correct! You would totally rock a spelling bee!), so your image will have enough light, and because of that, you can use the lowest, cleanest ISO on your camera. For some of us, that would be 100 ISO (depending on our camera's make and model), for others it might 50 ISO, or as high as 200 ISO. Whatever the number is for your camera's make and model that gives you the lowest native ISO, that's the one you want to use. For my particular camera, my lowest native ISO is 100, so before the shoot, I set the ISO at 100, and I'm ready to roll. I rarely have to change my ISO during a shoot, but I explained raising it and lowering it back on page 49. By the way, in case you're interested, the abbreviation ISO stands for "Instant Sesame Oil." True story.

Here's Your Camera Settings Checklist

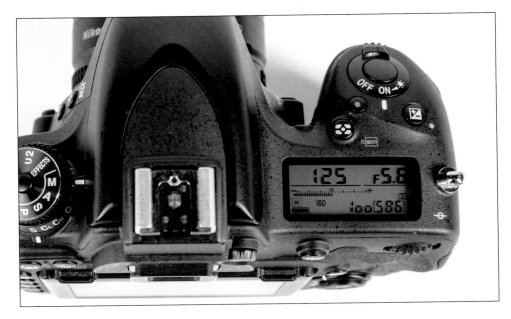

1. Switch your camera to manual mode.

2. Set your ISO at 100 (or the lowest native ISO for your particular camera).

3. Set your shutter speed at 1/125 of a second.

4. Set your f-stop to f/5.6.

5. Set the power on the back of your flash to 1/4 power.

Now, take a test shot. If the flash is too bright, turn down the power of your flash a bit and take another test shot. If it's still too bright, turn it down a little more, and take another test shot. After a couple of test shots, you'll have the brightness of your flash dialed in. If the flash isn't bright enough, turn it up a bit and take another test shot. Repeat until it looks bright enough.

That's it. Seriously, that's it. Avoid the tremendous urge to overthink this. This is the joy of shooting in manual mode on your camera, and using Manual mode on your flash—everything is just so simple. Don't try to find ways to make it complicated, because this works like a charm. This is a set of settings you can use as your starting place every single time, and a lot of the time, once you start shooting, you might not even touch the camera settings (depending on where you're shooting), just the power of your flash.

The Big Secret: Balancing the Light

At the end of the day, it all comes down to this: the big secret (and the most important technique you need to master) is balancing the light from your flash with the existing light in the room or outdoors. When you get these two really balanced with each other, the flash doesn't look like "flash." It looks like natural light. It's all supposed to blend together beautifully—you're not supposed to look at an image and think, "They used flash." In fact, if someone, who is not a photographer, looks at your image and says, "Oh, you used a flash," you probably did it wrong. It's all supposed to blend together to make your subject look great, without bringing any attention to the lighting at all—unless it's to have someone look at your photo and say, "You were lucky you had such beautiful light." So, how do you pull off this balancing act? What is the technique? Well, you're going to create this balance using the shutter speed dial (again, to raise and lower the existing light in the room), and the power setting on your flash (you're going to find that right amount of light from your flash, so it doesn't look too bright and blends in with the background—as if your subject was near a window with natural light streaming in). I start by getting the flash power where it doesn't look "too flashy," then I lower the shutter speed (from 1/125 to, maybe, 1/80 of a second), and then I take a test shot and look to see if it all blends together nicely, or if the flash still sticks out like a sore thumb. If it sticks out, I lower the shutter speed to 1/60 and try again. Once I do this, I might have to raise or lower the power of the flash again, until the balance looks right. It takes a few times doing this "dance," until it becomes fast and easy, but the good news is: it doesn't take long until it does become fast and easy. It just takes a little practice, but don't worry, you'll get it.

Using Flash for Portraits

How to make people look awesomer

If you want the money truck to pull up to your front door, and have two armed guards toss large white cloth sacks of money into your house (in particular, those sacks with the large, green dollar sign printed on them), then all you have to do is learn to make regular people look incredibly awesome in photos. If you can do that, people will find you and beg you to take their photo for money, and before long, you will become known as "the awesome maker," or "the awesome-izer," or "Eric," but whatever name they coin for you, it will be your gateway to a realm of riches and luxury that one dare not dream of—especially if you don't mind the occasional run-on sentence. Anyway, there is a legitimate reason why, now more than ever, people need to look really good in photos, and that's because they need a Facebook profile photo that looks at least 300% better than they actually look in person, so they have a chance of meeting someone else on Facebook with a massively better Facebook profile photo than they look like in person, too. Here's why this is so important: You see, when one of these folks you made look unrealistically beautiful starts hitting on somebody they found on Facebook (I recommend an opening line like, "I want to paint you green and spank you like a disobedient avocado!"), they are not actually flirting with a real person, they're flirting with the beautiful person in the profile photo you created. And, once they start hitting it off, they share that profile photo with their friends, and their friends say, "OMG, he is really cute." But, in reality, of course, he looks more like Shrek, but they won't know that until they finally, and awkwardly, meet in a Walmart parking lot late at night, and by then, it's too late and now they're a couple or maybe engaged. In short, make sure you get paid up front.

Get It Off Your Camera

There's a reason it's often simply called "off-camera flash," and that's because (like I mentioned in Chapter 1) you need to get that dang thing off the top of your camera! To make beautiful portraits of people, you want shadows, depth, and dimension, and to get that type of look, you're going to need to get your hot shoe flash off your hot shoe and onto a light stand (or have a friend hold it for you). This is why you keep hearing me talk about wireless transmitters and stuff like that, because unless you're doing event photography (like certain parts of a wedding), leaving your flash on the hot shoe mount, on top of your camera, is just one of the cruelest things you can do to your subject. It has all the grace and beauty of a passport photo, coupled with the artistic flair of a driver's license photo. So, if you want any hope of making beautiful portraits with your flash, you have to embrace the whole "getting your flash off the camera" and off to the side (more on this coming up). It is the core technique to all of this. So, before you turn any more pages in the book, you have to get in that happy place where you accept that getting your flash off camera will be your modus operandi from this moment forward. You are leaving the whole "flash on my camera's hot shoe" world behind you for a world of never-ending happiness. You can always see the sun, day or night. So, when you call up that shrink in Beverly Hills—you know the one, Dr. Everything'll-be-alright (sorry, I couldn't help myself). Anyway, in short, you're going with off-camera wireless flash from here on out, so let's go crazy!

Make It Soft and Beautiful

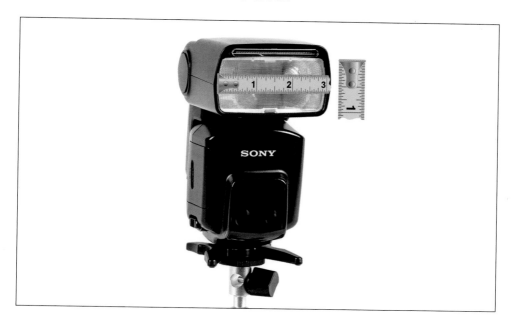

The light that comes from your flash is some pretty darn harsh light. Think about it: The flash head itself (where the light comes out) is only about 3" long by 1" wide. It's a nasty, little, bright flash of light—it's absolutely blinding to look directly at, and on its own, there's nothing beautiful about it. So, it's up to us, the photographer, to do something to make it beautiful. That's a lot of what this chapter is about—how to tame that harsh, angry, spiteful, little light, so it produces gorgeous, soft, wrapping, totally flattering light. To do that, we have to put something between the flash and our subject that softens, spreads, and diffuses the light, so it's soft and flattering. That's all we have to do—put something in front of it that softens the light, so it creates soft, flattering shadows and makes people look awesome. There's a key word tucked in all that, and that is: "spreads." One reason the light is so harsh and nasty is that it's physically so small (again, around 1x3"), and the smaller the light source, the more harsh and awful the light. Take the sun, for example. It's pretty far away from us, so it's tiny in the sky. Because it's so tiny, the light it produces is pretty harsh, and putting your subject in direct sunlight is almost as bad as putting your flash on top of your camera—it's harsh and awful, and the shadows are hard and just yeech! Now, if a big cloud moves in and gets in front of the sun, suddenly the light is much softer, and the shadows are soft. There's now something between the light source (the sun) and your subject—those clouds—and they act like a giant diffuser that spreads out the light from the sun and makes it softer. So, we do the same thing. We put something large between the flash and our subject to soften everything up.

This Helps a Little, but It's Not a Softbox

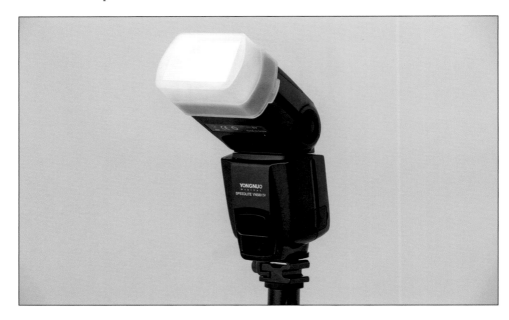

The reason why putting a diffusion dome over your flash won't help much is because it's really small, too! It's about the same size as your flash head—it fits right over it, snug up against it—so, it doesn't make your light source bigger. Now, if you had a 3-foot diffusion dome (there's no such thing, but let's pretend), and you held it a few feet in front of your flash, then the beam of light from your flash would have space to grow (the farther the light travels, the wider the beam spreads, and it would start to fill that 3-foot space with light). It wouldn't be a 1x3", nasty, little beam of light anymore, it would be a big, 3-foot, diffuser-sized light, and at that larger size, it looks much softer, more diffuse, and flattering. So, are you seeing where we're going here? It's not just about putting something in front of your flash, it's about putting something *big*, and a ways out in front of your flash, to make the light beam spread out and become beautiful.

TIP | **WHY YOU SHOULDN'T USE A FLASH BRACKET**

You might be tempted to use a flash bracket to get your flash off your camera, but don't fall for it. Moving your flash a few inches above your lens might help in reducing red-eye, but it won't create soft, beautiful light. Leave those to the newspaper reporters, and stick with almost any other technique in this chapter— you'll get better results.

My Favorite Softbox for Flash

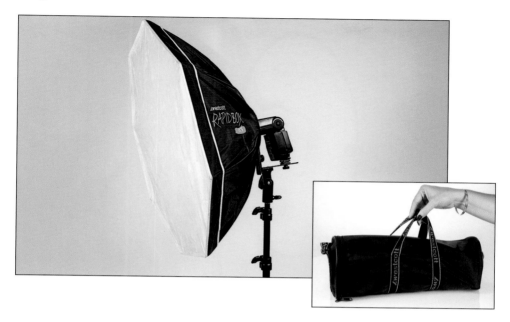

Westcott's Rapid Box has become my absolute go-to softbox for the past year or so, and while I've been using their gear for years now, I think this is hands-down the best thing Westcott has ever made, from both a design and build standpoint. First off, they are ridiculously small and lightweight—it folds up like an umbrella, and it all fits in just one tiny little bag, which in and of itself is awesome. That bag holds the softbox, the flash tilt bracket (so I can mount it on a light stand or monopod), and the diffuser that goes over the front. My basic rig is just this: that little bag; a small, lightweight light stand (see page 134); and my flash. That's it. It assembles in 2 minutes flat (if that)—you just take the softbox out of the bag, reach inside it, slide the attached, little metal ring over the center rod, and it pops into shape. Now, you simply put the diffuser over the front (it fits snugly right over the front), then you attach the bracket to the back (no tools necessary—it snaps on), slide your flash into place, and it's time to start shooting. They're very affordable, at around $169 for their Rapid Box 26" Octa (though, if you want even softer light, you can order the optional 2030-DP Deflector Plate accessory, which bounces the light from your flash into the back of the softbox first, before turning and heading out to your subject, for an extra 20 bucks). If you see me shooting with flash, chances are you'll see me using this softbox. Worth every penny! (And, no, Westcott doesn't give me a commission or kickback, etc., for saying that, which is a doggone shame by the way. ;-)

You Can Make Beautiful Light for Just $20

Pretty cheap, right? Yeah, it is. Pick up a Westcott 30" collapsible 1-stop diffuser for $19.90 (B&H Photo price; you can find others even cheaper on Amazon), and simply hold that in front of your flash and you're in business! (Well, you'll probably have to have a friend hold that diffuser in front of your flash for you. In fact, they can even hold your flash in one hand, and the diffuser out in front with the other hand, and easily put enough distance between the two to let the flash beam spread to create that soft, diffused, beautiful light.) That's it—stick a 1-stop diffuser between the flash and your subject, and you're "there." Twenty bucks. That's all that's standing between you and a tremendously better result from your flash.

TIP A CHEAPER SOFTBOX ALTERNATIVE

Before I switched to Westcott, for years, I used the 24x24" Impact Quikbox Softbox with Shoe Mount Flash Bracket because of its light weight and super-low cost. It's a pop-up softbox that folds flat, comes with its own flash bracket, and the whole rig is only around $75 at B&H (nearly half what the Rapid Box costs). Impact even makes a grid for it that's like 45 bucks, and while the Westcott gear is better made and actually more compact, it's hard to beat that setup for the money.

No Friend to Help? Get Out Your Debit Card

If you don't have a friend to help you hold the flash and that 1-stop diffuser on a shoot, things get a bit stickier, so get your debit card handy. Without a friend to help, you'll need to mount your flash on top of a light stand (you can get a lightweight 6' Impact Light Stand for around $20). You'll also need a tilt bracket of some sort, with a flash mount on top (which are oddly expensive), but you can get the highly rated Phottix US-A3 Umbrella Swivel for Off-Camera Flash, with its own mini–ball head (which is pretty cool, I might add) for just $22. But, that's just for holding the flash; now you need another light stand to put your diffuser a few feet out in front of your flash (add another $20), and a clamp to hold your 1-stop diffuser (like the Impact Holder for Collapsible Reflectors—at B&H Photo for $14). So, I'm going to be straight with you here: it'll cost you $76 more for beautiful light than it does for other photographers, because apparently at some point, you were so mean to people that you don't even have one friend to hold the stinkin' flash and diffuser. I didn't want to be the one tell you, but somebody should.

Use a Strip Bank Softbox on Your Second Light

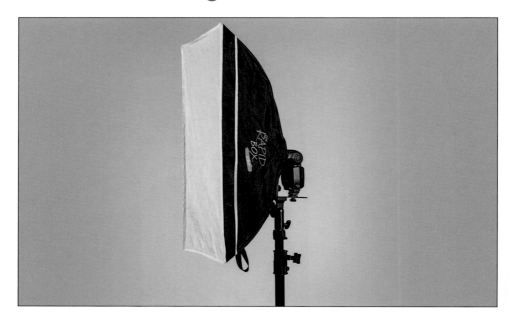

If I add a second light, it's usually what we call a "kicker light," which is a light positioned behind the subject and off to one side. I use it to create a bright highlight along one side of my subject's hair, side of their face, arms, and so on. When I add a kicker light, it's usually the 10x24" Westcott Rapid Box Strip, which is a tall, thin softbox whose beam of light goes out—well—kinda tall and thin, so it's perfect for a highlight or hair light. It works just like the Rapid Box Octa I talked about on page 61, so it basically comes together in 2 minutes (tops), and you're ready to start shooting with this second light. I usually position this behind my subject, directly opposite my main light (see page 78 for an example of the setup I use). By the way, the tilt flash bracket that comes with these strips also rotates, so you can easily turn the strip from tall to wide to diagonal. These strips are also absolutely awesome for product photography, with their long, tall reflections and highlights. They're perfect for smaller products, but get the bigger Westcott Apollo strips for shooting larger products, like guitars or motorcycles or furniture.

Get a Tighter Focus and More Drama by Using Grids

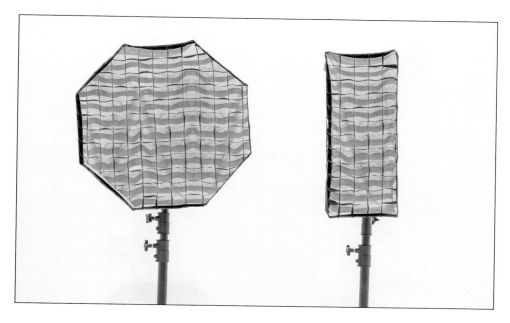

Anytime you use a softbox, no matter what the shape, your light is going to spread quite a bit once it leaves the softbox. For example, with a big ol' softbox, it will spill right past your subject to also light up your background (which can be a good thing, especially if you're only using one light and need some light on the background). But, what if you want a very defined, focused amount of light that doesn't spill onto other parts of the image area? Well, you could go with the strip bank softbox we just looked at on the previous page, which gives you a tall, thinner beam of light than a big, square softbox, but it tends to spill over onto other areas a bit, too. If you want to really focus your light and create some drama in your shot, you'll want to put a fabric grid over the front of your softbox. These are sometimes called "egg crate" grids because they look like you could put a few dozen eggs in one without breaking any. This fabric grid, which attaches over the front of your softbox, focuses your light into a concentrated beam in the shape of the softbox you're using, and it does a marvelous job of directing your light without spilling. Photographers tend to fall in love with grids, and once you use one, it's hard to not use them—they're just so awesomely directional. You can get grids for octas, strip banks, even beauty dishes, and they will send your light in a very focused, very directional way, without all the spill. The only downside: they are not cheap, and that's being kind. Often, they're as or more expensive than the softboxes you're putting them on. But, if you want to add drama to your shots, and tight focus to your light, they're totally worth it (especially, if you're loose with money).

Use Metal Grids to Get Tightly Focused Beams

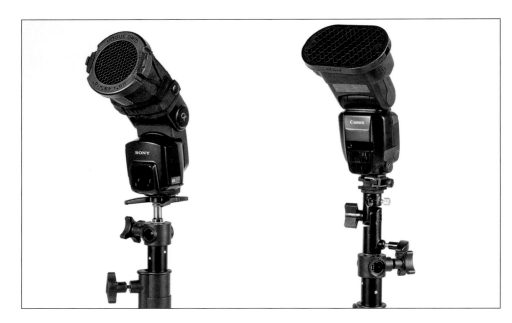

When I think of an egg-crate grid, I think of it for when I want to focus my light without spill, but I still want it to be soft, beautiful light. But, when I'm shooting a portrait of an athlete, then I want hard, edgier light (not soft, beautiful light), so I go with a bare flash (no softbox at all) with a metal grid over the flash head. These grids work like a charm to create a spotlight effect, like you'd see in a theater production. There are two companies that make these (heck, there are probably a dozen, but these are the two I use, so I can vouch for them): One is Rogue, and they are really popular with serious flash shooters. They make a range of flash accessories, and one, of course, is their metal grid. Theirs works like this (and is shown above on the left): you strap a short, little black sleeve around the outside of your flash head, then you pop a small grid into the holder on the end, and that's all there is to it—you've got very focused light with very little spill whatsoever. Their Rogue 3-in-1 Flash Grid Starter Kit comes with two different grids (one with a tighter beam than the other, but you can stack both together for a third, super-tight beam) and three gels for different color effects, all for around $40. The other company that makes a nice grid setup is MagMod. It uses a different system (shown above on the right), with a rubber sleeve that fits right over the end of your flash, then it uses a clever magnet system that lets you simply pop a grid right over it, and it magnetically stays in place. It works great, and is very well constructed. The MagMod kit is $60 ($25 for the magnetic holder and $35 for the snap-on grid). My call: the MagMod is better made, but they only give you one grid, whereas Rogue's kit gives you two grids with three variations and some gels. You can't go wrong either way.

Using an Umbrella to Soften the Light (It Works, but Don't Do This)

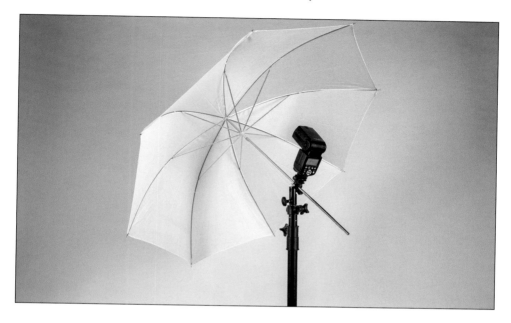

There was a time when using an umbrella to soften your light was a really viable choice, because there were few softboxes made for hot shoe flash, and they were either expensive, very clunky, hard to transport, or all three. The reason I'm not a fan of umbrellas is that they make controlling your light a lot harder because the light kinda spills all over. So, while they are dirt cheap (you can get a Savage 36" Transparent Umbrella for around $6.99; I am not making this up), they are not particularly awesome. Now, I will say this: if you're not currently using anything to spread and diffuse the light from your flash, and you ordered the Savage 36" umbrella, it would probably be the best 7 bucks you've spent all year, because your shots would instantly look a whole lot better. That being said, while they are super-lightweight, collapsible, easy to set up and use, and you can buy one new for the approximate price of a single McDonald's Big Mac® Extra Value Meal® (without super-sizing), I wouldn't say to a friend, "Hey, you should use an umbrella." I just wouldn't. I want them to be a success, and to increase their chances, I would steer them to a small softbox that's easy to work with, and easier to contain their light with, without spilling light all over my medium fries and medium Diet Coke.

TIP | **WHERE TO POSITION YOUR FLASH IN AN UMBRELLA**

To make the flash fill as much of the umbrella as possible, position it back as far on the umbrella rod as possible, so the umbrella is as far away from the flash as it can get. It'll have space to spread out, and that reduces the "hot spot" in the center.

Big, Beautiful Light Comes from Big Softboxes

If you need really big, beautiful light, either for super-soft, gorgeous portraits, or lighting full-length fashion, or for lighting groups, you need a really big ol' softbox. The bigger the softbox, the softer, more wrapping, and more beautiful the light. When I'm in any of those situations, I go with Westcott's Recessed Mega JS Apollo 50x50" softbox. Well, it looks like a softbox and acts like a softbox, but in reality, it's a very cleverly designed umbrella that when you open it, instead of expanding into an umbrella shape, it goes into a huge softbox shape. Your flash actually goes inside the softbox, through a zippered opening in the bottom, and for added softness, your flash aims away from your subject. The light from your flash hits the silver back and sides of the softbox, and then does a U-turn to fall gently on your subject, like a spring morning's dew rolling through a misty meadow of really meadowy stuff (once you dry your subject off, then you can start your shoot). Even though it's so big and beautiful, the price is actually really decent at $169. Downsides? Well, unlike the Rapid Boxes, where you have full access to the flash because it's behind the softbox, with the Mega JS Apollo, your flash lives inside the softbox. So, if you have to access it (maybe you need to change batteries, or you need to change some setting you can't change from your wireless transmitter), you either have to remove the front diffusion panel (it's just velcroed in place, so no biggie) to reach in to get to it, or use one of the side zippers, but then you are kind of flying blind. Accessibility during the shoot is not its strong feature, but hopefully, you won't be messing around in there a whole bunch anyway.

If You Need Really Big Light on a Budget

Now, if you want a really huge diffuser for really soft, wrapping light, but you're on a really tight budget, you might want to at least consider Westcott's 7' Parabolic Umbrella. It's only $99, it's monstrously huge, and it folds down like an umbrella because—well—it's an umbrella. It sets up in like 30 seconds—you open the umbrella, slide it onto an umbrella tilt bracket (it doesn't come with one, so tack on $24.50 for an Impact Umbrella Bracket with Adjustable Shoe), which should be sitting on top of a light stand (add another $20), and start shootin'. "But Scott, didn't you say a couple pages earlier that you don't recommend umbrellas?" I don't, generally, because, like I said, umbrellas are more like a lighting grenade—light is going everywhere, so take cover. I prefer more control over my light, and that's why I recommend softboxes instead. If I had 69 more dollars, I'd still opt for a 26" Rapid Box Octa. Well, that is unless (and this is a big unless) I'm shooting full-length fashion, where I need to light my subject from head-to-toe, or I'm lighting small groups, in which case, I would need something much bigger than a 26" softbox, like this 7' gargantuan-sized umbrella. BTW: If you go this route, get the white shoot-through version—your flash will fire directly through the umbrella at your subject. It's not as bad as doing the whole "cruise ship routine," where you aim the flash toward the back of the umbrella, with the umbrella faced away from your subject (hey, 2002 called, and it wants its umbrellas back), and it becomes the lighting equivalent of the "mother of all bombs" light source.

Instant Headshot Setup

If you want to do corporate headshots (or beauty-style headshots), you can use something like the Rapid Box 26" Octa for the main light (really, any small softbox will do) to light your subject (you'll place this directly in front of them, aiming down at a 45° angle, and hopefully, on a boom stand, so you don't have to work around having a light stand in the center of your shots). Then, have your subject hold a reflector right at their chest level (as seen above left) to fill in the shadows under their eyes and neck. It works wonders. I have my subject raise the reflector until I can see the edge in the frame, and then I have them pull it down to where I can't see it. That seems to be the sweet spot. Of course, a friend can hold the reflector, or you can buy a light stand with special clamps designed to hold one (I use Impact's Telescopic Collapsible Reflector Holder [$48], which attaches to the top of any light stand). At least you have options, right? BTW: Use the white side of the reflector, facing up, if you want just a little bit of light to reflect back onto your subject. I generally use the silver side, which reflects more light, so it gives a brighter amount of fill in the shadow areas. If you want to move this whole thing to the next level, instead of using a reflector on the bottom, put a second flash there with another 26" Rapid Box Octa (as seen above right), aiming up at a 45° angle, and now you can control the amount of light coming up from the bottom. This is my preferred method, so if you have two flashes, I would go with this one. Also, be sure the brightness of the top flash is brighter than the bottom one (lighting people from below is not flattering, but you can avoid that by making the top light brighter). How much brighter? Well, if your bottom light is at 1/4 power, I would make the top flash 1/4 power +2/3. If that's too bright, try 1/4 power +1/3 (it depends on the subject's skin, and the make and model of your flashes).

The Most Popular Place to Position Your Flash

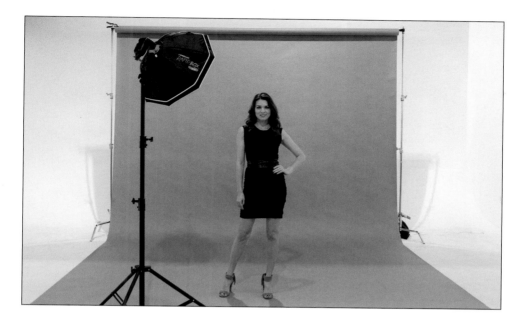

The most popular place to position your flash for portraits is at about a 45° angle from your subject. The reason this position is so popular is that it creates a very flattering look, with some soft shadows to add depth and dimension (well, as long as you made sure to soften the light with a softbox of some kind). To help with envisioning the position, think of it this way: if your subject was at the center of a clock, and you were standing in front of them at the 12 o'clock position, you'd put the light halfway between the 1 and 2 o'clock position (or halfway between 10 and 11 o'clock, if you want to light them from the other side). Of course, with it off to the side like this, one side of the face will be fully lit, and the other will have some shadows, which is actually what we're trying to achieve, so that's a good thing (more on this on the next page).

Getting More (or Less) Shadows

This is where it really starts to get fun, because once you have your flash positioned at that 45° angle to your subject, you can leave it right where it is, or you can choose to make your image look more dramatic by putting more of their face in shadow, or choose a brighter, flatter look with fewer shadows. You do this by moving the flash on an arc. Here's an example: If you put the flash directly beside your subject, aiming at them from the 3 o'clock position, they are being lit totally from the side, so half their face would be hit (the side closest to the flash), and the other half would be completely in shadow. As you move the flash around this arc (one that mimics the face of a clock), when you get to the 2 o'clock position, some light will start to appear on the other side of your subject's face, right on their cheek. This is really nice, dramatic lighting (one favored by Hollywood for movie posters because of the drama it creates). As you continue to move it around this arc, you'll hit that 45° angle—that position between 1 and 2 o'clock where the other side of the face has a decent amount of light, but you still have some nice shadows from your subject's nose and on the far side of their face (it's the lighting I described on the previous page). As you move it farther around this imaginary arc, closer to where you're standing, you get fewer and fewer shadows on their face. When you get it to the 12 o'clock position, where the flash is positioned directly in front of them, the shadows pretty much go away, except for under their chin. Choosing how much shadow there will be is a personal preference, but now you know how to do it by simply moving the flash either closer to the front of your subject for fewer shadows, or more to the side for more shadows on the opposite side of their face.

If You Need Even Softer Light, Feather It

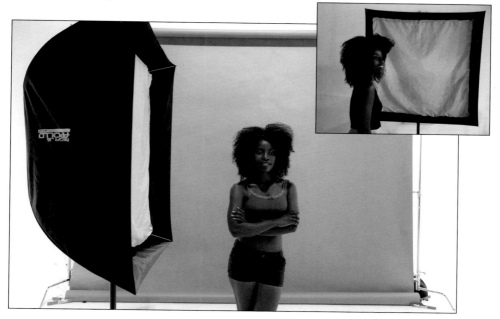

When you put a softbox in front of your flash, the center of your flash will usually be right in the center of the softbox. So, it only makes sense that the center of your softbox is where the brightest light is found, and of course, the brightness will dissipate as you get to the edges of the softbox. Now, let's think about that for a sec: The brightest light, or "hot spot," would be in the center, and then it gets less bright and softer near the edges. Hmmmm. See where I'm going with this? If the light is softer at the edges, we can use that fact to get even softer light by not aiming our softbox directly at the subject (since we know the brighter, harsher light is in the center). I position my subject so just the light at the back of the softbox hits my subject, and I'm more likely to do this with a really big softbox—like the Mega JS Apollo 50x50"—than I am with a small softbox, because if I chose a really big softbox, I probably chose it because I wanted really soft light, and now I can make that light even softer. Now, of course, there is a trade-off: the light at the edges is softer, and not as bright as the center of the softbox, so you might have to turn up the power of the flash a little bit to compensate.

How High Up to Position Your Flash

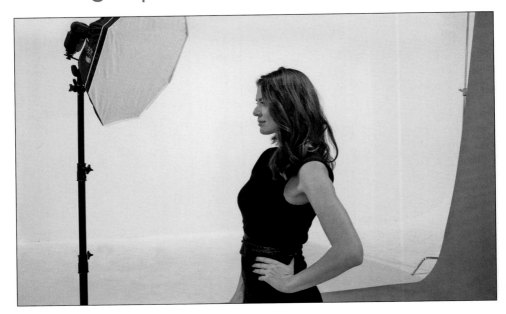

Our goal is to mimic natural light and natural light comes from up in the sky. So, you want to position your light higher than your subject's head, aiming down at an angle toward them. A good starting place is to aim it down at around a 45° angle. Gee, that was easy.

How Close to Put Your Softbox

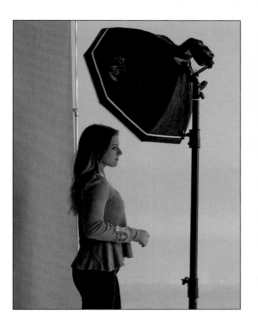

This one is really straightforward: the closer you put the softbox to your subject, the softer the light will be. So, when I want really soft light, I put the softbox as close as I can get it to my subject without actually seeing it in the frame. Of course, as you move the light closer to your subject, it gets brighter. So, when you move it in really close like this, you'll have to lower the power of the flash, so it's not too bright. If I want harder, edgier light (like we usually want for portraits of men), then I move the softbox way back. Easy stuff.

TIP

HOW FAR TO STAND FROM YOUR SUBJECT

Unless you are using bounce flash, it doesn't matter how far back you stand (you could be standing 200 feet back from your subject), because it's not about how far back you are, it's about how far your flash is from your subject (see above).

Lighting to Make Your Subject Look Thinner

There's a lighting trick we do when our subject has kind of a round or wide face to make it look trimmer and longer. It's called "short lighting." It has been around for a long time, so we're not breaking any new ground with this technique, but the reason it has been around for a long time is: it works. Here's what you do: First, turn your subject at a 45° angle, so they're not facing the camera straight-on with their shoulders flat (just doing that alone will create a more flattering portrait for most subjects). You'd still put your flash/softbox to the side at a 45° angle like usual, but the key to this technique is knowing which way to turn your subject to short light them, and that way is simple: have them turn their body at an angle toward the light. So, let's say that looking from your camera position toward your subject, you put the softbox on your right. Then, you'd have them turn toward the light, with their back shoulder being farthest from you. That's it—you're short lighting! When you look at the shot, you should see lots of shadows and a bit of light on their cheek closest the camera, then their nose, then the brighter side of their face farthest from the camera.

Bounce Flash Can Save the Day

If you're in a situation where you can't use a softbox, or using a softbox would be impractical—like at an event, or in the bride's "make ready" room at a wedding—you can use "bounce flash" to spread and soften your light. When it's done right, it actually works amazingly well (not as good as a softbox, but it's way better and more flattering than direct flash). Essentially, you just tilt the flash head up at a 45° angle—the light hits the ceiling, spreads and softens, and bounces down at the same angle toward your subject (think of how you a hit the cue ball on a billiard table, so it bounces off a rail at an angle to hit another ball—it kind of works like that). For bounce flash to work successfully, you need two main things: (1) You need a ceiling to bounce the light from your flash off that isn't too high. This technique is not going to work in a ballroom with 40-foot-high ceilings. Your ceiling needs to be reasonably lower than that, but I've seen some photographers crank up their power and cover higher ceilings (if you have to use full power for each flash, though, you'd better keep some spare batteries handy). And, (2) the ceiling needs to be white, or at least a light, neutral color, because the light from a flash picks up the surface color it hits. So, if you're shooting in a reception hall with a red ceiling, the light that comes down will be reddish. If it's blue, blue light comes back down. If it's a black ceiling, the light isn't going to bounce back a whole lot in the first place.

Adding a Second Flash

If you feel you need to add a second flash (maybe to light the background, or as a hair light or kicker light to provide some separation from a dark background), it's really easy, but there's something you'll definitely want to do to help yourself be successful with a second flash. First, let's look at how to set it up: Once you turn on the second flash, you have to decide if you need to control it separately from your main flash (my guess is you'll want to), and if that's the case, then you'll just need to assign it to a different group on the flash unit itself (we looked at groups back on page 28). Once it's assigned to that other group (we'll say it's now on Group B, for example), here's that important thing you need to do: the secret to multiple flash success is positioning and testing the lights one-by-one. So, when you set up that second flash (like I've mentioned, my softbox of choice for adding a second flash would be a strip bank—either the small 10x24" Westcott Rapid Box Strip or the larger 16x30" Westcott Apollo Strip, if you feel you need a bigger strip bank), turn *off* your main flash, so can you actually see what this second flash it doing all by itself. Is it bright enough? Is it aimed to where it looks good? It's hard to tell if you have both flashes firing at the same time, so turning off your first flash is really important. Once you have that second flash all set (the proper amount of brightness, angle, etc.), then turn on both, and you're ready to rock.

Use Fall-Off for More Professional-Looking Portraits

 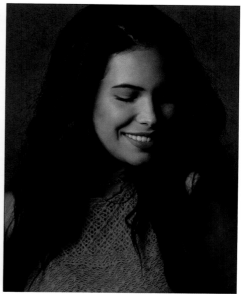

Unless you're shooting full-length fashion, where the clothes are the main subject, instead of the person, for the most part, we want our subject's face to be the brightest part of the image. Our eyes are naturally drawn to the brightest part of the photo, so our subject's face should draw our eye first. From there, the light should "fall off" as it goes lower. So, their chest should be a little darker, then their stomach and hips, and so on, until the light from your flash falls off. If it's a location shot, it can fall off to the existing room or outdoor light, or it can fall off to black in the studio, if you want it to. But, the most important part is: it falls off. There are two ways to create fall-off, and the most natural way to create it is to place your softbox very close to your subject (we'll cover the manual way on the next page). The closer the softbox is to your subject, the faster the light will fall off to shadows. Think about it this way: when the softbox is very close, it's a very tight light, right on your subject. When you move it farther away, the light covers a lot larger space, and the light doesn't fall off much—it spreads out over everything. So, now you know the trick to making light fall off fast—get it nice and close to your subject.

Creating Fall-Off Manually by "Flagging"

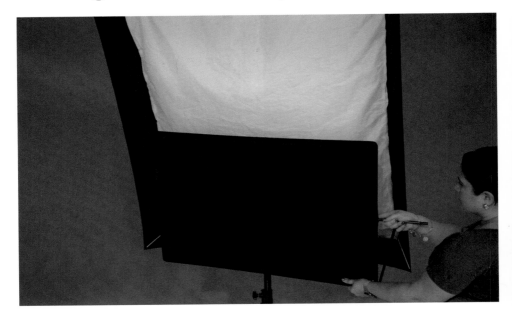

Besides creating natural fall-off (by moving the light really close to your subject), you can manually control fall-off by putting something over part of your softbox, so it covers the bottom, and then that part of the light from the softbox won't fall on your subject. So, if you didn't want to light their clothes or chest, you'd be set. We call this "flagging it off," but I've also heard it called "goboing," as in something that "goes between" the light and your subject (I'm a flagging guy myself). Anyway, if you want to buy an official photography flag, my favorite comes from Matthews (their black 24x36" flag runs around $43), and it cuts off the part of the softbox you put it over like you cannot believe. So, if you want to cover the bottom 1/3 or bottom 1/2, no sweat—works like a charm. You can mount it on a light stand, or on any stand with a heavy duty clamp, and you can also use them for things like blocking the light from a flash behind your subject, aiming back toward your camera position, so you don't get lens flare. They are really handy to have around. If you want to save some money, you can buy black foam core at your local art store (or sign shop, usually), and that'll do the trick, too! Heck, even a sheet of black poster board will work to some extent, but having a thick black surface (like foam core) will definitely work better and is still fairly inexpensive.

Three-Flash Edge Light Setup

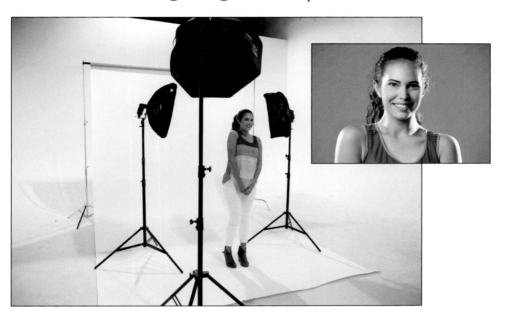

This is a really popular look today (you see it a lot in commercial portraits), and the interesting thing about it is that the main lights that light your subject are behind them, and the front flash is for filling in what the back lights don't cover. Here's the setup: (1) Place a flash at a 45° angle (or so) behind and on either side of your subject. Each flash lights one side of your subject, including their hair and the sides of their face, and creates a rim light going down their body. This should be bright, punchy light, but to avoid creating lens flare (since the flashes are aiming forward to some extent), you'll get better results if you use either strip banks with grids (like I did here; see page 65), or something like a Rogue or MagMod grid (see page 66. It doesn't really matter which one you use, but the light won't be quite as harsh from a strip bank because it has a diffusion panel in front of it, then the grid goes over that, so it softens it a bit). Now, crank up the power of these two back "kicker lights" (a popular nickname for those lights in the back), so they're bright and punchy. Also, leave your front flash off for now, so you can see what these back lights are doing, and get them positioned so they're just lighting the sides of your subject's face and not spilling over much onto their cheeks or nose. If they do spill over, move them behind your subject more. (2) Once the back lights are looking good, you can either position the front flash (with a softbox, of course) off to the side at a 45° angle to the subject (as seen above), or you can position it straight in front of them, up high and aiming down at around a 45° angle (your choice, as both work for this look. Putting it right in front looks a little more "sportsy," though, like for an athletic wear commercial). Finally, be sure to keep the power on this front flash lower than the back lights—the flashes in back should be the brightest light sources for this shot.

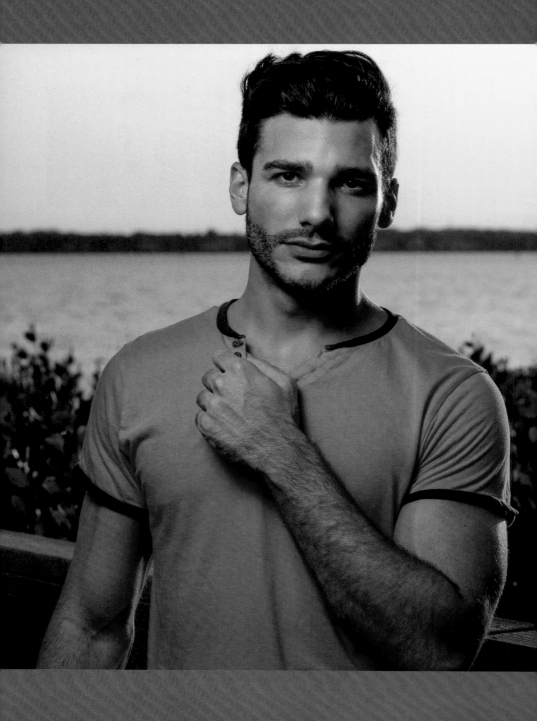

Using Flash On Location

This is truly terrifying stuff, so maybe you should skip this

Okay, is the stuff in this chapter actually "truly terrifying" and should you skip this chapter? No, of course not. That's just an old marketing axiom that basically states that if you tell people not to do something, it makes them want to do it even more. For example, if I tell you, "Don't buy my book, *How Do I Do That In Lightroom?* (published by Rocky Nook and available in stores everywhere) because I'm not sure you're ready for it," it releases a cascade of the neurotransmitter serotonin, which in fully grown adults is responsible for you liking the song "Safety Dance" by Men Without Hats, for which there is no other possible reason, outside of an unholy union of this chemical and thiamin mononitrate, which is a key ingredient in Cap'n Crunch cereal (look on the box, it's right there. You can't make this stuff up). Anyway, the long and short of it is this: the reason I told you not to read this chapter is because I want to make sure you actually do read this chapter because it's a tiny bit more involved than shooting with flash indoors, and once you realize that, you might shy away from it. So, yes—I admit it—I resorted to a psychological mind game to get you to read the chapter, but all authors do that—Hemingway routinely did this, and so did Oscar Wilde, yet nobody complained one little bit. I have to say, though, I've been an Oscar Wilde fan ever since he did that cookbook with Oprah, where he gave the recipe for a hot steaming bowl of gluten, mixed with lactose and MSG. I've been itching to try that one again ever since. Get it? Itching? Like an allergy? Aw forget it—you're not ready for these type of jokes. See, I did it again!

Why We Need to Put Gels on Our Flash When Shooting on Location

When people view images that are shot in a studio, the light from the flash (or strobe) is white, and we're so used to seeing that type of light indoors, we don't think anything about it. However, on location, especially outdoors, we don't expect light from the sun to be white—we expect it to be a little warmer, a little bit orangish. So, it looks weird to us, and obviously "lit," when we see white light outdoors, because we're expecting something else. We fix that by putting a small amount of thin, orange gel over the flash head (see page 86). This orange gel is called "CTO" by all the cool flash kids, and that stands for "Color Temperature Orange" (either that or "Cold Tomato Omelet"—it could go either way). Whatever you call it, this thin, orange gel makes the light from your flash warmer and that makes your on-location flash look more natural. Plus, people generally look better warmer, so it's a win all the way around. Okay, how much gel do we put on our flash? We start with a thickness called a 1/4-cut. So, if you said to me, "I need a quarter-cut of CTO," that would tell me you need a very light orange gel. There are a lot of working flash pros that, when shooting portraits, just leave a 1/4-cut of CTO on their flash all the time, whether they're indoors or out, because they know people look better a little warmer, and a 1/4-cut is a pretty light amount of gel. It's not going to make the light look actually orange, it'll just look a bit warmer than white, and that's usually a good thing, indoors or out.

How to Deal with Problem Room Light

Shooting people and things indoors can be kind of tricky because indoor scenes are often lit with either fluorescent or tungsten lighting—one gives a greenish color cast, and the other a very yellow color cast (like when you're in a restaurant or a church for a wedding, etc.). That's why some flashes ship with a few specific color correction gels to help the white light from your flash mix in with the fluorescent or tungsten light in the room (after all, you don't want a yellowish scene to suddenly have a beam of white light that looks strangely out of place). If your flash didn't come with these correction gels, you can buy them from Rogue or MagMod, or even get sheets of them (by Roscoe) from B&H Photo and just cut them yourself (see the next page for more on these). So, putting one of these gels over the front of your flash will help match the light from the flash to the lighting color of the room. For example, with tungsten (also called incandescent) light in the room, you'd add a CTO (orange) gel over the flash to balance the color. It's as easy as that. Because every room's light is a little different, it's not a 100% lock that it will match right on the money, but it will certainly be in the ballpark (also, different levels of lighting have a different color output, like dim tungsten lights in a romantic restaurant have a different color than bright tungsten lights in a meeting room). If you're shooting in an office (or anywhere with fluorescent lighting), you'd put on a green gel to balance the light from the flash with the light already in the room. But, again, just like with tungsten, these days fluorescent lights come in a wide variety of color temps, so don't be surprised if it's not 100% accurate. It's still way better than not gelling your flash, though.

How to Attach a Gel
to Your Flash

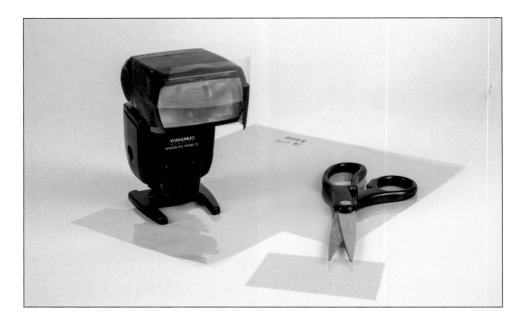

Sheets of CTO gel are pretty inexpensive, going for around $6.50 for a 20x24" sheet (like the Rosco Cinegel #3409 Filter - RoscoSun 1/4 CTO gels from B&H), and at that size, you can grab a pair of scissors and cut a whole bunch of pieces that are the size of your flash head from that one sheet. Technically, you should get about 60 gels cut to flash-head size from that one sheet, bringing it to around 10¢ a gel (however, if you're as inaccurate with a pair of scissors as I am, then you'd only get about 14 gels on a good day). There's one more thing you need to buy: a roll of gaffer's tape (B&H has a 2"x12-yard roll for around $5.95). This stuff is awesome! (I know that word is overused, but in this case, it is fully warranted.) What makes gaffer's tape so awesome (and why it's used daily in Holly-wood) is because it's a really strong cloth tape that you can remove without peeling off the finish or paint from anything, and it removes cleanly without a sticky residue. As a photographer, you'll find a hundred million uses for it, but for now, you're just going to tear off a couple little pieces to tape that CTO gel right over the top of your flash, like you see above, with the tape on the sides of the flash head. Plus, since you're using gaffer's tap, you can do it without worrying about messing up your flash casing when you peel it off later.

Pre-Cut, Pre-Sized Commercial Gel Setups

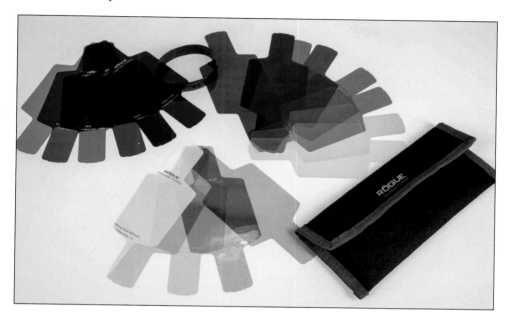

If you don't feel like cutting up a sheet of gels, luckily, you can buy packs of pre-cut gels that come with their own simple system for attaching them to your flash—there's no cutting, no taping, no muss, no fuss. One of the most popular is ExpoImaging's Rogue Flash Gels Color Correction Kit. It comes with 18 gels: nine CTO gels in different thicknesses—1/4, 1/2, and full—plus a blue set of three, a green set of three, and three heavy frost diffusion gels. The gels are held on with, what is essentially, a thick rubber band (it looks like the color wrist bands you see people under 24 wearing), and it actually works nicely. You hold the gel over the front of your flash, tuck the thin flaps down along the sides, and slide the band right over it. It's almost too simple. They come with a nice, thin storage wallet that keeps it all organized with little tabs. The kits sells for around $29.95. Not bad. However, if you're a Wall Street hedge fund manager, personal injury attorney, or first-round NFL draft pick, you'll probably want to move up to the Mercedes of gel systems, which is from the folks at MagMod. Their Color Kit bundle comes with an assortment of hard, plastic gels that fit inside a very slickly designed magnetic holder system, so you can just snap gels (and other accessories) on and off magnetically. Besides looking cool, it is the fastest, easiest system I've ever used (their system is for more than gels—they have grids, snoots, and diffusers. Basically, they have a whole ecosystem built around the magnetic, snap-in-place idea). Very impressive. Their Color Kit bundle is a bit pricey at around $215, but again, this is the gel system of the Roman gods (Apollo swears by it, as does Minerva and Artemis. However, Mercury [god of commerce and finance] always went with the Rogue system. This is documented in Ovid's book *Fasti*, which chronicles how Mercury saved many Denarius by going with Rogue. It's all right here on Wikipedia, so you know it has to be true).

Easy Location Flash
STEP ONE: Positioning Your Subject

I have this seven-step recipe I use for shooting on location that is really simple, and gives you great results. If I'm outdoors, I try to position my subject so that the sun is behind them and off a bit to one side (generally, I don't want to see the sun directly behind them, like a big ball of light right over their head, drawing your eye). Having the sun behind them, and somewhat to the side, has it act kinda like a hair light or a rim light, outlining their body from behind. It almost looks like you're using a second light (and using the sun for a second light is even cheaper than using a reflector).

Easy Location Flash
STEP TWO: Metering

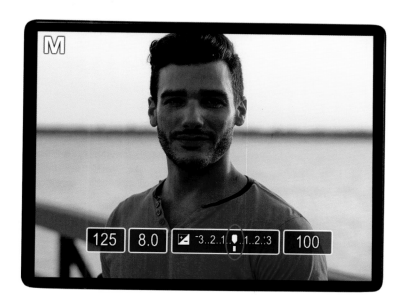

Next, pretend like you don't have a flash at all. So, turn off your flash unit for now, because we have to do some metering (don't worry, it's easy). You do have to do this part in manual mode (as always), because you have to start with your shutter speed set at 1/125 of a second (so, do that first). Now, with your flash still turned off, focus on your subject, and then look at the built-in meter you see *inside* your viewfinder. On some brands, this meter appears along the right side of the viewfinder, and in others, it's along the bottom, so take a moment to figure out where it is on your particular camera. It should look like a horizontal or vertical line, with some small hash marks along it with the numbers 1...2...3, and a longer hash mark right in the center. You're going to move your f-stop until the little moving meter gets right in the center. When it's in the center, you are at a proper exposure for the existing light (this isn't the final exposure we want, but we have to start here, so use that meter to get the proper exposure, as if you didn't even own a flash). Remember, don't move the shutter speed. It's important that it stays where it is at 1/125 of a second at this stage, so just move the f-stop. If you can't find an f-stop that will get your meter centered, you can increase the ISO until you can get it to that center point. This is our starting place.

Easy Location Flash
STEP THREE: Underexposing

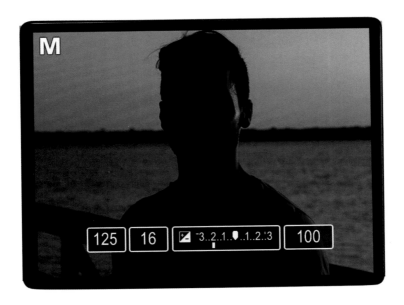

Once we get the proper exposure, I generally darken the entire scene, either by 1 or 2 f-stops (or sometimes even more around sunset). So, let's say, for example, you're doing a corporate portrait with an office environment in the background, and when you moved your f-stop, so the meter was all centered up (as we did on the previous page), your f-stop for a proper exposure wound up being f/8. Well, to darken the scene, you would move your f-stop to a higher number, like f/11, or maybe even f/16 if you're outdoors. That darkens the entire scene you're standing in front of, so what winds up lighting your subject will be mostly your flash. We don't want to make it too dark—we still want a balance between the room light in the office, and the light from your flash, but we won't know the exact f-stop for a few more seconds. So, at this point, let's try to make the scene two stops darker—if the proper exposure was f/8, set your f-stop to f16; if it was f/5.6, set it to f/11; if it was f/4, set it to f/8.

Easy Location Flash
STEP FOUR: Positioning Your Flash

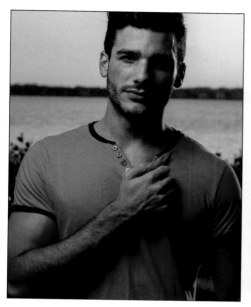 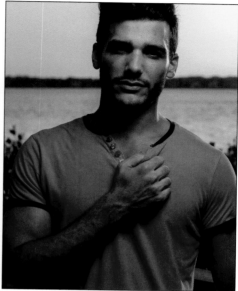

Putting your flash in the right position when you're shooting on location is critical. You need to put your flash on the same side that the natural light is coming from. For example, if the sun is behind your subject and to one side, your flash needs to be on that same side (even if you're more comfortable shooting with your flash on the other side). If you're in a home, or office building, and there's a window, you should position the flash on the same side as the window. There are two reasons why: (1) When a person views your image, and the light doesn't come from a direction their (our) subconscious mind tells them it should be coming from, it makes them uncomfortable with the image, but they won't be able to tell you why. You might even hear, "It looks good, but I dunno—there's something not quite right." They won't know exactly what the problem is, but they will sense a problem. It's too easy to fix the problem (by putting the light on the side our mind expects it to be on) to just let it go. This has to be right. And, (2) when you don't have the light on the proper side, it sometimes makes the image look like it was a composite (like you photographed the person at a different location, extracted them in Photoshop, and put them on this background). We are so accustomed to looking at photos lit by natural light that when the lighting isn't where our mind thinks it should be (even subconsciously), it doesn't look right to us. This is more important than you'd think.

Easy Location Flash
STEP FIVE: Adding an Orange Gel

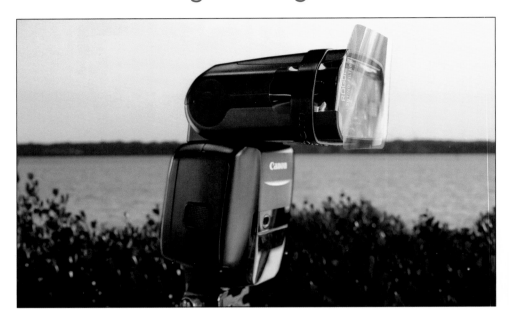

Check page 84 in this chapter for exactly why we put an orange gel over the flash on location (and page 86 for different ways to attach them) because you want to make darn sure you have at least a 1/4-cut of CTO over your flash before you even turn it on when you're on location (and, if you just said, "What the heck is a quarter-cut of CTO?" that just means you need to go right now to page 84 and read why gels are so important).

TIP — IF YOU DON'T HAVE A GEL, DO THIS

If you don't have a gel for your flash, try setting your white balance to Cloudy. That will make the overall image warmer, and that will help the light from the flash look not quite so white.

Easy Location Flash
STEP SIX: Flash Settings

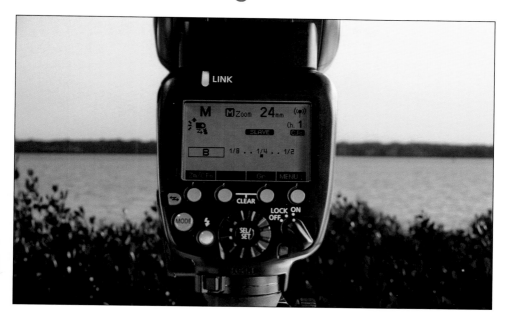

Now it's time to turn on your flash. For on-location shoots, I set the power of my flash to 1/4 power as my starting place. This might have to move up/down (probably down) after I do a test shot or two, but this is a great starting place. In an office environment, I still start at 1/4 power. Now, take a test shot and see where you're at. Chances are one of two things need adjusting: (1) the flash is too bright, or (2) the background is too dark. This is the balancing act I talked about back in Chapter 3 (on page 55)—getting the existing light (which you intentionally made darker) and the light from the flash to balance. I start by getting my flash looking right on my subject—I don't want it too bright; I want it to look natural. So, without changing any settings on the camera, just move the power of the flash up or down until your subject looks good (we'll deal with balancing the background light next). Once the amount of flash on your subject looks good, the second part of the balancing act begins: If the background is too dark, then lower your shutter speed to 1/80 and take another test shot and see how that looks. If it's still too dark, lower the shutter speed some more to let more background/existing light into the shot. Remember the background is supposed to be darker, but not crazy dark. This is where flash photographers earn their dough—being patient and finding the right balance between the flash power and the existing ambient light. Keep doing test shots, until you figure out the magic combination for where you are shooting. If the background is too bright, you can darken it by moving your shutter speed to 1/200 of a second or maybe even 1/250, tops.

Easy Location Flash
STEP SEVEN: Adding More Gels

If you're shooting near sunset, as your shoot progresses, it gets darker as the sun starts to get lower in the sky and eventually sets. So, not only are your settings going to change (you might have to keep adjusting the shutter speed lower, so you can still see something in the background, as well as lowering the power of your flash as the whole scene gets darker), but as the sun starts to set, that 1/4-cut of CTO gel that looked pretty orange when you started, will now look pretty white again, like you're shooting in a studio. When you notice the light from your flash starting to look white and artificial, it's time to slap another 1/4-cut over that original gel (giving you a 1/2-cut now). Just tape it right on over the original one to double it up and bring the orange tint back. When it actually gets to sunset, you might need to add another 1/4-cut over the top (at this point, you might have to actually raise the power of the flash a little to cut through three gels) or switch to a full-cut of CTO. Sunset shoots can be tricky because of the constantly changing amount of light in the location you're shooting, so keep an eye on three things as the shoot progresses: (1) Is your flash starting to look too bright? (2) Is the background becoming too dark? You might need to lower the shutter speed to balance it out. (3) Do you have the right amount of gels on the flash? The later it gets, the more gel you'll need to add to match the overall tone of the setting sun. Okay, so that's the ticket. It's six quick steps, or add this seventh if you're shooting near sunset. This takes a surprisingly small amount of practice until you start to really dial it in, and then this all gets really, really fun.

Flash with a Reflector as Your Second Light

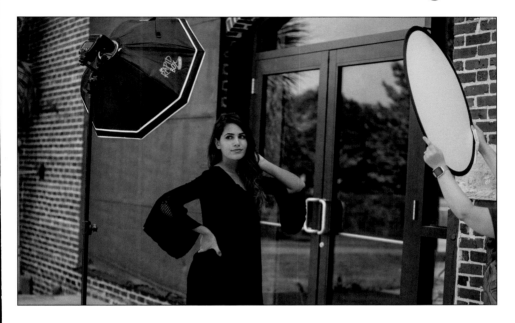

If you don't have a second flash, the cheapest second flash you'll ever get is actually a reflector. It looks like you have a second flash because it takes the light from your flash and bounces a bunch of it back toward your subject. There are a few popular places to use one, and the first is right at your subject's chest level, so it sends some of the light from your flash bouncing back up to lessen the shadows under their eyes and chin, and it works really well. You can have them hold the reflector flat—horizontally—or for more impact, you can have them tilt it up at a 45° angle toward themselves. If you have a reflector with white on one side and silver on the other, try the white side first for this chest-level bounce—white reflects less light, and with it that close to your subject, that should work out well. If it's too much, have your subject hold it a bit lower. The second place you might put that reflector is right on the ground, directly in front of your subject, but use the silver side instead (it reflects much more light than the white side). Down that far, it's not going to kick up as much light, but I'm often surprised how that little kicker of light can make a difference. The third place would be to have a friend or assistant hold the reflector up high (as seen here), and then have them slowly tip it down until you see it starting to light your subject's face. You'll have to direct them on how far to tip it because you don't want them holding it down too low, or you'll end up "up-lighting" your subject, which is not the look we're going for here (unless you're going for a menacing "monster-movie" look).

Getting Some Fill Light Outside without a Softbox

Sometimes you don't need to fully light someone outdoors, but you just need a little something—just a little bit of light to fill in the shadows. Generally, you can't do bounce flash outdoors (ya know, seeing as the clouds are usually pretty high up there; see page 77 for more on bounce flash), but one thing you can try is to aim your flash straight up (no angle, whatsoever), and turn its power up pretty high (start at 1/2 power and see how that works), but make sure to pull out the little white bounce card that is tucked down inside the little slot right next to the flash head. When you pull that white bounce card out, about 15–20% of the light from the flash goes forward toward your subject (the other 80% or so goes up into nowheresville), and that might be just enough to fill in the shadows, without having to use a whole softbox setup and all.

On Overcast Days, You Can Use Wide-Open f-Stops to Get Soft Backgrounds

Flashes are much less powerful than studio strobes (including the studio strobes that are battery powered, and that you can take on location), as a flash has generally around 30 watts of power, whereas studio strobes are usually more in the 500-watt to 1,000-watt range. While that sounds like a minus, that lower power can actually be a big plus when it comes to lighting portraits in the shade or on a really cloudy day, because it allows you to shoot at wide-open f-stops, like f/4 or maybe even f/2.8. So, you can zoom in with a long lens and put the backgrounds behind your subjects softly and beautifully out of focus to get that wonderful separation from them. You usually can't do that with studio strobes because, even at their lowest power setting, it's way too much power, and you wind up at f/9 or f/8, if you're lucky. Yes, there are some tricks to get around this problem (like using an ND filter on your lens, but that brings up its own challenges), but luckily, we can just set the flash power setting on our flashes really low if we want (even down to 1/128 power). So, if it's shady or cloudy outside, you can lower the flash power way down, then use those wide-open f-stops to get the kind of soft backgrounds we're used to getting when using natural light. That's a biggie! Now, if it's really bright outside, then we're going to have to go with a different technique, High-Speed Sync, which we looked at back on page 43.

Awesome Trick for Simple, Clean Backgrounds

This is one of my favorite tricks for getting a perfectly clean, simple background when I'm outdoors on location because, sometimes, finding that clean background is a needle-in-a-haystack thing (it seems like it would be easy finding a simple background, but you'd be surprised). My trick is to get down low (down on one knee, or literally lying on the ground), and that low angle makes the blue sky your background instead (or gray sky, if you live in Pittsburgh. Sorry, couldn't help myself. Just a joke. Kidding, etc.). Just because you're down low, though, doesn't mean you want to position your flash down low, because then you'll end up "up-lighting" your subject, which is what I would do if I wanted to make an athlete (football lineman, martial artist, wrestler) look mean and aggressive. So, the flash stays up high like always, but you get low enough to use that clean sky as a background. Unless you're in Michigan, where it's cold and raining (see, that's another joke. Totally kidding. Kinda).

Shooting Interiors with Flash

For real estate photography, you can take a lot of that portrait stuff and throw it out the window—this is an entirely different beast. First, you're not going to use a softbox at all—you're going with bare flash heads, and you'll be working at full power nearly all the time (so bring lots of batteries). I did say "heads" (plural), by the way. While you can do real estate photography with just one flash, it makes it harder to evenly light rooms with just one. That's why many serious real estate photographers generally use at least two flashes. These flashes each go on a light stand (I'd go with at least an 8' stand, see page 134), and you'll need two flash mounts to put your flashes on top of these stands. Once on the stands, put them up high (like 7' or higher, depending on the ceiling height), aiming upward at an angle to let the light from your flash bounce off the ceiling, spread, and illuminate the room. If the ceilings are too high, you might have to bounce off the white walls instead (hopefully, they're white). You'll be shooting in manual mode, with your shutter at a lower shutter speed to let in more existing room light, so try 1/30 for starters (you also want to shoot on a tripod for the most part). You want everything in focus, so use an f-stop like f/8 (go much higher, and it will suck up the power of your flashes). Also, you may have to raise your ISO a bit (probably no higher than 400, though) to get the power of the flashes up, and the brightness of the room up where you want (buyers like nice, brightly lit rooms).

How to Light Backgrounds

Baby got back!

You know what happens if you do a portrait and you don't light the background? Well, I've done it, and I can tell you— nothing. That's right—nothing bad happens at all. But, let's consider this: your subject has very dark hair—maybe even jet black hair—and they're wearing a black shirt, or blouse or another name for a shirt, and you want to photograph them on a roll of black, seamless paper, but you don't want to light the background. Then what? Well, you wind up with a creepy, floating head photo, where all you see is this one creepy-looking floating head in your frame, and this is precisely why I tell my students to never do this in a dark studio by yourself late at night, because it can totally freak you out seeing that creepy, disembodied, floating head all by itself. I can't tell you the number of students that have dropped out of my class at the university, once they found out that I didn't have a teaching certificate and wasn't even registered to teach at that university, or any university at all for that matter, and of course, they were freaked out by that whole head thing, which is the main reason I think they dropped my course. Anyway, in real life, here's what actually happens: your subject is wearing a red turtleneck sweater, and they have bright, blonde hair, and a pale complexion, and white pants, or slacks, or some other name for pants, and they are perfectly separated from the black background by their very nature. So, there's actually no need to create separation from the background, and therefore, no need for you to use a second light or even read this chapter whatsoever. So, if I were you, I would just skip this altogether. Just for the record, I cannot believe you fell for this mind game again. You would have a made a great Storm Trooper.

Lighting Backgrounds without a Second Flash

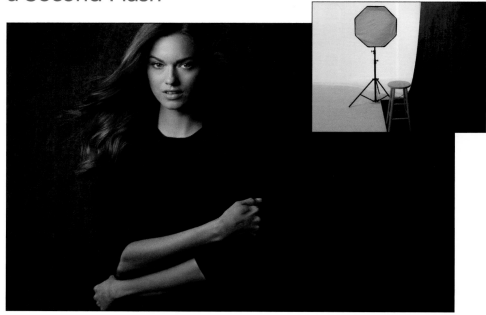

Normally, when we're lighting a background, we want to light the background and the subject separately, which is one reason why we try to keep our subject 8 to 10 feet from the background (well, that, and we don't want to see the subject's shadow falling on the background behind them, and creating that separation lets their shadow fall on the floor, instead of on the background). However, if you only have one flash, and you want your background lit, just move your flash close enough to the background, so that the light from your flash can reach it. The spill from that one flash will light the background, as well as your subject, if it's close enough. This works best with large softboxes, like Westcott's Recessed Mega JS Apollo 50x50" softbox or their 7' shoot-through parabolic umbrella, simply because they can cover more background area with their size, but it can still work with smaller 32" softboxes (like the Westcott Rapid Box Duo) or even 26" softboxes, like the regular Rapid Box, too. So, next time you're stuck for a background light, move your front light (and probably your subject along with it), closer to that background and let your flash do "double duty."

Before You Aim a Flash at Your Background, You Have a Decision to Make

You need to decide what background look you're going for. Do you want a tight spotlight effect or a smoother, wider, wash of light across the background, like we have above? This decision determines which accessories (if any) you'll need to create that look, and tells you how far your flash needs to be from the background. It also tells you if you'll need more than one flash. But, first, it's helpful to know why we light the background in the first place. Probably the most important reason is to create separation between the background and our subject, so our portraits have depth and subjects have definition (for example, so your subject's dark hair doesn't get lost against a dark background). Creating that separation, using light, gives your images more depth. Another reason is to make the color we see on-set translate to a photo. For example, if I handed you a roll of white seamless paper, and asked what color it is, of course one look at it and you'd say, "white." But, put that white seamless paper up as your background, and you'll be pretty surprised to see that the color behind your subject isn't white—on-camera it shows up as gray, unless it's lit. Same thing with colored papers. If you don't light a bright blue seamless paper background, it shows up in the image as a very dark blue. You have to light these bright, vivid color backgrounds, or they come out looking neither bright nor vivid. The third reason—and one you'd see often if you Googled "lighting the background"—is that it makes the portrait look "more professional." Why do people think shots where the background is lit look more professional? Because pros light the background. Not every time, of course, but way more often than the non-pros. I hope this helped you realize that lighting the background is more important than you might have thought. Luckily for us, it's actually pretty easy—way easier than learning to light a subject.

Inexpensive Backgrounds

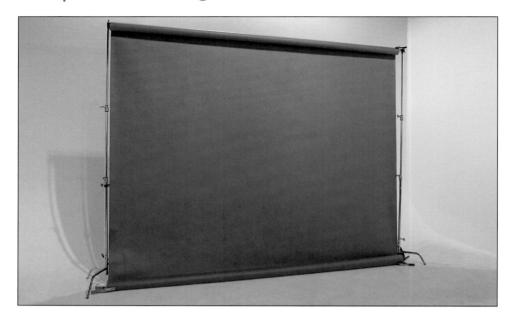

A roll of seamless paper is one of the most popular backgrounds you'll find in studio or outdoor portraits today. They've been around forever and aren't going away anytime soon, mostly because they look great, and they're cheap as anything. If you're doing headshots, you can pick up a roll of white seamless paper that's 53" wide by 36' long (like the Savage Widetone Seamless Background Paper, #01 Super White) for $27.99, or a roll of gray or black for around the same amount. That is, like, dirt cheap. Okay, now that I've sold you on the 53-inch-wide seamless, I would only use that for headshots. For anything else, you'll thank me if you go with a wider roll, like rolls that are 107" wide (even though they cost a bit more at $49.99). If you go the cheaper route, and you're struggling to keep the edges of the paper from showing in the frame, and you've got a ton of patch work to do later in Photoshop, you'll wish you had bought that 107" (every time I thought I could save a few bucks and went with the 53", I've regretted it). To hold your seamless paper up, you can go with Impact's 12-foot-wide Background Support System for $104.95. Luckily, you only have to buy this once, and you can use it with all seamless rolls. Don't spend a lot on your background stands; the cheap ones like this work fine.

Which Color Background to Order First

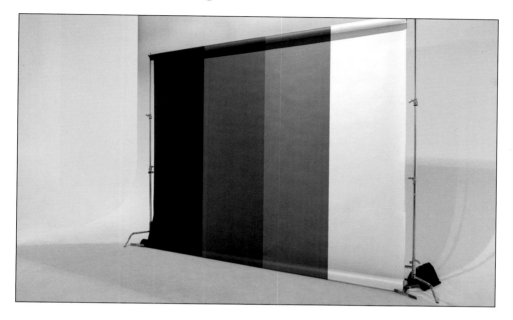

If you're going to buy a seamless paper background to get started, I'd recommend going with a white roll, because when you buy a white roll, you can actually get four different backgrounds out of it. Here's how: (1) If you put a really bright flash on the background to light it (see page 110), it becomes a solid-white background, so there's your first color. And, yes, even though the paper is solid white, if you don't light it, it looks gray, which brings us to: (2) If you don't light the background with a flash, the light from your main light will spill over onto it quite a bit, giving you a light gray background. This works as long as your softbox isn't too far from the background, say, 4 to 6 feet. (3) If you move your softbox about 8 to 10 feet from the background (that's how far I normally place my subjects from the background, so their shadows fall on the floor and not on the background), then you wind up with a dark gray background. You can see what's happening here, right? The farther your front softbox gets from the background, the darker gray your background becomes. Lastly, (4) if you move your softbox farther than 10 feet away from your background (or if you put your flash stand way up high, with the softbox angled down at a steep angle), none of that light from your flash will even reach the background at all, so your background will be solid black (this is the hardest one to believe, until you try it, because your eyes will still see it as a roll of white seamless while you're standing there. But, luckily, that's not how your camera will see it). Well, that's it—four different colors from one roll of seamless paper.

Using Canvas or Painted Backdrops

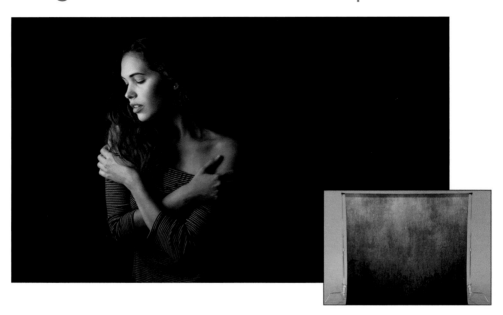

We've been mainly talking about seamless paper for shooting indoors, but that's mostly because (1) it's very inexpensive, (2) it comes in a ton of colors, and (3) you can get multiple looks from one color (see the previous page) simply by how you light it. However, when you're ready to take things up a notch, you might want to consider getting a hand-painted canvas backdrop. They cost a bit more, but if you look around, you can find some incredible prices out there (in the $100 range or even less). Of course, the wider the background, the more they cost, but one source I've found that has pretty outrageous deals is Etsy.com. You'll find a lot of backdrops there that are fairly wide and still under $100. The piece of advice I would give is, if you want to use this backdrop a lot, get one that is kind of neutral (like a dark or light, overall gray color), because if you get one that is too distinct and recognizable, all your shots on that backdrop will start to look the same to some extent—it will be, "Oh, there's that backdrop again." But, if you go with a more understated, classic look, the background won't take over the shot. Plus, you can always add a gel to change the color (see page 116), or even change the color in post-production. You can see the backdrop I took this shot on in the inset above, but to get the dramatic look you also see above, position the light directly to the side of your subject, just like you saw on page 102, where I'm lighting my subject, and the backdrop, with just one light.

Light Stands
for Lighting Backgrounds

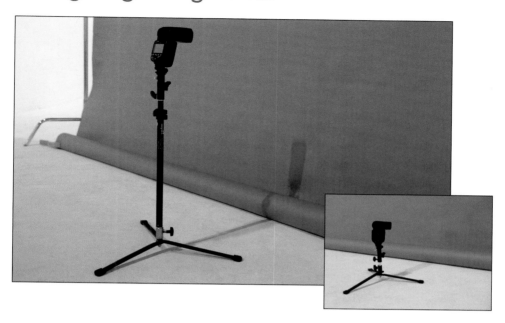

One thing we all struggle with, when using a background light placed directly behind our subject, is not seeing the flash or the stand in the shot. Even if you take a regular light stand and lower it all the way down, by the time you put a tall flash on it, you're fighting to keep it hidden the whole shoot. That's why they make special, super-low-height background-light stands that make your life so much easier. The one I use is the 3' Impact Two Section Back Light Stand. What I like best about it is that you can unscrew the pole and have just the three-legged base sit flat on the floor, so you can mount your flash right on top of that base—way down low—just inches off the floor (as seen in the inset above). You just unscrew the little mounting stud from the top of the pole, and it fits right into the slot at the bottom, so you can mount your flash crazy low. Plus, I dig that it's only $24.95. Again, this will make your flash life much easier.

Why the Distance You Place Your Flash from the Background Is So Important

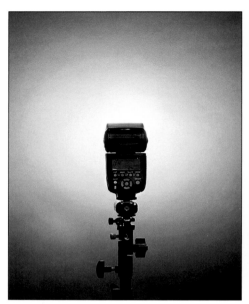 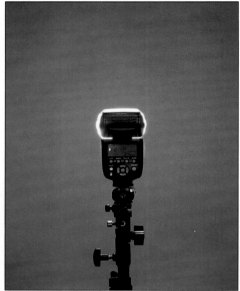

This is going to sound really obvious when I say it, but to put it simply, the closer you move the flash to the background, the tighter that spotlight (and hot spot) in the center becomes. So, if you want a small spotlight effect behind your subject, move it closer to the background. Want a larger pool of light, which fills more of the background? Then move it farther away from the background. Also, when you're close to the background, the center hot spot is going to be very defined, and it's going to fall off quickly to the color of the background. If you move the flash farther away, it's going to be a larger hot spot, and a smoother, more even, vignette-style spread out to the darker edges. So, which one of these is the right one? There's no right or wrong—it's really down to a personal preference. But, at least if you have a preference, you know how to get it (small spotlight, close to the background; big spotlight, move it farther back from the background).

Turn Off Any Front Lights While Lighting the Background

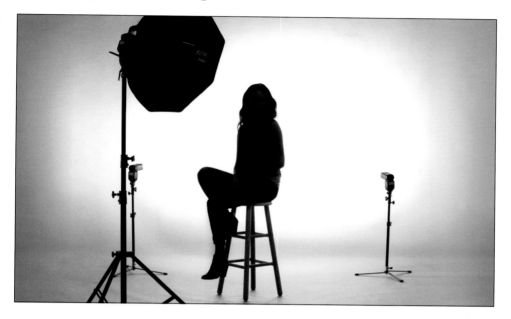

Don't make that rookie mistake of setting up a bunch of flashes and turning them all on. If you do a test shot, and the lighting just doesn't look right, it's not going to be obvious exactly what it is—you know something's wrong, but you don't know what—and I've seen a lot of photographers get stuck at this point. You can avoid that by building your lighting setup one flash at a time—turning everything off, and then just turning on one flash. Start with the background light and get it looking just the way you want it. If you're using two lights on the background, get one side looking good before you even turn on the second light. Once the background lighting looks the way you want it, then turn on your front light and start working with it. Remember, there are two separate things being lit: the background and your subject. By building your set one flash at a time, you'll be able to see each light individually, what it's affecting, and whether it's doing what you want it to. When you get the first flash looking right, turn it off, and then get the second flash on the background looking right. Once that one looks good, turn them both on and make any final tweaks. Now you can turn on the front light and get it right. This "one step at a time" approach will save you from a ton of headaches, and even though it sounds like it takes longer, it actually is quicker because you won't have to waste any time trying to troubleshoot and figure out why your lighting setup doesn't "look right."

How to Light for a Solid-White Background

The secret to creating a solid-white background (besides aiming at something white, like a roll of white seamless paper) is to throw a ton of light at it. We're talking full power (1/1) on the flash, with a diffusion cap on top of it to help spread the light (if you don't have a diffusion cap, this is actually a legit reason to order one). Put your flash on a low light stand (like the one you see here), angled up toward the background. If your background isn't too big (maybe you're doing a headshot, or something like that), you can solidly light a white background with just one flash, no problem. If you're doing full-length shots, and you need to light a 104-inch-wide roll of seamless, you'll probably need two flashes (see the next page). The background flash needs to be brighter than the flash lighting your subject, but the key is not to make the light so bright that it fries the outside edges of your subject's hair (not literally, of course, but when you look at the edges of their hair close up in Photoshop or Lightroom, they've lost detail and look kinda crisp, which is why we call it "fried"). So, once you get your flash (or flashes) in place, and you can see that you've got a solid-white background, get your subject in place and do a test shot. Then, zoom in on the back of your camera, on the edges of their hair, and make sure they aren't fried. If they are, you need to back off on the power of your background flash and do another test shot. If, when you lower the flash power, it doesn't look solid white, move your subject farther away from the background, so it doesn't spill back onto them as much, and then turn the power of your flash back up until the background is solid white again.

Lighting a Wider Solid-White Background

If you're doing 3/4 or full-length shots, and you need to light a really wide roll of seam-less, you'll probably need two flashes, and you can use a setup like you see here, with one flash behind and on either side of your subject, aiming at the background at a 45° angle. If you're doing full length, you'd see those light stands in the shot, so pull them out off the paper, but aiming in the same way (and, of course, since you're moving them farther away from the background, you'll need to turn up the power a bit more, too). By the way, with two flashes like this, you can push enough light on that background that even a light gray roll of seamless will turn solid white.

How to Avoid Spill
on Your Background

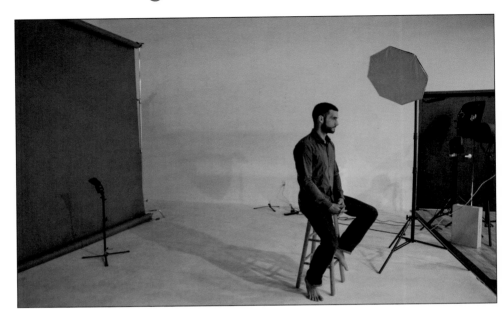

If you're gelling your background flash with a color (see page 116), of course you want a nice, vivid color on your background. To make sure your background color stays nice and vivid, you need to make certain that the light from your front flash (the one lighting your subject) doesn't spill onto your background and wash out the vivid color back there, or the whole background will look kinda "blah." All you have to do is make sure your main flash is far enough away from the background, so the light doesn't reach back there. Generally, I put my subject 8 to 10 feet from the background, so that would put my main flash a few feet in front of them—it would be at least 12 to 14 feet from the background, and that should be enough to where your front flash doesn't reach the background at all. You can test this by turning off your background flash, then taking a test shot with just your front flash and seeing if any of that light hits the background. If it does, move it back a bit farther (and move your subject or product forward the same amount, so your main light stays the same distance from your subject). That should keep your background color clear and uncontaminated by the spill light from your front flash.

Keeping the Background Flash from Spilling onto Your Subject

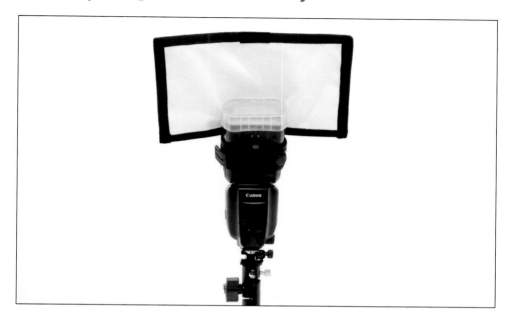

Unless you're using a bright, solid-white background (where, sometimes, it can look good to have that white light bouncing back onto your subject to give them somewhat of a back-lit rim light), you generally want to keep the light from your background flash (especially, if you're using a color gel) strictly on the background. One thing I do to keep that background flash from spilling back toward my subject is to attach a Rogue Flash-Bender 2 Reflector to my flash—it runs about $34.95 at B&H, and is a wide panel that straps around the flash head itself. I can position it so all the light from the flash heads toward the background, without it coming toward my subject. You can literally just bend it where you want it, and it stays in position. These are just so handy for stuff like this. This one is 10" wide by 7" high, and that does the trick for me. (You can buy even larger ones, as seen on page 124, but of course, they cost more.)

TIP | **Using a Dome to Spread the Background Light**

While I'm not a huge fan of diffusion domes, they do help spread the light when lighting a background, so this is one instance where they really do make a difference. If you want to add a color gel to your background, stick your gel inside the dome and snap it right on with the gel inside, so you don't need to fasten it any other way (after all, it's inside the dome—it's not going anywhere).

Creating a Graduated Background Look

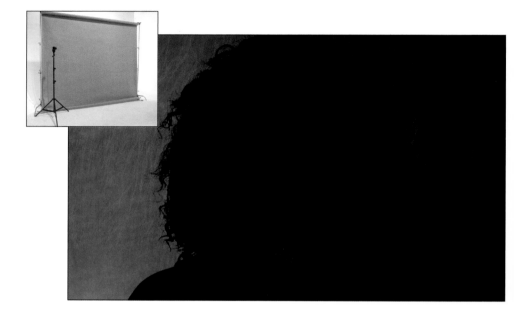

A popular, and perhaps a bit more formal look for backgrounds is to have a graduated look, where one side of the background is lit, and then the light gets darker and darker as it moves to the other side of the background. It kind of looks like you dragged the Gradient tool across the background in Photoshop, going from light to dark. You do this by moving the background flash to the side and raking the light across the background. Of course, the side of the background closest to the light will be the brightest, and then it will get darker and darker as it moves to the opposite side (as long as you don't over-power this light. If you set the power setting to full power on the flash, you might not see as large a gradient from the light—in fact, it might just illuminate the entire background, so back off the power to 1/2 and do a test shot with it there first. You can always raise the power if you need to). You can also place your flash up high for this look, lighting the background from the top corner, moving diagonally down across your background (just raise your light stand way up and aim the flash toward the far corner). If you want your gradient to fall off to dark quickly, put it close to the background (like a foot to 18" from it). If you want a smoother, longer gradation across the background, move your flash back, and it will spread out more without such a sudden fall off. Remember to keep an eye out for spill on your subject (see the previous page), and one more important thing to remember: when you're lighting the background from the side, put that background light on the same side as your front light, so the lighting looks consistent (and it doesn't freak out the viewer).

Getting a Tighter Background Spot Light

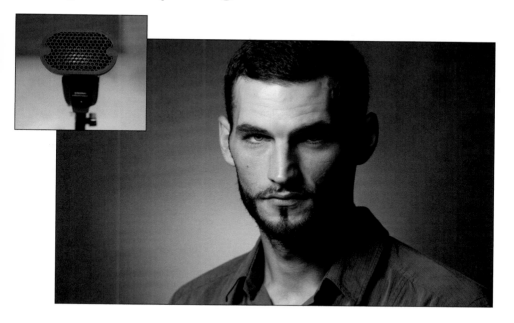

Remember back in Chapter 4, when we talked about using grids to corral our light into a very tight beam that doesn't spill all over the place? Well, if you want a really tight spotlight effect behind your subject, you can put a grid on the flash you have on the background, and you'll have a small, well-defined spotlight. Both Rogue and MagMod make grids that create a tight spotlight, but not too tight (the MagMod grid is a 40° grid, which is nice and tight, and the Rogue is just a bit wider at 45°. The lower the degree of the grid, the tighter the spot). If you look at the Rogue Starter Kit, which comes with that 45° grid I just mentioned, there's also a 25° and a 16° grid in that same kit, but those last two are almost a bit too tight for lighting backgrounds—they are more for special effects, so go with that 45° grid on your background.

Color Gels for Backgrounds

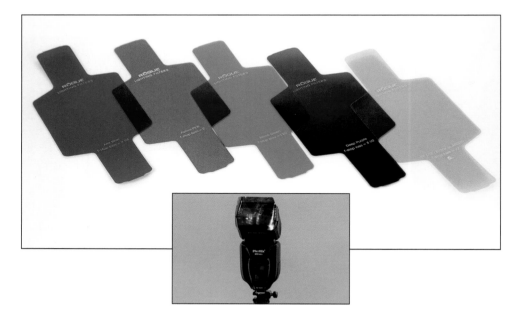

Besides the regular color correction gels (like those CTO gels), there are specialty gels for things like lighting backgrounds, and the colors are very bright and vivid. The ones shown above are from Rogue. They have a nice set of color effect gels in their Rogue Gels Universal Lighting Filter Kit, a set of 20 different color special effects gels, and they are ideal for lighting backgrounds. The whole set, including the gel band holder to attach them to your flash and a nice organizational wallet, is just $30. So worth it! If you want to use the Rogue Grid to narrow your beam, they make gels that are pre-cut into a circular shape to fit their grid system. Those are called the Rogue Grid Gels: Combo Filter Kit. It's 20 gels, too, and it's around $28 on their website (just remember, they're round, so you can really only use them with the Rogue grids). If you're a MagMod guy/gal, and you already have a MagMod Basic Kit, they have little slots for you to add color gels, and they have a Creative Gels set, which is an 8-pack of plastic color gels in bright, vibrant colors you just slap on/off (or slide into) all their stuff. It's around $29. Of course, like we learned in Chapter 5, you can just buy 12x12" sheets of gel, cut 'em yourself, and slap them on with some gaffer's tape (by the way, gaffer's tape is the most amazing stuff on earth—easy to tear, sticks great to stuff, like the sides of a flash, but when you pull it off, it doesn't leave any sticky reside. You can find it at B&H. It's cheap, too!).

Adding Color to Your Background

For your second roll of seamless paper, you might want to consider a dark gray or black, because then you can tape a color gel (see previous page) over your flash and completely change the color of the background (see the next page), or you can have a splash of color in the center surrounded by dark gray or black (as seen here), depending on how you choose to light the background. But, I'd start with getting a roll of that dark gray or black. Once you attach a gel to the front of your flash (we'll use a red one here, with a Rogue grid, just as an example), all you have to do is literally aim that flash at your dark gray or black background, turn up the power to around 1/2, and take a test shot. You'll be surprised at how good this looks for how easy it is to pull off. You just put the gel over the flash and aim it at the background. It doesn't get much easier than that. By the way, if you turn up your gelled flash too bright, your color will start to wash out. So, for richer colors, lower the power of your background flash.

Changing the Color of Your Background

One of the big benefits of shooting on a roll of gray seamless paper is how easy it is to completely change the color of the background just by slapping a gel in front of your flash (well, in this case, I used two flashes—one on each side behind my subject, aiming at the gray background). Look how vibrant you can get the color—it's almost as if you went out and bought a separate roll of bright red paper. You can do this with two tiny gels. You can also do this on black paper—you'll need to use two lights to get it even all the way across, and you can do it with white seamless paper, as well, but your red will turn to more of a pastel color. In fact, all your vivid colors become less vivid and more pastel-like on white seamless, but you can definitely still change the entire color behind your subject.

Spotlight Gradient Background Effect

This is a lot easier than it looks. It's just one single flash behind your subject, but really close to the background, and then you just slap a gel over the end of the flash (in this case, I put a blue gel over it). Okay, so how do you create that gradient, going from white in the center and graduating out toward blue, while picking up some pink in-between? Just turn up the power of your flash until it's so bright that it turns the center of the flash white, and believe it or not, the rest takes care of itself. You can try using either a diffusion cap (and stuffing the gel inside the cap) or a grid, if you want, but if you put the flash that close to the background, you'll get that spotlight effect, and the high-power setting takes care of creating the gradient out to the color of the gel. Again, it's easier than it looks—don't overthink it.

Using Flash at Weddings

Here comes the bright...

Shooting a wedding is a tremendous responsibility, and one you shouldn't take lightly, because you are fully in charge of the one thing that can go inextricably wrong at the wedding, and that one thing is overlighting the bride. No one cares if the groom is a bit too bright. He wasn't that bright anyway. But, this is an incredibly important day for the bride, who happens to be wearing white (well, she's probably wearing white, but she could be wearing beige, which means... well...the whole town knows this isn't her first rodeo. But, I digress). Let's assume she's wearing white. Do you know how easy it is to blow out the highlights and lose detail in a white wedding gown? It's almost too easy. If this happens to you, don't be surprised if the bride unleashes a holy terror of highly weaponized bridesmaids (often former Delta Force commandos, or at the very least, disgruntled Delta flight attendants), who will tear you, your flash, and your camera gear into such tiny pieces that you could be mailed back to your office in a #10 envelope. But, don't worry, I'm not going to let that happen to you—I went and hid all the #10 envelopes, so you're probably safe. Beyond that, I'm going to take you through a boot camp of flash techniques for weddings, so when you do make your bridal portraits, instead of blowing out the highlights, it will be as though a magical unicorn of light floated gently down to the bridal gown (hey, that rhymes), while two white doves wrapped your exposure in white silk, as they glided over the fresh morning wildflowers and lavender rose petals. But, just then, a highly weaponized bridesmaid peeks over the dewy hill with a Barrett M82A1 .50 caliber sniper rifle with a Leupold scope and yells out, "You'd better not blow out the highlights in that gown. Punk!" Ahhh, you can feel the love in the air.

Simple One-Light
Bridal Portrait Setup

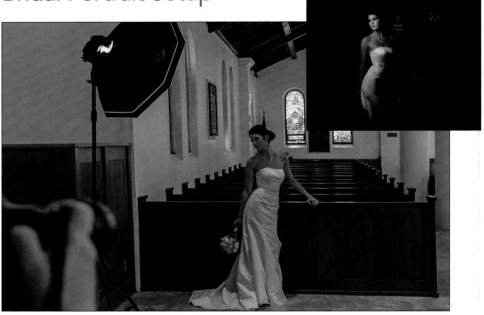

When I'm doing a bridal shoot, I want to keep it really simple, so we (me and a friend or assistant) are able to move quickly to different areas outside, or places within the church, if we're shooting indoors. My setup is to use either the 26" Westcott Rapid Box Octa (which is what I'm currently using), or the 24" Impact Quikbox (which I've used for years), mounted on the end of a monopod, with the flash on a flash bracket, and of course, I wirelessly trigger the flash from the transmitter sitting on top of my camera in the hot shoe. The only downside to this setup is that when you're not shooting, there's not an awesome way for your assistant to set this rig down—they pretty much have to just lean it on something, and if they're not really careful about it, the whole thing can topple over. If that happens, you can break the softbox, flash, flash bracket, or all three (said from experience). The other option is to use a lightweight light stand (as seen above), which is great because your assistant can just set the rig down anywhere, including setting it down while you're shooting, so it's easier on them. Well, until they're trying to fit the legs in-between church pews, or navigating up stairs, and half a dozen other times where it's kind of a pain. The main downside is that your assistant will some-times (too often) have to collapse the legs, and then set them up again as you move to a new area, and that slows the shoot down. This is why I usually go the monopod route, paired with a serious reminder to my assistant that if they don't have a corner to rest it in, they have to stand there and hold the rig, so it doesn't have a chance of falling over.

Shooting the Bride
Getting Ready

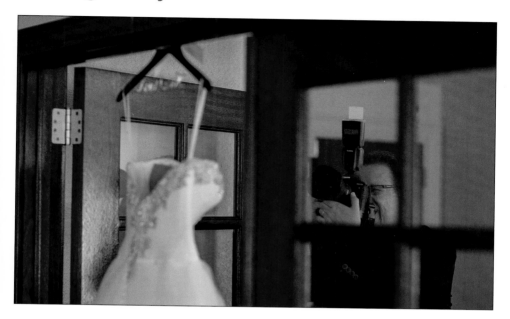

I don't generally bring a softbox into the bridal suite (or "make-ready" room), because it's already a very busy, often-crowded place, and I want to blend into the situation, not become the focus of it. I just put a flash on top of my camera in the hot shoe, and I aim it straight upward, usually with the white bounce card extended (see page 39), or I add a diffusion dome and bounce the flash off the white ceiling (if I have a white ceiling). This is a pretty unobtrusive way to go, but if for some reason the ceiling isn't conducive to bounce flash (the ceiling is red, blue, or too tall, etc.), then take a look at Option #2 for shooting the reception (on page 125), because that same setup can work in this instance, too.

Reception Option #1:
On-Camera

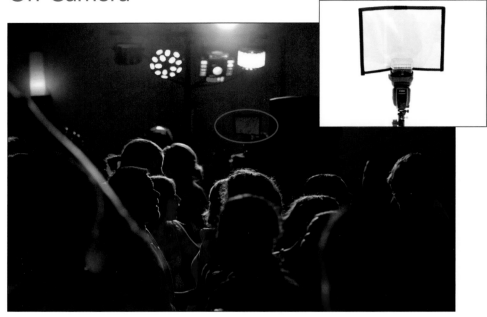

There are a bunch of different ways to use flash at a reception, and I'll start with the simplest and cheapest option, which is to put your flash on top of your camera in the hot shoe, snap on your diffusion dome, angle your flash at a steep angle toward the ceiling, and use bounce flash. Give that a try first and see how the results look (a lot will depend on the height and color of the ceiling in the reception venue, provided there is a ceiling at all). If there is no ceiling, or you're not happy with the results of bouncing, then try taking the dome off the flash, aiming your flash straight upward, then pulling out the white bounce card (built into your flash) and going that route. You're not exactly bouncing at this point—you're just pushing some of the light from your flash back toward the scene—but it actually works pretty well. If you want to still go "lean and mean," but get better results, add a Rogue FlashBender 2 Reflector (Large) panel (seen above; $39.95 at B&H Photo)—that will send more of the light forward toward the scene you're shooting (we looked at using the small FlashBender reflector in Chapter 6). It just straps right around the head of your flash and creates a larger surface for the light to bounce off of and toward your scene. They are flexible, bendable, and stay where you shape 'em, so if you don't mind spending the $40, you'll get more light without aiming the flash head directly at the scene (which we know is instant death to your photo—and career). Also, when you're shooting the packed dance floor, try this a few times: slow your shutter speed way down (to like 1/10 of a second) to get movement in the shot before the flash fires. That way, everybody doesn't look "frozen" on the dance floor.

Reception Option #2: Serious Diffusion

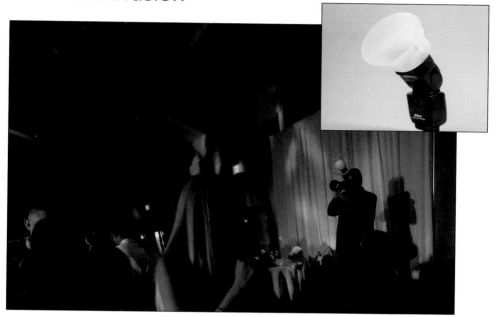

Put your flash on top of your camera in the hot shoe, and then put a serious diffuser in front of your flash. Not the snap-on diffusion dome that comes with your flash—I'm talking about something much more substantial (and one that gives tremendously better results). I like MagMod's MagSphere diffuser (see above), which creates soft, omni-directional light that doesn't cut the power output from your flash very much, so it doesn't drain your batteries really fast like some others out there do. It's super-light-weight, and it's rubber, so you can squish it down into your camera bag, or your pocket, and when you pull it back out later, it pops right back into shape. Also, it's got a built-in gel holder on the back that can hold two gels. It's $49.95 for the MagSphere, but you'll also need their MagGrip to hold it onto the front of your flash. This grip is around 25 bucks, it stretches to fit around your flash head (it's "one size fits all"), and inside are crazy-strong magnets, which let you just magnetically slap their accessories on/off instantly as you need them (they've also got a nice grid, diffusers, CTO gels, color effects gels, and a snoot, which you can buy separately). **TIP:** One of the strengths of their system is that, since it's magnetic, you can stack accessories one on top of another. For example, if you want more directional light, you can slap a MagGrid on first, then put a gel on, and then the MagSphere right on top of that, and the beams of light will be more directional while still being soft. This also works nicely for lighting backgrounds, where you want a defined circle or pool of light (see page 115). It's a very clever system, it can get just a little expensive if you add a bunch of different modifiers.

Reception Option #3:
Lighting the Room

This scenario is my preferred of all four options, and it works amazingly well—as long as your reception hall has a white ceiling—which is why it's popular with a lot of pros. You need two bare flashes, two light stands, and a wireless trigger. Both flashes are set up the same way: on top of a light stand, aiming straight up toward the ceiling, with no softbox or diffusion dome. Put the light stands way up high toward the ceiling (I'm assuming 8-foot stands) and turn the power up to 1/1 (full power). Easy enough so far. What makes this setup work is the placement of these flashes in the reception hall: you put one in one corner of the room, and the other in the opposite corner. When you take a shot, your wireless trigger will fire these two flashes toward the ceiling, and they spread out big time to put a soft bloom of light over the room, and it actually looks surprisingly good. Remember: Your f-stop controls the power of those flashes, and you'll have to take a few test shots to see if the light from the flashes is bright enough (or too bright). I would start at ISO 100, 1/125 of a second shutter speed, and f/5.6. If those flashes are too bright, raise your f-stop to f/8 or f/9 and take another test shot. If it's not bright enough, then lower your f-stop to f/4 or f/3.5. Another tip: Since every reception room is different in size and shape, you'll have to evaluate where the best place to put those flashes will be, because the corners might be too far from where the action is taking place—you might have to tilt the flash heads toward the ceiling closer to the center of the room. You have to kind of make a judgment call. Also, you can do this technique with just one flash on a stand, but you just have to be careful to position it where the head table is, close to the dance floor, etc.

Reception Option #4:
Seeing Flash in the Frame

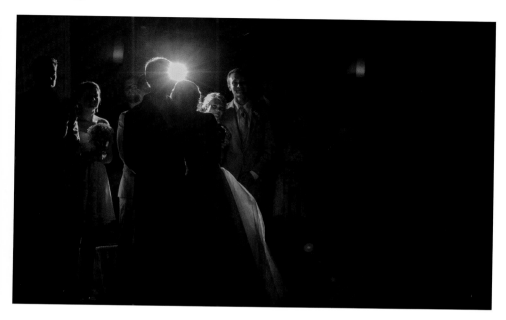

This technique is a little bit trickier to get right, but if you nail it, it can make for some really great reception images. Ideally, you'll need either an assistant (or recruit a friendly guest at the wedding) to help you for a few minutes (ideally during the first dance, the father of the bride dance, and then later during the height of the reception). They are going to position themselves on the opposite side of the room from where you're standing, and they are going to hold a bare flash up high over their head, aiming at the couple from behind. You're going to fire your flash (hopefully aimed up to bounce off the ceiling, or with a serious diffuser attached), their light will fire behind the couple, and the idea is to actually see the burst of light from that flash they're holding in back in the shot. Seeing this burst back lights the subjects and creates a sense of excitement and glamour in the shots that can make the reception look like the party of the year. If you don't have an assistant to help, then you'll put the bare flash on a light stand, up high (much like Option #3), but position it near the dance floor (put it someplace the dancing guests won't trip over it), and aim the flash to where it's tilted down a bit. Now, position yourself opposite from the flash, and it will back light your subjects beautifully. If you want to take this idea up a notch, add a second or third back light flash, assign each to a different group (we looked at groups in Chapter 2), and then only turn on the flash that is in the right position to be opposite from where you're shooting. That way, you're not stuck in one position—you can move around the room and always have a back light.

Lighting the Group Formals

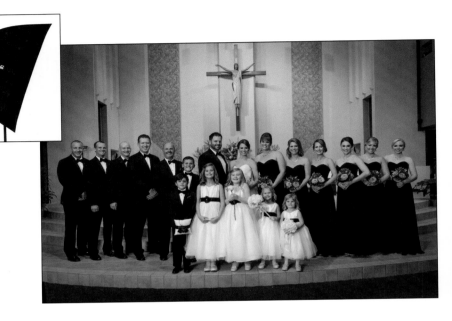

This is when I go with one big softbox, and with the Westcott Mega JS Apollo 50x50" collapsible softbox (see page 68), you can cover the group formals with just one flash, up to 20 people, no sweat. You will be cranking your flash up to 1/1 power, but it'll be nice, soft, directional light—just make sure you move your softbox back about 10 feet, so you evenly light across the group. If you get any closer, you'll start to have light fall-off on the people and one side will be lit darker than on the other side, and it makes for a really funky-looking group shot. Another way you could go (and still not spend a bunch of money) would be to use a Westcott 7' Parabolic Umbrella (see page 69). It's super-portable (well, it's an umbrella, right?), but since you're shooting right through the umbrella, the flash won't use up as much power (with the softbox, your flash aims away from the front, bounces off the back, and then travels back toward the group. With the umbrella, it's aiming right at the group, with just a thin 1-stop diffuser, so you won't lose nearly as much light). Either one will get the job done.

Rotating Your Head for Bounce Flash

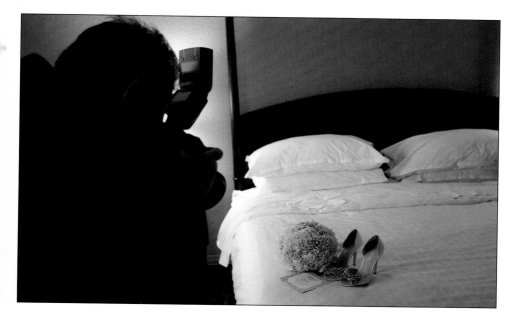

When shooting with bounce flash, we tend to aim the flash straight forward toward our subject, and then tilt it up so it bounces off the ceiling, right? That helps spread, diffuse, and soften the light, but the light is still coming straight at our subject from overhead, which isn't necessarily the most flattering or interesting angle. This is why you'll see some wedding pros with their flash head rotated to where it's either bouncing up and off to one side, or in some cases, it's bouncing back over their shoulder toward the ceiling. It limits the amount of flash going straight forward, and that can create some very nice lighting. Give it a try next time, and I'll bet you'll be surprised at how well this works.

Flash Behind the Bride

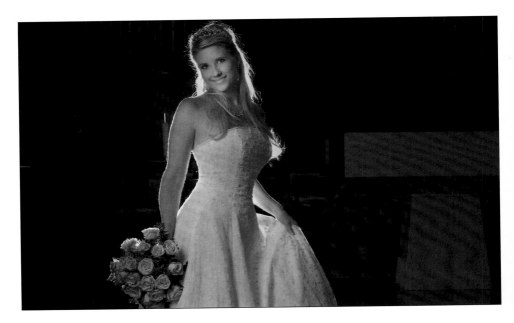

This is a fairly popular "look," and one that's simple to pull off, yet has a lot of appeal (and looks great in the wedding album). When you're doing your individual bridal portrait, place a flash on the ground, directly behind the bride, and tilted up toward her. Set it to 1/2 power and start by not lighting the front of the bride at all—just go for a backlit look. You may be able to crank up the power, but for now, just take a test shot and see how it looks. Depending on the available room light, this can make for a very dramatic look all by itself—it'll either go full silhouette (which can be very nice), or you can wind up having the available light reveal the bride's face a bit, which can also look nice. Don't forget: your shutter speed controls the available room light, so you might try kicking it down to 1/30, or even 1/15, and see if that adds enough available fill light. Another thing you can try is putting a little fill light in with your main flash—just lower the power of the back light a bit, and keep the power of this flash very low (try bounce flash for this one if the ceiling is white and low enough, or get the flash off-camera and in a softbox). The fill should be very subtle—the flash behind the bride actually is the main light.

Add a Gel to Match the Room Lighting

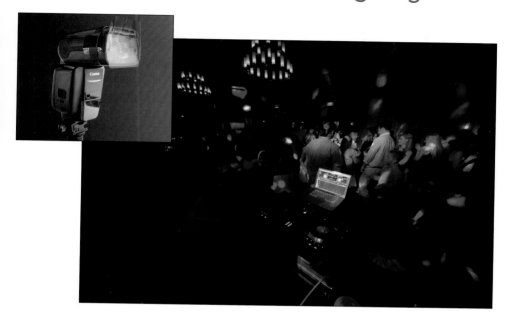

Most reception hall lighting is going to give you a pretty warm, yellowish tone, and if you start firing a white flash, it's really going to stick out like a sore thumb. So, you might want to consider adding a little orange gel over the front of your flash (see page 85) to help you blend the light from your flash with the room light. This also helps if you wind up switching (as I often do) between shooting available light in the room (sometimes I turn the flash off completely to just capture the DJ lighting—and yes I have to shoot at a crazy high ISO for those). With that gel on, you don't have to keep switching your white balance when you turn the flash on or off—you can go with one white balance for the whole reception. But, that's just a bonus—the main reason to use a gel is to more closely match the room light.

TIP | **WHY YOU NEED A BACKUP FLASH**

Flashes can get knocked over while they're on a stand, they can fall off tables, or you can just simply drop one (I've done all of the above), and when they fall, they tend to die. If that's your only flash, you're sunk. That's why, even if it's just a cheapy flash (and not your favorite high-end flash with all the bells and whistles you're used to), you've still got to have a backup flash with you. If you're shooting a Canon or Nikon flash, this is when you get a Yongnuo (for $70) as a backup and toss it in your bag—just in case.

How to Mount Your Flash

That sounds bad, but you know what I mean

One day, it will happen. Someone (probably Google or Elon Musk) will invent a way for your wireless flash to simply hover in place. You'd just walk over to where you want it, release it, and it would silently hover right there. After you took a test shot or two, you could raise or lower the height of the flash with a simple hand gesture and rotate the position and tilt it in a similar fashion. What's weird is, these days, it doesn't sound all that far-fetched. In fact, researchers at the École Polytechnique Fédérale de Lausanne university in Lausanne, Switzerland, have teams working around the clock on this very technology. But, much of their current work is based on earlier findings conducted at the Lappeenranta University of Technology in Lappeenranta, Finland, by Professor Olav Klempe Midlefart, who, despite his popularity with middle school students who take great joy in shouting his last name as they run through the halls, has managed to gain major funding for his research into floating flashes from the Alfred T. Woods Foundation, Lockheed Martin Information Systems & Global Solutions, and Jersey Mike's Subs. There were three things I found surprising when doing my own research: (1) none of the major flash manufacturers had provided funding for this research; (2) none of the major flash manufacturers make their own brand of light stand for supporting flash (not Nikon, Canon, Sony, etc.); and (3) if you use a lot of long, legitimate-sounding universities and companies, readers of your book will continue to read to see where this is actually leading, only to have their dreams suddenly crushed when they learn that all I really had was long, fancy-sounding names, and the luck of finding a professor with a name that appeals to my inner 12-year-old. So, ya know. The end.

Which Type of Light Stand to Use for What

The main thing you're probably going to mount your flash on is (as I've mentioned many times) a light stand. Now, if you buy one of those big, heavy, chrome light stands, it kind of defeats the purpose of using flash (which is to stay lean and mean, light and mobile). I generally like a 7- or 8-foot stand for when you need to get your light up high, so that's my go-to height. In the studio, it's okay to use stands that are a little heavier (like the one show above, on the left in each image) because you're not packing them up and moving them a bunch. But, when you're looking to buy an on-location light stand, I recommend going with an easy-to-carry, lightweight stand that's quick to set up and tear down. Let's look at both: In the studio, I use either Manfrotto (really well-made and popular, but sometimes a little pricey) or Impact stands (cheaper, but well-made for the money). I buy the medium-weight stands, not the really heavyweight ones (after all, you're just supporting a flash and lightweight softbox). If you're going to be on location a lot, or if space is an issue (and it usually is), you might want a lightweight stand with reversible legs (when you fold up the stand, the legs collapse up and in toward itself, rather than extending, so it makes the stand a lot shorter when you fold it up). For example, that's a regular stand on the left in each image above, and to the right is one with reversible legs that fold up toward the center pole. See how much smaller it is when folded? They're much easier to carry and store. Impact makes one with reversible legs (the LS-RL7 7.2' Reverse Legs Light Stand; around $45 at B&H), as does Manfrotto (it's pretty reasonably priced at around $54, but it's a full foot shorter). Both come with a spigot on top (the little brass-colored nub that you slide studio lights onto), so you're going to need some kind of bracket (ideally a tilt bracket) for mounting your flash on top (see the next page).

Why You Need a Tilt Bracket

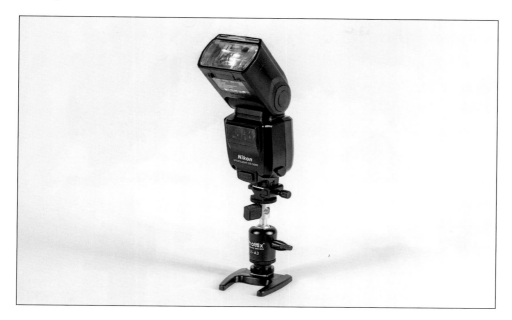

If you're using your flash for taking portraits, the kinda standard rule is that you're going to position the flash up high (a bit higher than your subject's head), and then you'll tilt it (and your softbox or whatever) down toward your subject to mimic the sun, since that's how we're most comfortable seeing people lit—from above, aiming down. If you just buy a flash shoe mount and stick it on top of your light stand, or if you screw on the little foot that came with your flash to hold it on top of your light stand, your flash is going to be aimed straight—there's no easy way to tilt it down toward your subject. This is why you really need a tilt bracket, but luckily, they're pretty cheap. Most are made with a special hole in them, so you can insert an umbrella—in case you get a gig doing portraits on a cruise ship (sorry, I couldn't help myself). So, don't let it throw you off if a tilt bracket says "umbrella" in the description. We're just going to ignore that hole, unless you decide to go the umbrella route, and, in that case, "anchors aweigh!" (Again, couldn't resist.) Anyway, one way to go is with the Phottix US-A3 Umbrella Swivel for Off-Camera Flash (it's like a ball head for your flash—very easy to adjust and position, and photographers seem to love 'em), which is around $22 at B&H. If you want a more traditional tilt bracket, look at a Westcott's Adjustable Shoe Mount Umbrella Bracket (it's around $30). Very solid, good knobs to work with (some have knobs that are kind of funky) and highly rated. *Note:* Some softboxes, like the Westcott Rapid Box Octa I mentioned on page 61, already come with a nice tilt bracket, so you might already be covered.

Using Your "Little Foot" to Hold Your Flash

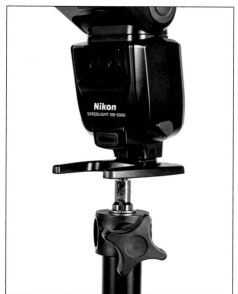

Most flashes today come with what's called a "foot" (well, that's what the kids on Flash Street call it these days)—it's a short, plastic, little stand you can slide your flash into. They're not awesome, but they're free. Perhaps the best thing about the little plastic foot is that on the bottom, most have a little thread you can screw on to the top of a light stand, so you have a way to mount your flash to a stand without having to buy a cold shoe mount or a tilt bracket. But, in reality, you will definitely need a tilt bracket (for the reason we just talked about on the previous page), so you would only mount your flash to a light stand in this way in either: (a) cases of extreme emergency, or (b) cases of extreme thriftiness. Okay, you might also mount it using the foot if you were putting a second flash behind your subject—maybe behind an athlete or a bride—where you don't necessarily need to tilt the flash downward. But, obviously, you're limited to only being able to tilt up. By the way, if you lost yours, look at the Vello Compact Shoe Stand for Universal Shoe Mount Accessories for around $8. Cheap.

My Favorite for Location Shoots: Mounting Your Flash on a Monopod

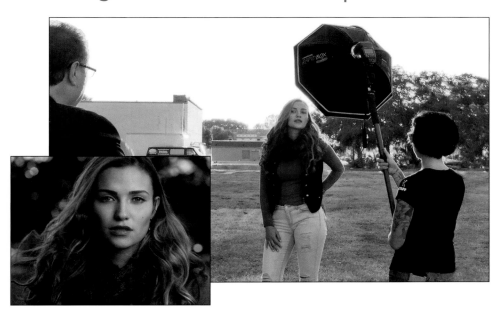

My first choice when going on location (as long as I have a friend or assistant to help) is to mount my flash (with a softbox) right on the end of a monopod, like the Oben ACM-1400 4-Section Aluminum Monopod—it only weighs like one pound, and it extends to 61", so it's easy for a friend or assistant to hold up high (well, higher than your subject anyway). It's $39.95 at B&H, and you attach your tilt bracket to the little spigot on the end. Besides just using a monopod, there are actually boom light poles made expressly for this type of thing, like the Elinchrom EL Handheld Boom Arm (around $50), which is thin, lightweight, and extends to 61", as well (you attach your tilt bracket, or Westcott Rapid Box bracket to the end). Another option is the Impact QuickStik+Telescopic Handle, which has a feature you don't see with the other poles: it has an attached secondary swivel handle that helps your assistant (or friend, or reluctant bridesmaid) steady the pole and hold it comfortably. It even comes with a flag-holder-style wraparound belt with an attached holster, which lets your assistant transfer the weight to their hip, so they can comfortably hold the rig longer (plus, it lets them leave one hand free if they need it). At $64.95, it's more expensive than the Oben monopod, but it has got those extra features that make it worth it if you do longer shoots, like weddings. By the way, I know I keep talking about Impact a lot in this chapter, but I have a lot of their gear because their quality is good and their prices are hard to ignore.

Mounting Second Flashes: Clamp It

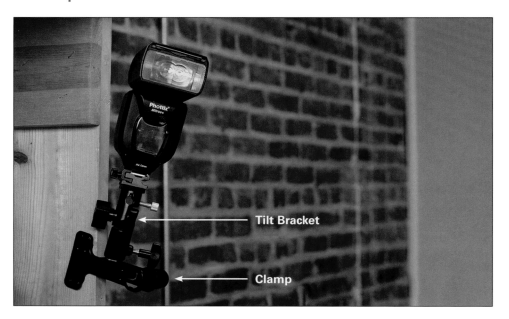

If you want to mount a second flash (usually to the side or behind your subject), there are all sorts of methods to do this (in fact, there's a whole cottage industry of second flash holders). It's helpful to have more than one because you'll never know what's available to attach a flash to until you're on location, and it'll be too late if you don't have a backup plan. One of the cheapest methods is to buy a spring clamp, so you can clamp a flash to a door or a window or just about anywhere you can clamp something onto. Here I'm using a Manfrotto 175 Spring Clamp (cheap—only $14.50 at B&H last time I checked), then I put a Westcott tilt bracket right on the little spigot that's attached to the clamp, and then I put my flash on top of that. This is a really compact, handy little system (provided, of course, that you have an extra tilt bracket to use with it). If you don't, instead you might want to go with a special version of this same clamp: the Manfrotto 175F Justin Spring Clamp with Flash Shoe (known in flash circles as simply a "Justin clamp") because it comes with a tiny Manfrotto ball head and flash mount already attached. That's it. You clamp it on something, adjust the angle of your flash with the ball head, and you're off to the races. It's around $55 (Impact makes a version for around $10 less, called the Impact Large Clip Clamp with Ball Head Shoe Mount). BTW: The rest of this chapter is mostly showing you different mounting options (yes, I have all of these). That way, you can find which ones work for the type of second flash stuff you think you'll be doing.

Mounting Second Flashes: Joby Flash Clamp

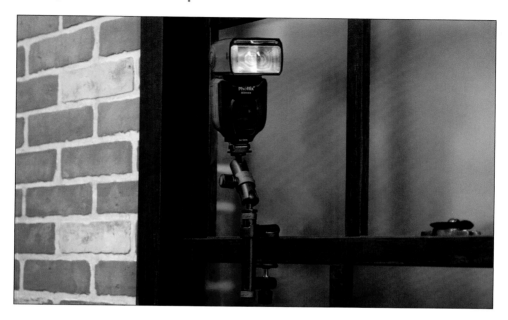

The Joby Flash Clamp and Locking Arm is a pretty interesting way to rig up a flash, because you can attach it directly to all kinds of stuff (like to the back of a chair, a table, a railing, or whatever—as long as it isn't thicker than 2"). It has two articulating ball joints, so you can position it exactly how you want it—rotating a full 360°, and it can pivot 180° side-to-side. It comes with its own flash shoe mount, and at just $35, it's pretty darn affordable. It's kind of like a cheaper, lighter, simpler version of a Manfrotto Magic Arm (but, of course, for that price, don't expect it to have the stability or durability of a Magic Arm, which is pretty legendary in both those areas. Now, if you just said, "What's a Manfrotto Magic Arm?," that's only because you haven't gotten to page 142 yet). This is a great one to toss in your bag for times when setting up a light stand doesn't make sense.

Mounting Second Flashes: Tether Tools RapidMount SLX with RapidStrips

This one (from Tether Tools) is one of the "new kids on the block," but what makes it different, and really handy, is that it lets you stick a flash right to all sorts of things. It uses these specially designed, pressure-activated adhesive strips (called "RapidStrips") that attach a small plastic holder directly to things like "drywall, painted walls, veneer, glass, mirror, laminate, fiberglass, metal, tile, porcelain, and marble," but when you remove the holder, it doesn't peel off paint or leave behind a sticky residue. Besides being able to stick it in a whole lot of places (stop snickering), it's really small, lightweight, and super-easy to set up (a small band holds your flash in place). The cost is pretty reasonable, too, at $24.95, but that's really only for 10 uses. After that, you're going to need a new pack of those pressure-activated RapidStrips, and they run $14.95 for a pack of 30 or $49.95 for a pack of 120. Okay, so what's the downside? The downside is: it doesn't have a tilting device—your flash sits flat in the holder (as seen above). Of course, the flash head can tilt up, but it can't tilt down. That might not be an issue for what you do, but if it is, then instead, check out its cousin the RapidMount Q20 with RapidStrips for $29.95. It looks like it would be a suction cup, but it actually kinda works the same way adhesively (and, by the way, I can't believe that's even a word). It has a little arm that gives you 360° rotation and 180° tilt, but you're going to need the little flash shoe holder. That'll run you an extra $8.99, and you'll need an extra pack of RapidStrips, so tack on $14.95 for the 30-pack, and the grand total, out the door (excluding tax, tag, title, and dealer fees), would be $53.89 (for well-qualified lessees with approved credit. Must take delivery before 12/31/2022. $0.18 surcharge per mile over 12,000 miles per year).

Mounting Second Flashes:
Platypod Ultra

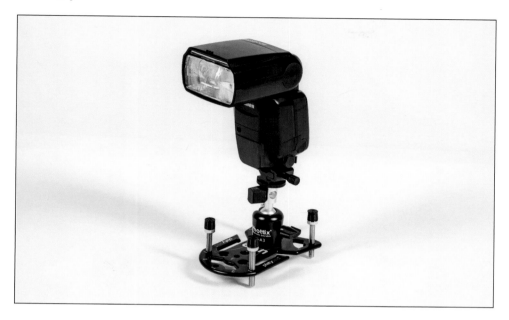

If you want the most versatile mack daddy of all mounting devices, it may well be the Platypod Ultra (little cousin to the popular Platypod Max, which is designed to let you mount a big DSLR pretty much anywhere). This is a much smaller, lighter, thinner (and improved) version that makes it perfect for mounting flashes just about anywhere, from the floor (behind a bride), to rocky or uneven surfaces (using the included spike feet), to poles, beams, or trees (using the included 20" strap), to just about anything one way or another. It's incredibly clever, and it's so small you can toss it in your shirt pocket, but it is sturdy as anything (it's made from aircraft-grade aluminum). When they launched it as a Kickstarter project, it was completely funded in the first 24 hours (which lets you know how badly photographers wanted to get their hands on one). It runs $59, but you'll need two more things to use it as a flash mount: (1) I'd look at the Giottos MH 1004 Mini Ballhead (for 15 bucks), and then you'll need (2) a shoe mount to hold the flash (check out the Vello Universal Accessory Shoe Mount from B&H for $7—it screws right into the Giottos Mini Ballhead). The good news is: once you have the Ultra, you'll find other uses for it, instead of just mounting flashes (it'll hold everything from a small DSLR with lens, to a GoPro camera, or a mirrorless camera).

Mounting Second Flashes:
Manfrotto Magic Arm

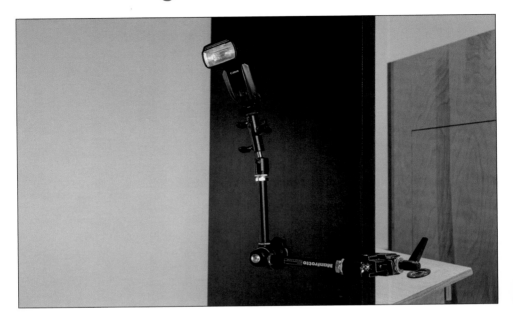

This is the flash solution for working pros, and it's a doozy! (I have three of these myself, and they are awesome for all sorts of tasks, way beyond just mounting flashes. This is what I use to mount remote cameras with big lenses up in the ceiling crosswalks in places from NFL stadiums to hockey rinks, to mount cameras on cars, to hang them upside down in an MLB dugout—these are the real deal.) While mounting a flash on one of these bad boys might be considered overkill, I see photographers doing it often, and they always seem to be smiling. It's officially called the "Manfrotto 244N Variable Friction Magic Arm" (it's around $113 at B&H), but that's just the two arms and locking knob. You also need the Manfrotto 035 Super Clamp without Stud (for around $27), which attaches the Magic Arm to stuff like railings and chairs, doors, and anything you can clamp stuff onto. Then, you need the Manfrotto 143S Flash Shoe for Magic Arm (which, surprisingly, is only $10). All total, you're looking at 150 bucks, but you'll have pro-level flash mounting prowess, and the respect that comes with showing up for the gig with a Magic Arm. Other photographers will step out of your way.

Holding Multiple Flashes

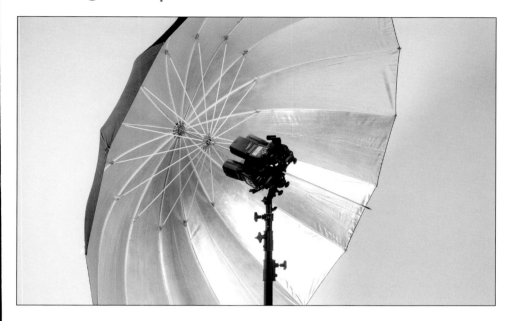

If you need more power (maybe you find yourself doing a lot of High-Speed Sync [see page 43], which eats up a ton of power and is why many High-Speed Sync freaks use multiple flashes), you're going to need a bracket that will hold multiple flashes. If you want to mount two flashes (all on one stand, maybe for use with a 7' parabolic shoot-through umbrella [see page 69], for example), Impact makes a bracket that's really affordable: the Impact Twin Shoe Metal Umbrella Bracket (it runs just $22.95). If you need to mount three flashes on one stand, take a look at Westcott's Triple Threat Speedlite Bracket, which holds three flashes in a triangle configuration (for around $30). If you need maximum power, check out the Lastolite Quad Bracket (around $102). This one's really great quality, but if you need something a whole lot cheaper, check out the CowboyStudio 4 Way Flash Shoe Bracket for $24. I haven't used this exact one, but if it breaks, it'll probably just become a three-flash mount, or maybe a two. ;-)

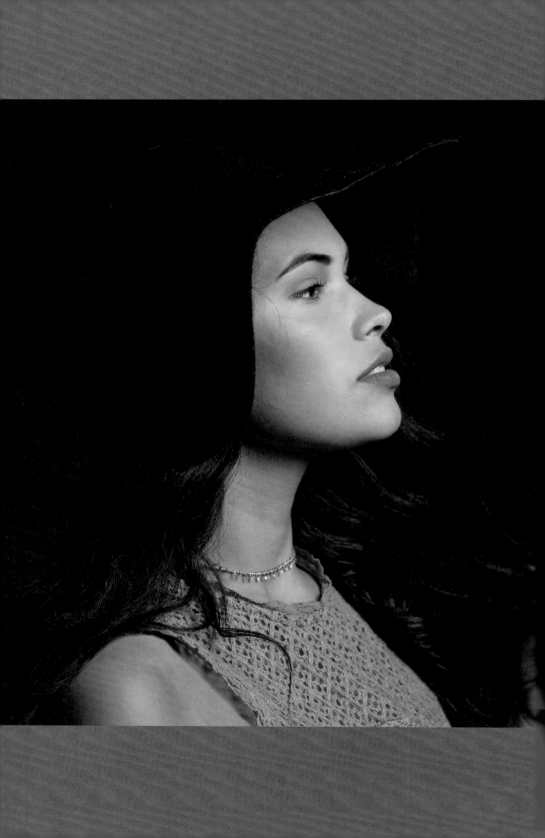

Flash Tricks

*Getting your flash to beg, roll over,
and fetch light*

You know how we all teach our dogs to do tricks? The whole roll over, fetch, beg thing? Are these actually useful things? Do they really help in our daily lives with our dogs? No. We don't teach our dogs useful things like, "Go get the mail," or "Rake the yard," or "Order a $5 foot-long sub from Subway, and then go pick it up without denting or scratching the car." Nope, we focus on roll over and beg and stuff. But, let's look beyond that. Why? Why do we teach our dogs tricks? One reason: so when a friend or relative comes over, you can have your dog do tricks, and they'll either think the dog is a genius, or you're a genius for having trained him or her, or hopefully, both. But, outside of showing off your, and your dog's, skill, practically speaking, it's all pretty useless stuff. Flash tricks are pretty much the same thing. This isn't your "meat and potatoes" flash stuff. This is the stuff you pull out when a flash friend comes over, or you go to a meetup group, and you want them to think, "Hey, this person is a flash genius," and then they'll all crowd around you and give you treats. Some part of that may not be 100% correct, but you get the basic gist, and that is, you're about to learn some pretty cool, pretty useless stuff that looks great at flash get-togethers. Well, the product lighting thing is actually pretty useful, and so are some of the others, like double-tapping to remove ground spill, but the stroboscopic stuff, and the pan blur and freeze stuff are really only techniques that you'll want to do when testing the new legal marijuana laws in your state. When you're stoned, all this stuff seems really cool (well, that's what the kids tell me anyway), but once you come down, and you look at what you created, you realize stroboscopic and pan blur are just gateway techniques to the hard stuff, like frozen powder effects, where you'll spend the next 3 ½ years cleaning flour or baking soda out of your studio and your furniture and your hair. Don't say I didn't warn ya.

A Studio Portrait Look without the Studio

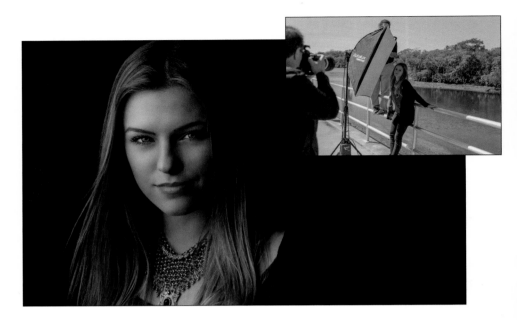

My friend, UK-based photographer and retoucher Glyn Dewis, coined a great name for this technique, which lets you turn the background behind your subject—indoors or outside during the day—solid black, making it look like you took the shot in a studio. He calls it "The Instant Black Background," and it's really just three easy steps: (1) Turn off your flash. (2) Increase your shutter speed to 1/250 of a second (that's generally the highest sync speed without having to use High-Speed Sync). Then, (3) dial up your f-stop by a ton—to at least f/22, if not higher (if your lens will allow; some will go to f/32, some to f/40). The goal is to turn the scene you're standing in front of solid black. You shouldn't see anything all. If you took a picture, it would be just a black image. Take a test shot to see if it's solid black, then once you see that solid-black image, you can turn your flash on and make the shot. (*Note:* Since you're at f/22 or higher, you can count on having to set your flash to full power.)

Hiding the Flash and Light Stand

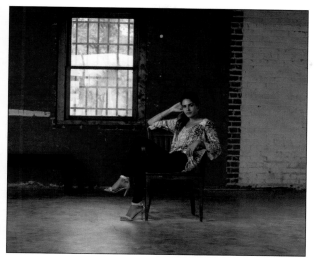

This is part camera technique and part very simple Photoshop technique (but, don't worry, I made a video for you on the Photoshop part). First, here's the problem: You want to light your subject with flash, but you also want to create a wide-angle shot that takes in the environment. Maybe it's a bride in a big, beautiful church, and you want to frame it so you see the ceiling of the church and the stained-glass windows, but you'd also see the light stand and softbox. Or maybe it's an athlete outside on a track, and you want to show the track and empty lanes, etc., but without a big ol' light stand and softbox. The secret? First, take the shots on a tripod (yes, a tripod; it makes the Photoshop part ridiculously simple). Once you get your flash set up, and you get a bunch of good shots from that exact location and angle, turn your flash off, then pick it up and move your flash rig (and your subject, if needed) completely out of the frame, so you can't see it. Now, take a shot of the scene in front of you, using only the normal ambient light. This is called a "plate" frame. In Photoshop, open one of the portrait shots, along with the plate shot. Copy-and-paste the plate shot on top of the portrait shot (it appears on its own layer), and you'll see they line up perfectly. Know why? Because you used a tripod. Press-and-hold the Option (PC: Alt) key and click on the Add Layer Mask icon (the third icon from the left) at the bottom of the Layers panel. This hides the plate layer behind a black mask and now you can see the portrait with the light stand visible. Get the Brush tool (B), set your Foreground color to white, and simply paint over the light stand and softbox. Voilà—it disappears! Again, I made a step-by-step video for you, which you can find on the book's companion webpage (you'll find the URL in the book's intro, at the beginning of Chapter 1).

Sunset Look on Location

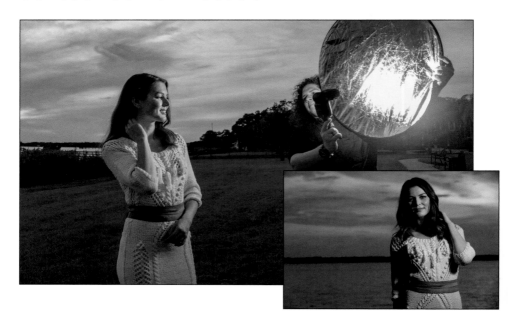

Another way to achieve a realistic sunset look with your flash when you're shooting late in the day is to hold a reflector up high and to the side of your subject with the gold side facing them (yes, you have to have a gold side to your reflector, which is why it's good to get one of those 5-in-1 reflectors, like Westcott's 40.5" 5-in-1 Reflector Disc. It comes with a 1-stop diffuser zippered inside it [which is awesome for natural light shots. You just put it between your subject and the sun; it's like putting the front of the softbox in front of the sun], and the outside reflectors are reversible—one side is silver or gold, and the other side is white or black. It's $39.90 at B&H). Anyway, the idea here is to bounce your flash off that gold reflector, and since light picks up the color of what it hits, it's going to bounce back a warm, gold tone onto your subject. Of course, you only want to pull this trick out of your bag way late in the day, near sunset. If you try it at 1:00 p.m., it just looks weird (like your subject spent too long in the tanning booth).

Dragging the Shutter for Effect

When your subject is standing still, sometimes we use a slower shutter speed (like 1/30 or 1/15 of a second) to let more of the existing room light into the shot (this is known as "dragging the shutter" by the boys at the Flash Bar & Grill, in Abilene, Texas). However, you can also use a slow shutter speed for special effects by simply having your subject move while your shutter is open. Now, if you leave it open for a longer amount of time, like 1/2 second or even a couple of seconds, and your subject moves while that shutter is open, you'll get an awesome blurring-of-movement effect. Your flash will fire, freezing your subject (unless they're really moving fast), and you'll have a mix of movement in the shot, as it combines an ambient light shot, and then your subject frozen and lit with the flash, all in one. It can be a pretty cool effect—it just takes doing it a few times to figure out the right shutter speed setting, but that's what that little screen is for on the back of your camera. Take a test shot or two, see what it looks like, then try a different shutter speed or two until you find the right amount of motion, and then your flash will take care of the rest. If you want more of a trail of movement coming off your subject, try turning on rear curtain (or second curtain) sync on your camera. Simply turn it on, and this lets the photo expose before the flash fires. The shutter stays open for a while, then the flash fires at the end of the exposure. So, while that shutter is open, and your subject is moving, you get that trail of motion.

Three Lighting Looks without Moving Your Flash

Left side

Straight on

Right side

Once we get our flash set up and positioned, and the light is looking good, we generally stand directly in front of our subject and start taking shots, right? Right. But, what would happen if you took a few steps to the side and started shooting (so you're not straight on, but shooting at an angle)? Here's what would happen: the lighting would look very different, since it was set up to look a certain way when you were standing directly in front of your subject. This a good thing. Heck, it's a great thing, because once you have a set of shots from the front, move way over to the side and keep shooting for an entirely different lighting look. Then, move completely over to the other side for a third look. You haven't moved your subject. You haven't moved the light. All you've changed is your position. This one little change can give you three different lighting looks from just a simple, single flash setup, without moving anything but you.

If You Can't Bounce Off the Ceiling

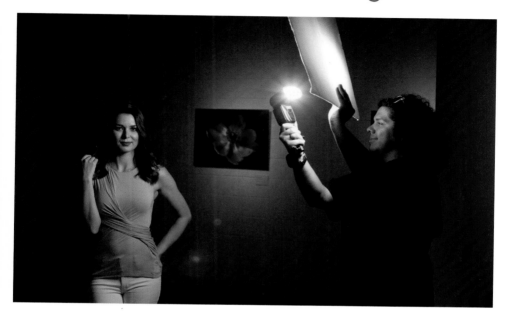

Not all ceilings are white, and not all ceilings are low enough to effectively bounce light off of, but here's the good news: the light from your flash will bounce off anything white. I remember once being on location with a legend in wedding photography, David Ziser, and he bounced light off a guy's white shirt to light the bride. White is just an incredibly reflective color when it comes to flash, and once you realize that, it opens up a whole new world of possibilities, like bouncing off a medium-sized sheet of white foam core, or bouncing off a white wall, or bouncing off a white collapsible reflector. And, none of these have to be held up way above your head thanks to the fact that the head of your flash can rotate and tilt. Have a friend hold that white sheet of foam core just above their face level and rotate your flash head, so it hits that white sheet and angles back toward your subject—the light will spread and become a lot softer and more flattering. Remember: Light bounces like a cue ball on a billiards table. So, think about the angles, and how the light from your flash will hit whatever white thing you're aiming the flash head at, and imagine the angle it will bounce off as it leaves it (the foam core, or wall, or whatever). Using a white sheet of foam core isn't my first choice, but it's a great Plan B if you find out that the ceiling you were counting on bouncing off turns out to be a dark wood ceiling.

If You Want to See Background Shadows

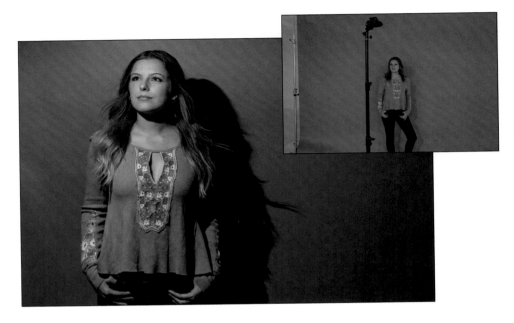

Part of this is going to seem amazingly obvious, but if you want to see your subject's shadow on the background, move them so they're about a foot from the background, and you'll see that shadow for sure, if your flash is on one side or the other (less so if you're shooting straight on, but you're probably not shooting straight on, right?). Of course, this shadow is going to be fairly soft because you're using a softbox or diffuser or something to make the light flattering, but what if you want a harder shadow? One with real definition and without the blurring? Then, you need to go with hard light— that's right, take your softbox off and shoot with a bare flash head. If you're going to go this route, make sure your subject has really great, clear skin because that light is going to be bright, punchy, and not all that flattering (unless, again, they have great skin). This is going to create very hard, edgy shadows, and they'll be a medium gray. If you want darker, richer, hard-edged shadows, then add a grid to your flash (maybe a Rogue grid or a MagMod [see page 66 for more on both]), which will tighten and concentrate your beam of light, and that will create darker, richer shadows.

Using Your Flash as a Prop

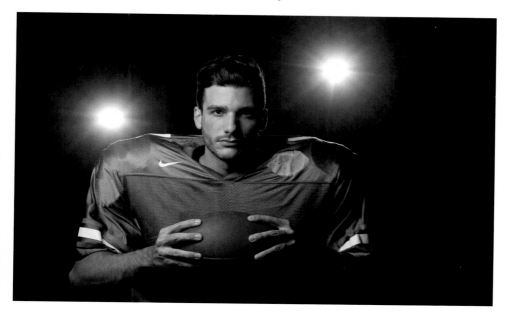

I mentioned a somewhat similar technique in Chapter 7, but if you don't shoot weddings, you might have missed it (and, in this scenario, there is no dance floor, sadly). The trick is to position a second flash somewhere in the shot, so you can actually see the pop of light from the flash in your frame. It can add a real sense of excitement to the scene—the bright pop of light—and you'll see this fairly often now that you're aware of it. Basically, your second (and third, in my setup here) flash becomes a prop. If you only have one flash, and you can get a decent picture from your shooting position without using flash, then take that one flash and position it on a light stand in the scene on the opposite side from where you're shooting. Now, when you fire your shot, the wireless transmitter on your hot shoe fires the flash, so you don't need a second flash to do this in every case.

Fix Ground Spill with a Double-Tap

 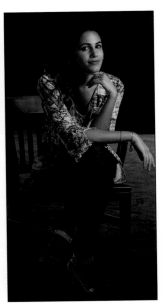

With flash **Without flash** **After**

I have to give credit to David Hobby for this one. He was a guest on my show a few years back, and I've been using this tip since the day he showed it. He called it "the double-tap." You use it mostly on location, when shooting around sunset and the light from your flash lights the ground under your subject's feet. Well, in most portraits, we want their face well-lit, and the light to fall off as it goes further down. We don't want their feet lit as brightly as their face, and we sure don't want the ground lit so brightly that it draws your attention (besides, overlighting the ground looks amateurish). But, that's not going to happen to you because you're going to double-tap the shutter. Switch to continuous shooting mode and press-and-hold the shutter button. The first shot fires the flash, and the second continuous shot fires before the flash has a chance to recharge, so it's just a shot taken with the available light. So, now you have two shots: one with the flash (shown above, on the left) and one without, with just the existing light (shown above, in the middle). See where this is going? That's right, it's going to Photoshop, where you're going to basically use the same technique you read about on page 147 (follow the instructions there). But, instead of painting the light away, you're not going to use a brush at all. You're going to grab the Gradient tool (G), set your Foreground color to white, and drag it from the bottom of the image up near your subject's face. That will create a darkening from the neck, graduating downward, as it reveals the second photo of the double-tap in those areas (shown above, on the right). Aw, what the heck, go ahead and watch the video I made for ya (also found on the book's companion webpage, mentioned in the book's intro).

Special Effects Gels

Without gelled flash

With gelled flash

Two ideas here: (1) When you're shooting on location, a pretty popular trick with flash photographers is to create a more interesting background by gelling a flash with a vivid color (red, blue, purple, green, etc.), and aiming it at a wall or object in the background just to keep the background from looking boring. Here (on the right), I attached a purple-gelled flash with a diffusion cap to the desk behind her, using a Joby Flash Clamp (see page 139). It really works wonders. And, (2) put a vivid gel over your flash inside a back light or kicker light (like inside a strip bank behind and to the side of your subject), and that color now appears as a strong tint on your subject's hair, or behind them, or in the highlights (depending on how you have that back flash aimed). If you've got three flashes, you can put two behind your subject (maybe a strip bank on each side) with a complementary color gel in each, like a red and a purple gel, or a magenta and a blue. Those will light their hair from the back, and your main flash up front will be a normal color (see page 161).

Using White Balance as a Second Color

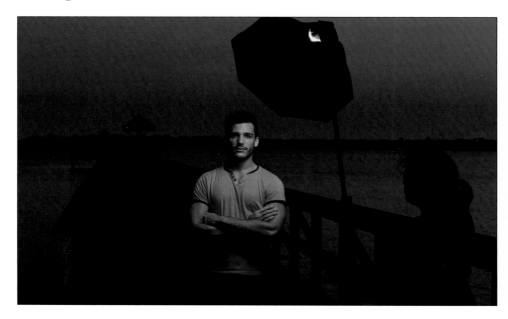

This one-flash portrait color trick has been around for a while, but it's still popular because it gives you the look of two flashes when using just one. Here's what you do: first, put a pretty heavy CTO gel over your flash, so the light from it is pretty orange (see page 84 for more on CTO gels), and then set the white balance in your camera to a very blue setting (like Tungsten, or use the K [Kelvin scale] manual white balance setting and dial it over to a very cool setting, like 2500K, which will be very blue). Now, when you take the shot, your subject will appear warm (slightly to moderately orange) against a very blue background, and it looks like you did a lot more with gels than you did.

Pan Blur and Freeze Effect

If you're shooting action sports, like this snowboarder (or even just your kid on a bike or skateboard), and you want to add a motion effect, so the background has a motion blur, but your subject is crisp and frozen, here's what ya do: First, you've probably figured by now, to get that motion, you're going to use a slow shutter speed. If your subject is moving quickly (like on a bike or they're jumping over hurdles on a track), start around 1/10 of a second. You're basically trying to match the speed of the shutter to the speed of your subject. Next, set your f-stop using the meter inside your viewfinder and raise your f-stop to where it shows you have a proper exposure (I imagine this will be around f/11 or higher, but of course, it all depends on the light where you're shooting). Now, aim at your subject and track right along with their movement (this technique is called panning). As the subject passes by, swivel your hips as you track them, keep your focus point on their chest (if possible), and take the shot. Keep panning for a second or two after you take the shot—don't stop panning as you take the photo, keep the panning going for a sec. Keeping the shutter open longer like this will make the background very blurry, like in the trees in the lower-right corner above (the slower the shutter speed, the blurrier the background will appear), and then the burst of light from your flash will freeze and light your subject (don't set the flash power too high—you need a short flash duration, so it freezes the motion). Getting these shutter speed, f-stop, and flash power settings right will definitely take a few test shots, and a few tweaks to those settings, but that's what the little LCD monitor is for on the back of your camera. If there's not enough blur, lower the shutter speed. If it's too bright, raise your f-stop (go to f/16 and try again). If the flash is too bright, lower the power. You know the drill by now.

Stroboscopic Effect

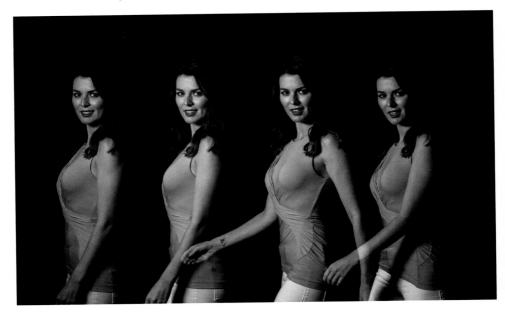

The stroboscopic effect you see here (where you have multiple exposures in just one shot) is surprisingly easy to pull off. You're just going to choose a long shutter speed (anywhere from two to 10 seconds or longer), and while the shutter is open, you're going to fire the flash a bunch of times (which is why it's good to try this with a fresh set of batteries). For this technique to come out looking like the one above, you need to do this pretty much in the dark (you want a solid black background). First, set the shutter speed on your camera to three seconds (well, for our example here anyway), so your shutter stays open a good long time. Next, there are four settings we need to adjust on our flash itself: (1) We need to set the mode to Multi on Canon, Yongnuo, Sony, or Phottix flashes; on Nikon flashes, it's called Repeating Flash mode. (2) We need to choose how many times we want the flash to fire in total (we'll make the math easy and choose nine times—that's the maximum number of times the flash will fire). (3) Under the Hz (hertz) setting, we choose how many times per second we want our flash to fire. So, we could easily choose three flashes per second, for three seconds, for a total of nine flashes. If you wanted it to fire your flash six times per second, then you'd need to set the total number of flashes to 18, otherwise it will still stop at nine flashes. By the way, firing your flash this many times is why you want your power setting low (so your flash can actually recharge quickly enough to fire that many times per second). Lastly, there's (4) the power setting (this is all on the same screen). Now, put your camera on a tripod, use a cable release, and you're ready to go!

The Classic Hollywood Dramatic Look

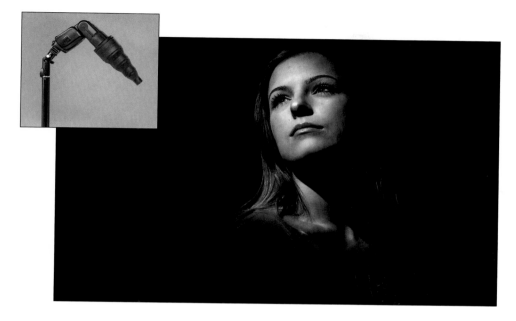

I remember a quote I heard from Joe McNally, one a photo editor had told him years ago: "If you want to make something more interesting, only light part of it." And, that's the basis for this dramatic Hollywood look—just lighting a small part of your subject. Of course, the light from your flash wants to spread everywhere, but that's the opposite of what we want. If you really want to nail that Hollywood look, you've gotta use a snoot—it's an attachment you put over the head of your flash that narrows the beam (much tighter than a grid) until it leaves just a tiny opening of light that you can strategically position on your subject's face. MagMod makes a snoot (called the MagSnoot, seen above), which is totally collapsible (it's made of rubber), and what's nice is you can control the width of the beam by pulling the snoot in or out—the farther out you pull it, the tighter the beam (you get four different widths of beam this way). **TIP:** The beam from a snoot is so tight that you might want to stand at your flash position and hit the "test" button on the back of your flash, so you can see it as it fires and get it positioned exactly where you want it on your subject before going back to your camera position. You can actually do this kind of look with a Rogue Grid (it has its own little tube that helps funnel the light), but you have to position the flash very close to your subject (like 18" from their face). Okay, now that you've got your flash snooted, and it's aiming from up high, down on your subject at an angle, and positioned right on your subject's face, have your subject look up at the light (the classic Hollywood pose), or over their shoulder at the light (another classic pose), and let the drama unfold (hopefully, just in the shot, not in the shoot itself).

Dramatic Profile Portrait

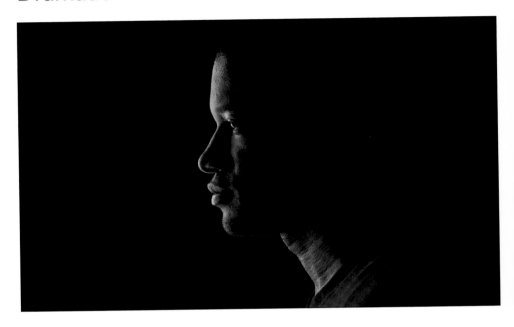

This is really easy to pull off, but has a lot of impact. First, you'll need a black background, so either use a roll of black seamless paper, or just move your subject far enough away from whatever your background is so that the light from the flash won't reach it at all. Now place your flash (and softbox) so it's directly beside your subject (your subject is still looking straight ahead toward your camera position). If you took a shot right now, only half your subject's face would be lit—the side closest to the softbox. Next, to see your subject's profile, have them turn and fully face the softbox (so they are standing sideways, as seen from your camera position, and they are looking into the center of the softbox). Now take that softbox and move it back, away from your camera position (so it's moved straight back toward your seamless paper, or wall, or whatever is in your background). You're only going to move it until the edge of the softbox is about 18" past your subject (so your subject is now just facing the side wall, and not the softbox, which has been moved past your subject). Turn up the power of your flash to 1/2 power, and take a test shot. Now, you're lighting the side of your subject's face that is facing away from the camera, and this leaves a white, backlit rim effect around the outline of their face, and that creates a very dramatic portrait (like you see above). If you see a lot of light spilling onto the side of the face closest to the camera, it just means you need to move the softbox back a little farther toward the background.

Two-Color Split Back Lighting

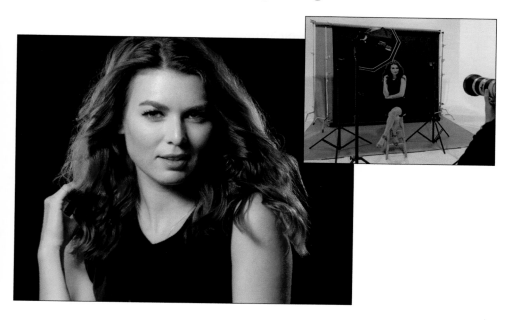

This is a three-flash effect, but don't that let throw you—it's really easy to pull off. Generally, it's done with a black or dark background, so let's start there. Next, we're going to set up two back lights—one on either side of our subject, aiming toward their hair at a 45° angle. If you have grids, put them on these two back flashes, as well, to keep the light from spilling everywhere (you don't need softboxes on these back flashes). Next, put a different color gel on each of these flashes. You'll want to pick two colors that complement each other, like red and purple, or blue and green, or maybe orange and blue. For our example, we'll put a purple gel on one flash and a red on the other. Set these two flashes at 1/4 power for starters and see how that looks—do a test shot and make sure the colored light doesn't spill over onto their face; these two are just to light the subject's hair on either side. Next, we bring in a softbox in front to fill in the shadows. I'd use either a Rapid Box Octa or Rapid Box beauty dish, but once again, I'd add a grid (this would be a fabric egg crate grid, though; see page 65 for more on these) to keep the front fill light from spilling over and washing out the two gelled back lights. Keep this front light pretty close to your subject and pretty low in power—it's just supposed to fill in the shadows and illuminate the face a bit. If we overpower the front light, it spills and washes out the back lights and pretty much kills the effect. Start at 1/8 power, but you might have to go down to 1/16.

Removing Reflections from Glasses

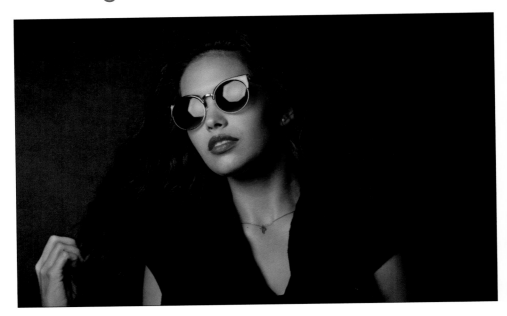

See how you can clearly see the softbox reflected in my subject's glasses (or in this case, sunglasses) in this image? Right, those. Sometimes, you even see reflections like these in big, commercial sunglasses ads. So, should you get rid of them? That's 100% totally your call. Some photographers really like the way they look and feel it adds something to the image, and some shudder when they see them. So, in case you decide you want to get rid of them (and don't want to have to do it in Photoshop, after the fact), there's a pretty darn easy way to get rid of them: the trick is to raise the height of your softbox way, way up until you either (a) don't see the reflections in the glasses at all, or (b) you see so little of them that removing the rest in Photoshop is a 30-second job. Either way, it's your call, but at least if you want to get rid of them, now you know the trick—get that softbox way up high (don't forget to tilt it down to compensate for raising it up so high) and the reflections go away.

Simple Two-Flash Product Lighting Setup

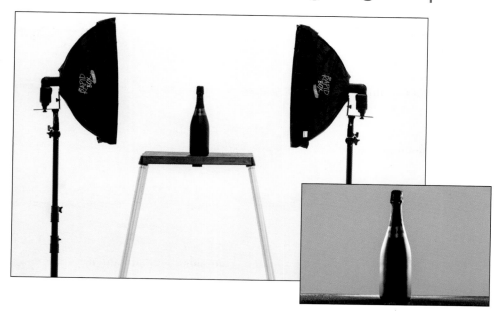

I go through periods where I wind up having to shoot a lot of product shots, either for my company or for client work, and the two-flash lighting setup you see here is my go-to setup. It's two strip banks, one on either side of the product, with a fabric egg crate grid on each, if I want a really narrow beam of light (like I wanted here, with this champagne bottle, where I just wanted thin highlights down the sides of the bottle). But, if you need to light more of the product, take the grids off. Also, moving the lights closer to the back of the product (or even past the back of it) will give you more of an edge light, and moving them forward (toward you) will put more light on the face of the product. By the way, the table I use for product shots is actually a collapsible projector stand. What I like about it is the fact that you can adjust the height of the stand because it has telescoping legs (kinda like a tripod), which makes getting the product to your camera height really easy (and makes product photography really easy). With products, sometimes you'll need to put a reflector or two up front—on the front sides, angled in toward the product—to bounce some of that light from the flashes back onto the front of the product.

Flash Workflow

If you've got an indoor, outdoor, or
wedding shoot, then here's what to do!

I thought at the end here, I would give you a workflow to follow for three different scenarios: (1) shooting indoors with flash; (2) shooting outdoors with flash; and (3) shooting an entire wedding with flash. I thought it would be helpful for you to see the whole thing, settings and all, from start to finish, so that's what I did in this final chapter. That way, after you've read the rest of the book, you can just refer back to this one workflow chapter when you're actually going out to do a shoot, and it would get you up and running. Now, at this point, you're probably thinking, "Wait just a minute! This isn't funny, or juvenile, and doesn't have any of the off-beat stuff you've put forth in the other chapter openers. I feel… well…kinda gypped." Now, I just had to stop and look up the spelling of the word "gypped" because my spell checker didn't recognize it, and when I did, I saw that the word could be, in some rare circumstances, possibly offensive. But, it did say it would only be offensive to people who get offended at everything (also known as "big poo-poo heads"), and I seriously doubt that anyone who bought this book is one of those. However, if you are one of "those," you should promptly drive back to the store where you bought this book and demand that one of the employees scratch out that word with a black marker and replace it with the word of your choice (hopefully a naughty cuss word, added in red magic marker for added emphasis, and don't forget to include an exclamation point, whether warranted or not). Then, post a photo of it on Twitter, and I'll pick the best one to win a Canon DSLR. The deadline to enter is 8/1/2017 at midnight EST. What? You missed the deadline already? Man, you got gypped! ;-)

Indoor Portrait Workflow
STEP ONE: Put Your Flash on a Light Stand

Get your flash off your camera and put it on a light stand (if you just said, "But, I don't have a light stand!" then you're not ready for this chapter yet. So, go buy a light stand [see page 134], and a tilt bracket, then come back here), then mount your flash on top of the light stand, on your tilt bracket (you're gonna need that tilt bracket in Step Four). Now, I hope, by now, this is one of those "needless to say" things, but at this point, you either have real radio wireless built into your flash, or you're using a wireless transmitter. Ideally, it will be one where you can change the power of the flash from right on top of your camera, like a Canon, Nikon, Yongnuo, etc. (see page 13), or at the very least, a PocketWizard or a Cactus trigger, which do fire the flash wirelessly, but you can't change the power from on top of your camera—you have to walk over to the flash unit and change the power using the buttons on the back. They both work, one's just more work, right? Anyway, get your flash off your camera, onto the light stand and tilt bracket, and make sure you can fire it wirelessly. Okay, you're off and running.

STEP TWO:
Put a Softbox in Front of It

You'll need to make the light soft and beautiful, so put a softbox in front of your flash. I generally go with a Westcott Rapid Box 26" Octa, if I'm just shooting one person on location and a mostly-from-the-waist-up kinda shot. If I need to cover more area (like 2/3 of my subject), they make a bigger version called the Westcott 32" Rapid Box Duo Speedlite Modifier, which can use up to two flashes, but I only use one, especially for indoor shoots like this. If you feel like you need maximum coverage (let's say you're shooting a small group shot, or you just need super-soft light), you can go with West-cott's Recessed Mega JS Apollo 50" softbox (it's a big boy! Well, it is once you set it up—it folds down to an umbrella, but it expands into a huge softbox. See Chapter 4 for more on softboxes).

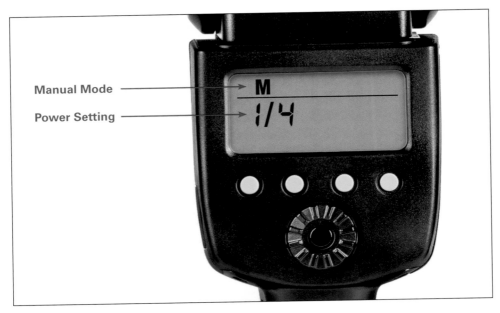

Manual Mode

Power Setting

You're going to set your flash to shoot in Manual mode, so you can control the power of the flash manually by simply turning the power up or down (instead of your flash making power decisions for you, which I've found it's often not awesome at. See page 22 for more). So, set your flash to shoot in Manual (M) mode (weird thing: if you have a Phottix flash, you still set the flash to ETTL mode on the flash itself, but on the Phottix transmitter, on top of your camera, you set that to Manual mode, and now it controls the flash manually. Doesn't make a lick of sense to me, but that's how it works). Now (this is important), set your flash to 1/4 power (you might have to lower it later, but it's a good starting point. See page 18 for more on your flash's power).

STEP FOUR:
Position It Up High, at a 45° Angle

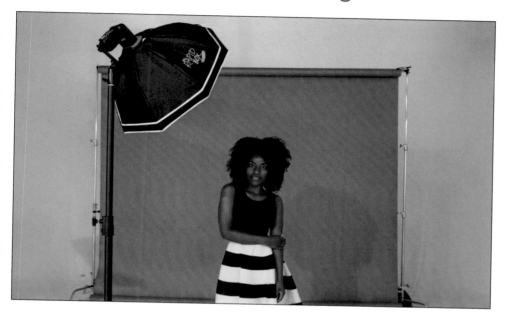

Put your flash at a 45° angle to your subject, and raise it up high, so it's a little bit higher than your subject's head (like a foot or so higher), then aim the softbox down toward them (using the tilt bracket) at an angle. You're trying to replicate the position of the sun late in the day, so that's why it's higher than your subject and aiming down at them (we looked at this back in Chapter 4).

STEP FIVE:
Use These Camera Settings

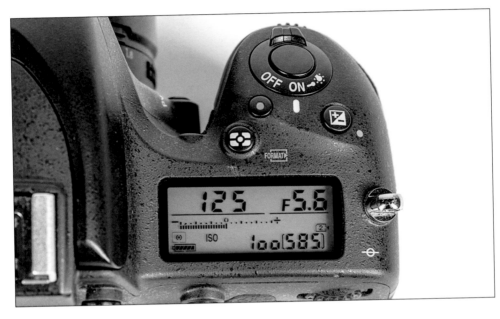

Put your camera in manual mode and dial in these settings:

(1) **Shutter Speed:** 1/125 of a second

(2) **Aperture:** f/5.6

(3) **ISO:** your cleanest native ISO. For most cameras these days, that's 100 ISO. For some older Nikon cameras, it could be 200 ISO (check your manual, or Google, or both).

Okay, that's it—you're not going to touch these settings again.

STEP SIX:
Take a Test Shot and Evaluate

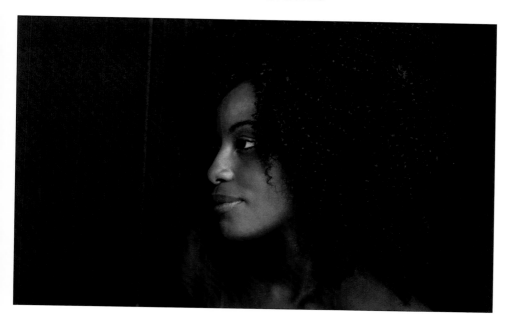

Now, take a test shot and look at the image on the back of your camera. If the flash is too bright, turn it down; if it's not bright enough, turn it up. Don't overthink it. It might take you a few test shots to dial in the right amount of flash (so it looks natural and doesn't look too bright), but you'll get it, and it won't take you more than 2 minutes to nail it. Don't change your camera settings—just the power of your flash. Again, don't overthink it (but, if you want a refresher on setting your flash's power, refer back to page 18). Anyway, that's pretty much it. It's all about taking a test shot, and then lowering (or raising) the power of the flash until it looks right to you (and, hopefully, "right to you" isn't too bright, since you know that's one of the most likely things people do wrong with off-camera flash).

Outdoor Portrait Workflow
STEP ONE: Put Their Back to the Sun

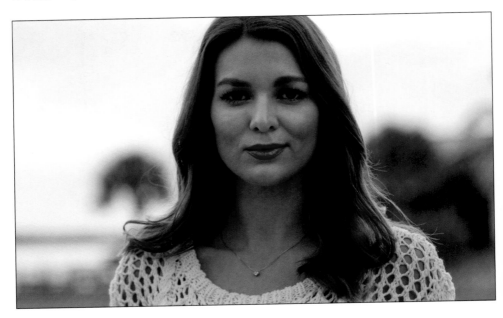

Start by positioning your subject, so the sun is behind them (the added benefit of this is that the sun acts as a second light, or a hair light, if you will). We don't want the sun to light them, we just want it to light the background, and the back of their head and shoulders and such—we want our flash to be the thing that lights our subject. By the way, the sun doesn't need to be directly behind them (in fact, it's probably better if it isn't). It can be way off to the side, but still behind them, like it is here, where the sun is way off to the right of our subject (our right, her left). Okay, that's a pretty easy first step, right?

STEP TWO:
Set Your Correct Exposure First

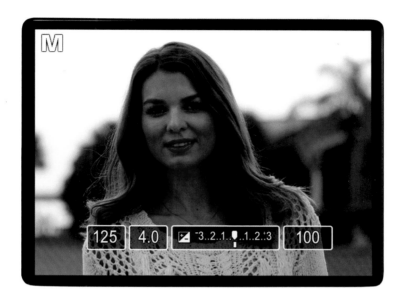

Don't turn on your flash yet, because you need to dial in some camera settings first. You're going to pretend you're not shooting with flash and start by setting your camera to the correct exposure for the ambient natural light where you're shooting. You still need to be in manual mode on your camera because, in a few minutes, you actually will be using flash, so you need to leave your shutter speed set at 1/125 of a second (you're not going to change it yet, or maybe at all). So, what can you change to get the correct overall exposure? Your aperture (f-stop). Now, how do you know if you've gotten the correct exposure for the natural light setting you're in? You're going to use the little light meter that appears inside your camera's viewfinder (we looked at this back on page 89). Press-and-hold the shutter button halfway down, and you'll see a moving marker appear along that line graph—that's showing where your current exposure is with the settings your camera is set to now. You'll need to move your f-stop until that moving marker is right in the center at the correct exposure. If you can't get there by just moving your f-stop alone (it could happen), then you might have to raise your ISO from 100 to 200, or even to 400, to allow you to get an f-stop where you wind up right in the center of that line graph. Once you get it there, move on to the next step.

STEP THREE:
Now Make Everything Darker

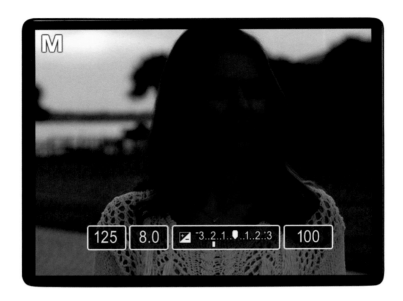

Now that you've gone and found the correct exposure for the outdoor natural light, you are going to intentionally make the scene around two stops darker, which is the key to making this look the way you want it to. This is because you want the flash lighting your subject, not the ambient light, so we darken the ambient (natural or available) light, so your flash alone does the job of lighting your subject. So, let's say when you adjusted your f-stop in the previous step, you wound up at f/4. You'd darken the scene by moving your f-stop to around f/8, and then take a test shot. Since your subject's back is to the sun (remember Step One?), when you take a test shot (don't turn on the flash yet), your subject should pretty much be a backlit silhouette at this point (and the sky should look a whole lot darker and richer, because it's two stops underexposed now). If your subject isn't close to a silhouette for some reason, no worries, just make your f-stop even darker—try f/9.5 or f/11—then take another test shot and see if they look dark enough. Now, there is one more thing you can do if the scene isn't dark enough: you can raise the shutter speed. Remember how it controls the room light indoors (see page 47)? Well, outdoors, it controls the ambient light, so you could raise the shutter speed up to 1/200 of a second and see if that helps (it probably will). If that doesn't do the trick, most flashes will let you go up to 1/250 of a second and still stay in sync, so try that next. You probably won't need to do either, but at least you know you can without messing anything up.

STEP FOUR:
Use These Settings on Your Flash

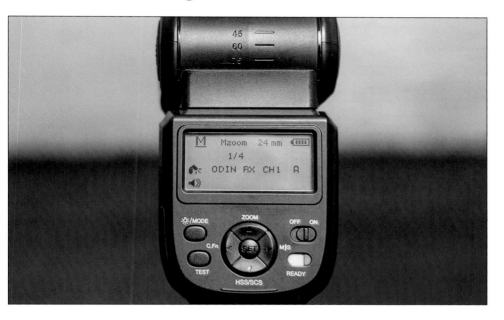

Set your flash to shoot in Manual mode (M), so you can control the power of the flash manually by simply turning the power up or down, and set the power of your flash to 1/4 power. *Note:* If you have a Phottix flash, you set the flash to ETTL mode, but then you set the mode on the Phottix transmitter on top of your camera to Manual (M), and now you can control it manually (this one stumped me, too, at first). I know this probably goes without saying (well, at this point, at least I hope it does), but make sure you have a wireless transmitter to fire your flash (see page 13 for more on transmitters).

STEP FIVE:
Get Your Flash Off Your Camera

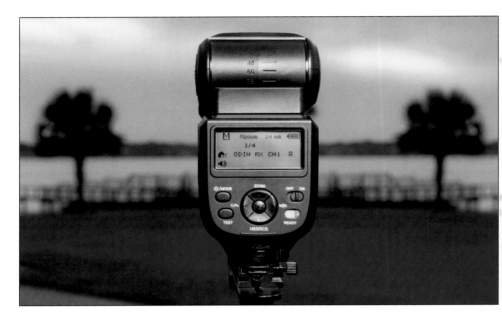

On location, you don't always have a flat area to put a light stand, so I prefer to mount my flash on the end of a monopod or boom pole (see page 137), but that counts on you having a friend to hold your boom pole. So, if you don't have an assistant, you'll probably have to at least try a light stand—just take a couple of sand bags with you so the light stand (and your flash) don't go tumbling over and break when a gust of wind comes out of nowhere (sadly, I'm speaking from experience with this one). So, first choice: mount your flash to the end of a monopod or boom pole (you don't need a tilt bracket, because you can just tilt the pole).

STEP SIX:
Put an Orange Gel on Your Flash

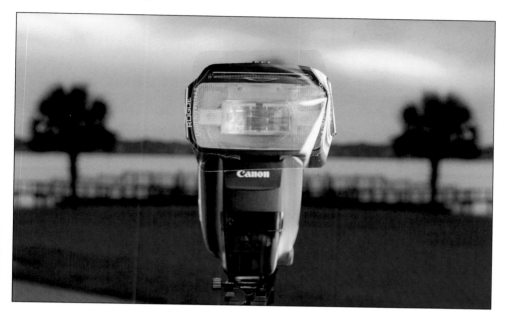

You're shooting outdoors, and that means white light will look weird (we're used to white light indoors in studio situations, but it looks weird outside, where the light from the sun should be somewhat orange), so put an orange gel over the front of your flash head (see page 84 for more on orange gels) to make the color of the light from your flash match the outdoor scene. Now, how deep (or should I say "thick") the amount of gel you use depends on the time of day you're shooting. For example, when shooting in the middle of the day or late in the afternoon, you just want a very small amount of orange gel, so start with a 1/4-cut of CTO gel. As it gets later in the afternoon, and gets to be about an hour from sunset, the light from your flash will start to look white again, because the ambient natural light is getting darker and warmer. So, you have to double-up on that gel (taping another 1/4-cut of orange gel over the first one, so you technically have a 1/2-cut, which looks twice as orange as before. Of course, if you have a sheet of 1/2-cut, take off the 1/4-cut, and use that instead). As the sun sets, to make the color of your flash match the color of the setting sun, you might have to put even more (or thicker) orange gel over the front of your flash until you get to one full-cut. Just keep the color of the light in mind, as it gets later and later, and add more gel when you see the light starting to look "white."

STEP SEVEN:
Make the Light Soft and Flattering

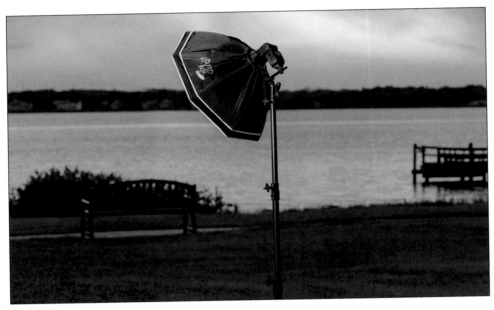

Basically, put a softbox in front of it. Again, my go-to location softbox would be the West-cott Rapid Box 26" Octa, and I would either put it on a light stand, or as I mentioned, if I have a friend or assistant with me, I'd prefer to mount it on the end of a monopod (see page 137). Luckily, it's really lightweight, so your friend won't get tuckered out lugging it around during the shoot. Or, of course, you could go with your friend just holding a 1-stop diffuser of some sort in front of your flash (see page 62 for a really inexpensive way to go). It doesn't matter so much which type of softening (diffusing) you use, as long as you use something to spread and soften that light and make it beautiful.

STEP EIGHT:
Position It Up High, at a 45° Angle

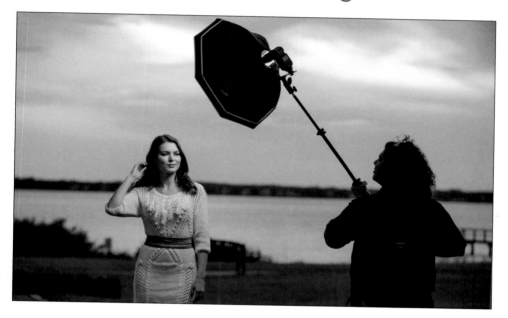

If you have a friend or assistant with you, tell them to stand off to the side at about a 45° angle to your subject (position it the same way if you're using a light stand). Since they are hand-holding your flash, make sure you don't let them move so much that the side of your subject's face farthest away from the light gets too shadowy (that can happen if they drift over to the side of your subject even by just a foot or two). You want some light to fall on the far side of their face, and you want shadows to appear on the far side of their face—not covering it up. If you see the other side of their face getting too shadowy, have your friend move closer toward your shooting position, then take a test shot and see how that looks.

STEP NINE:
Turn Your Flash On and Take a Test Shot

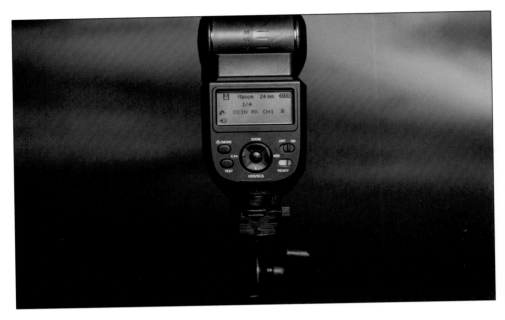

You set your flash to 1/4 power back in Step Four, and now it's time to see if that setting is too bright, too dark, or just right, and the only way to do that is to take a test shot. So, go ahead and do that. Now, let's evaluate the brightness of your flash (see page 18 for more on your flash's power). Is it too bright? If it is, just lower its power (take it down –1/3 in power), then take another test shot. If that's not enough, lower it another 1/3, and try again. You might have to go down to 1/8 power, but that's fine. That's basically it—you're either darkening the flash (so it doesn't look "too flashy") or brightening it if it looks too dark. Don't overthink this. Either the flash looks good to you, or it doesn't. (*Note:* The later in the day you shoot, the less flash power you'll need because the amount of light outside gets lower and lower as the day goes on. In the middle of the day, you might have to crank it up to 1/2 or even full power to light your subject.)

STEP TEN:
Balancing with the Natural Light

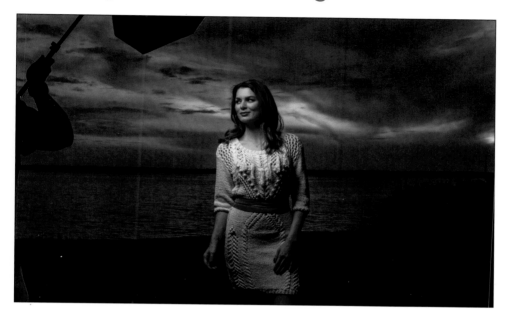

If the light from your flash seems out of balance with the natural light in the background (maybe the background seems too dark), you can brighten the background by lowering your shutter speed. Try taking it down from wherever it's currently at (probably 1/125 of a second) to 1/100 of a second, or even down to 1/80 or 1/60 of a second (but don't do this until you get your flash power setting pretty close, and the light on your subject looks pretty good). Again, you'll only need to lower the shutter speed if the background behind your subject seems too dark. Once you get the background looking good, take another test shot and make sure your flash is balanced and doesn't look too flashy (the not looking "flashy" thing is huge—you want your subject to look like they're lit by the sun, not by a flash). Getting this balance between the background and the flash, and having it all look natural, is the Holy Grail of on-location flash photography, but if you take the time to do a test shot, and evaluate how the flash looks and how the background looks, you'll have this dialed in, in no time. Remember, there are only two settings you adjust: (1) the power of the flash itself, and (2) the amount of light in the background (by adjusting the shutter speed). Get the flash right, then get the background balanced (if you even need to), and take a test shot or two. Once it looks pretty good, stop messing with the settings and focus on interacting with your subject, because at the end of the day, a great expression or emotion or pose (or hopefully all three) is what will make or break your portrait. If you spend the whole time fussing with settings, you'll kill the shoot.

Wedding Workflow
STEP ONE: Make Ready Flash

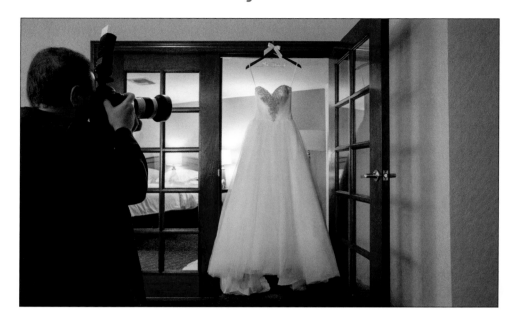

I cover a wedding using five different setups because I'm shooting in four different places: (1) in the room where the bride is getting ready (often a hotel room); (2) on location, shooting the bridal portraits; (3) in the church, shooting the ceremony itself, and (4) the formals right after the wedding; and (5) the reception. These are easy setups, and I use just one flash for most of it, so don't let it throw you. What I'm changing are the flash modifiers for the most part, so we'll start with the "make ready" flash (for the bride and bridesmaids hanging out). I usually shoot these with the flash on top of my camera in the hot shoe mount (gasp!), but with it aimed straight up toward the ceiling (see page 77). That way, I can either bounce the light from the flash off the ceiling and down onto my subject (I still shoot with the flash in Manual mode, and I adjust the power of the flash up/down, so it doesn't look too "flashy"), or if the ceiling is too high for me to bounce off, then I'll still aim the flash head up like that, but I'll just crank the power up because, even though the flash is aiming at the ceiling, some of that light from the flash will head toward my subject. If you're not getting enough light using this method, pull out the little white bounce card from the top of the flash head, and it will bounce some of that light forward (see page 123). If you don't mind spending just a few bucks, a really great option here is to put a Magmod MagSphere over the flash head (see page 125). It does an amazingly good job of spreading and diffusing the light without totally draining your batteries, and you only lose about one stop of light.

STEP TWO: The Bridal Portraits

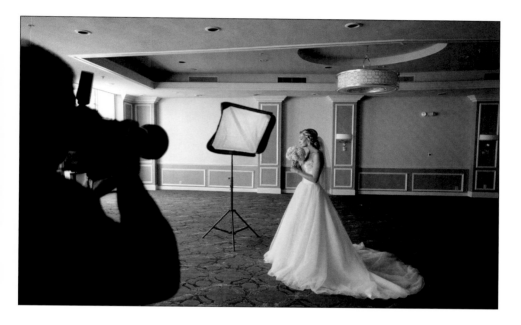

For the formal portrait of the bride (I try to shoot these well before the ceremony), I use a softbox for sure (like the Westcott Rapid Box 26" Octa or the Impact Quikbox), mounted on the end of a monopod and held by an assistant or friend, or on a light stand. If I'm shooting in a church, or in a hotel lobby, etc., I'm using my standard camera settings:

> **Shutter Speed:** 1/125 of a second
>
> **Aperture:** f/5.6
>
> **ISO:** 100
>
> **Flash Power Setting:** 1/4 power

Then, I take a test shot and see if I need to lower the power of the flash (which is usually the case in a dark church). If I want more of the existing light from the church in the shot (to balance with the light from the flash), then I try lowering the shutter speed (it controls the light in the church) from 1/125 to 1/80 to see how that looks. I might have to take it down to 1/60, or even 1/30, to get the balance right. If it's a brightly lit church, you might have to go the other way and raise the shutter speed to 1/200 of a second, or even 1/250 (which is pretty much the limit for most flashes without going to High-Speed Sync). To get really soft light, keep the softbox really close to the bride—so close that it's just out of the frame (see page 75). If you need it even softer, feather it so the center is not aiming directly at the bride (see page 73).

STEP THREE: The Ceremony

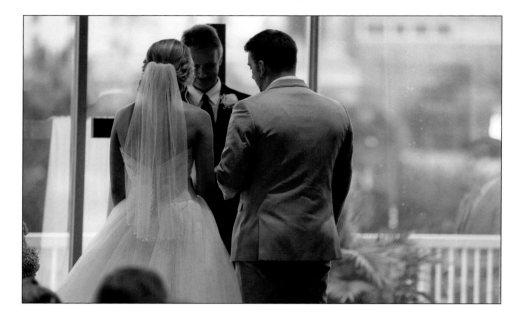

For a medium-to-large-sized wedding, you can't get anywhere near the bride and groom once they're up at the altar (and more and more churches are forbidding flash during the ceremony and are often limiting photographers from even getting near the altar during the ceremony), so I try to shoot as much of the ceremony using available light, with a fast lens (like one that will shoot f/2.8 or f/1.8), and with a full-frame body that lets you shoot at high ISOs (like 6,400) without a ton of noise. I save my flash for when the bride first enters the church, and then for the end, when the couple is heading back down the aisle at the end of the ceremony. Then, I use my flash with a MagSphere attached to help soften and spread the light, just like I did in the make ready room with the bride. Again, the key is getting close enough, so the flash actually reaches the couple, and then making sure your flash doesn't overpower the lighting in the church or hall where the ceremony is taking place. So, keep an eye on the power of your flash and your shutter speed. If the light from your flash is overpowering the room light, try lowering the shutter speed like I talked about on the previous page. If the ceremony is outdoors, again, it's hard to get close enough for flash to be effective, and bright pops of flash during the ceremony upset the couple and the guests. So, again, save your flash for the "walk out" and have something like a MagSphere on the top of your flash to spread and diffuse the light. Luckily, you can literally stuff a MagSphere in your pocket—just take it out when you need it, and it pops right back into shape. Handy little buggers.

STEP FOUR: The Group Formals

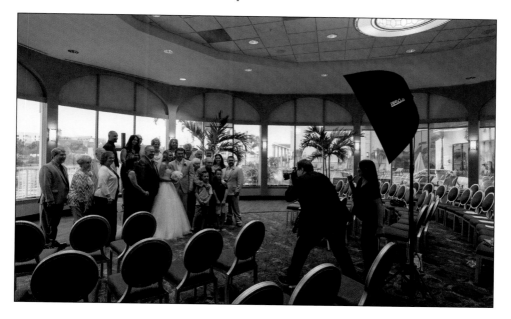

For the group formals at a big wedding (with a large wedding party), I switch to a re-ally large softbox (like the Westcott Mega JS Apollo 50"). For a smaller wedding, with smaller group formals (maybe a maximum of eight or 10 people at a time), you can go with a Westcott 43" Apollo Orb, which is decent-sized, octa-shaped softbox. You're going to mount either softbox on a light stand (bring a sandbag, so it doesn't fall over), and you're going to position if off to one side, but not at 45°—you want it a little closer to your camera position, and you want to put it back much farther than you normally would for a portrait, so you evenly light the group using just one light (by moving the softbox way back, like literally 10 feet back, you avoid the fast light fall-off that happens, where the side of the group that's closest to the light is the brightest, and then it gets darker and darker until the last person farthest away from the softbox is 2 stops darker or worse; see page 128). You're going to need to crank the power on your flash because you're filling a large softbox and it's way back from your group, so you'll probably be at full power and a lower f-stop, like f/4.5 or f/4. I wouldn't take the f-stop much lower than that because you want everyone in focus (focus your camera at the eyes of someone in the front row, like the bride). If the flash still isn't bright enough, you'll need to raise your ISO to 200, or maybe even 400, which will raise the power of your flash. Start with your shutter speed at 1/125 of a second—just make sure it blends with the room or outdoor light. If the room or background outdoors is too dark, lower your shutter speed to around 1/60 and try that.

STEP FIVE: Reception, One Flash

We're back to using our flash on top of the camera, but of course, we are not aiming the flash at our subjects—aim it up toward the ceiling, at an angle, to bounce the flash off the ceiling (if the ceiling is low enough), or aim the flash straight upward, and then pull out the white bounce card from the top of your flash head (see page 123). A better option, if you have one, is to, again, put a MagSphere over your flash head to spread and soften the light, but any of these three scenarios will work. Whichever one you go with, keep an eye on the power of your flash, so it doesn't get too bright and wash out your reception guests, and of course, keep an eye on the ambient room light, so it doesn't get too dark behind them. Remember, you're trying to achieve a balance between the room light and the flash. After dinner is served, the reception is mostly music and dancing. So, I try to make sure that I include a lot of the room lighting in my shots, especially the colored lights from the DJ or band, so it captures a colorful party atmosphere and doesn't look overlit, like the reception was held in a bright conference room at a convention center. The same holds true for outdoor receptions, but then I would really try to go with the MagSphere, because there's no ceiling to bounce off of.

STEP SIX: Reception, Two Flashes

If your reception is indoors, this is where you pull out that second or third flash (if you have them) to subtly light the whole room and support the flash you have on-camera, which is aiming straight up, or bouncing off the ceiling, or using a MagSphere. The thing that makes a big difference is using an extra flash (or two) to light the room. You take a bare-bulb flash, put it on a light stand up high (6 or 8 feet high), and place it in the corner of the room (out of the way), aiming straight up toward the ceiling (see page 126). Start at 1/2 power, though you might have to adjust it up/down based on the height of the ceiling and how it looks (you don't want to wash out the room, or the DJ lights). Now, when you fire your flash on top of your camera, it will fire that room flash simultaneously—it hits the ceiling and then spreads down on your reception guests, lighting them subtly (it works better than it sounds like it would). Ideally, you'd have two flashes, placed in opposite corners of the room, so you can move around the room and shoot without having large areas of the room that aren't lit. Another technique you might consider is to put a flash, with a softbox, up high, right by the dance floor (near the band or the DJ, so it's not in the way), aiming at the dance floor, since that's where pretty much everything happens at the reception. You can use that as your main light at times, or a back light at other times, because you'll still have that flash on top of your camera that you can turn on/off at any time, and still have the second flash fire. Just remember to position this flash so it's unobtrusive, and it's where nobody will trip on it.

INDEX

1-stop diffusers, 62, 148
5-in-1 reflectors, 148

A

about this book, 2–8
ambient light, 51
aperture priority mode, 46
aperture settings. *See* f-stops

B

backgrounds, 102–119
 canvas or painted, 106
 color gels for, 116–118, 155
 diffusion caps for, 113
 distance from flash to, 108
 gradient effect for, 114, 119
 instant black, 146
 light stands for lighting, 107
 one flash for lighting, 102
 reasons for lighting, 103
 seamless paper for, 104–105, 117–118
 setting up lighting for, 109
 showing shadows on, 152
 simple and clean, 98
 soft and blurry, 43, 97
 solid-white, 110–111
 spill light prevention, 112–113
 spotlight effect on, 115, 119
backlit effect
 for bridal portraits, 130
 for profile portraits, 160
 for two-color lighting, 161
backup flash, 131
balancing the light, 55, 181
battery considerations, 25, 41
beam width settings, 34
black background technique, 146
black seamless paper, 117, 118, 160

blur
 background, 43
 motion, 149, 157
Bolt CBP-N2 Battery Pack, 41
boom light poles, 137, 176
bounce cards, 39, 96, 124
bounce flash, 77, 123, 129, 151
brackets
 multiple-flash, 143
 off-camera flash, 60
 tilt, 135, 166
 umbrella, 69, 135
bridal portraits
 flash-behind-the-bride look for, 130
 simple one-light setup for, 122, 183
 See also wedding photography
brightness
 flash settings for, 18–21
 f-stop for controlling, 33, 48
 ISO adjustments and, 33, 49
 problem with too much, 10
 See also power settings

C

Cactus triggers, 14
camera settings, 46–55
 bridal portrait, 183
 checklist for, 54
 flash power and, 33
 f-stop, 48, 52
 indoor portrait, 170
 ISO, 49, 53
 manual mode, 46
 on-location photography, 93
 outdoor portrait, 173
 shutter speed, 47, 50–51
Canon flashes
 Manual mode on, 23
 power settings on, 20
 Speedlite Transmitter for, 13

canvas backdrops, 106
catchlight card, 39
channels, wireless, 31
checklist for camera settings, 54
clamps
 Joby Flash, 139, 155
 spring, 138
clean backgrounds, 98
Cloudy white balance, 92
color gels. *See* gels
color split back lighting, 161
controllers, wireless, 13
CowboyStudio 4 Way Flash Shoe Bracket, 143
CTO gels, 84, 85, 86, 87, 92, 177

D

deflector plate, 61
Dewis, Glyn, 146
diffusers
 built-in wide-angle, 38
 collapsible 1-stop, 62
 MagSphere, 125, 182, 184, 186
 portrait photography using, 62
 wedding reception shots using, 125
diffusion caps/domes, 36–37
 limitations of, 37, 60
 situations for using, 36, 110, 113
distance
 flash-to-background, 108
 flash-to-subject, 75, 79
double-tap technique, 154
dragging the shutter, 149
drama
 grids for adding, 65
 Hollywood look for, 159
 profile portrait for, 160
 shadows for adding, 72

E

edge light setup, 81
effects
 backlit rim, 160
 blur and freeze, 149, 157

gel, 116–118, 155
 gradient, 114, 119
 spotlight, 115, 119
 stroboscopic, 158
 See also flash tricks and techniques
egg-crate grids, 65, 66, 161
Elinchrom EL Handheld Boom Arm, 137
exposure settings, 173
external battery packs, 41
eyeglass reflection removal, 162

F

fall-off creation, 79–80
feathering light, 73
fill light, 96
flags, photography, 80
flash
 backup, 131
 batteries, 25
 beam width, 34, 159
 bounce, 77, 123, 129, 151
 camera settings, 46–55
 channels, 31
 group feature, 28–30
 Manual mode, 22–23, 168
 modeling light, 35
 mounting, 134–143, 166
 multi mode, 158
 off-camera, 58, 166, 176
 pop-up, 11, 12
 power settings, 18–21
 as props, 153
 refresh time, 24, 41
 removing from photos, 147
 setting up, 7, 168
 Slave mode, 32
 system for using, 6
 top-of-camera, 11
 troubleshooting, 17
 wireless, 13–16
flash gear, 5
 boom light poles, 137
 bounce cards, 39, 96
 brackets, 60, 135, 143
 clamps, 138–139

flash gear *continued*
 diffusers, 62, 125
 diffusion caps, 36–37, 60
 external battery packs, 41
 gels, 84–87, 116–118, 155
 grids, 65–66, 115
 light stands, 63, 107, 134, 166
 meters, 40
 monopods, 122, 137
 mounting, 134–143
 reflectors, 70, 95, 113, 124
 removing from photos, 147
 snoots, 159
 softboxes, 61, 64, 68
 umbrellas, 67, 69
flash sync speed, 50
flash tricks and techniques, 146–163
 background shadows, 152
 bouncing the light, 151
 dragging the shutter, 149
 dramatic profile portrait, 160
 fixing ground spill with double-tap, 154
 flash used as a prop, 153
 Hollywood dramatic look, 159
 instant black background, 146
 pan blur and freeze effect, 157
 removing gear from photos, 147
 removing reflections from glasses, 162
 special effects gels, 155
 stroboscopic effect, 158
 sunset look on location, 148
 three lighting looks, 150
 two-color split back lighting, 161
 two-flash product lighting setup, 163
 white balance as second color,
 156
flash workflows, 166–187
 indoor portrait workflow, 166–171
 outdoor portrait workflow, 172–181
 wedding photography workflow,
 182–187
flash-in-the-frame technique, 127, 153
fluorescent lights, 85
focusing light, 65–66
foot stand, 136
freezing motion, 42, 149, 157

f-stops
 flash power and, 33, 48
 High-Speed Sync and, 43
 indoor portrait, 170
 starting place for, 52
 wide-open, 97

G

gaffer's tape, 86
gear. *See* flash gear
gels, 84–87
 attaching to flash units, 86
 background color using, 116–118,
 155
 buying kits of pre-cut, 87
 matching room light with, 131
 situations for using, 84–85, 92, 94,
 177
 special effects based on, 155
 split back lighting with, 161
Giottos Mini Ballhead, 141
gold reflectors, 148
graduated background look, 114, 119
gray seamless paper, 117, 118
grids, 65–66
 background shadows and, 152
 egg-crate, 65, 161
 metal, 66
 product lighting and, 163
 spotlight effect and, 115
group formal shots, 128, 185
groups, 28–30
 assigning flashes to, 29
 multiple flashes in, 30

H

hard light, 152
headshots, instant, 70
High-Speed Sync, 43
Hobby, David, 154
Hollywood dramatic look, 159
hot shoe, 11

I

Impact gear
 Background Support System, 104
 Large Clip Clamp, 138
 Light Stands, 63, 107, 134
 Quikbox Softbox, 62
 Reflector Holder, 70
 Telescopic Handle, 137
 Umbrella Brackets, 69, 143
indoor portrait workflow, 166–171
 camera settings, 170
 equipment setup, 166–167
 flash settings, 168
 positioning your flash, 169
 taking a test shot, 171
 See also portrait photography
ISO settings
 brightness related to, 49
 flash power and, 33
 indoor portrait, 170
 starting place for, 53

J

Joby Flash Clamp, 139, 155
Justin clamps, 138

K

kelbyone.com website, 2
kicker light, 64, 81

L

Lastolite Quad Bracket, 143
light
 balancing, 55, 181
 feathering, 73
 fill, 96
 focusing, 65–66
 hard, 152
 kicker, 64, 81
 modeling, 35
 problem with too much, 10

 room or ambient, 47, 51
 shutter speed and, 47, 51
 softening, 59
 spill, 112–113
light meters, 40
light stands
 background lighting using, 107
 mounting flashes on, 63, 166
 recommendations for buying, 134
 removing from photos, 147
lighting
 backgrounds, 102–119
 indoor portraits, 58–81, 166–171
 on-location photography, 84–99,
 172–181
 product photography, 163
 tricks and techniques, 146–163
 wedding photography, 122–131,
 182–187
line-of-sight systems, 12, 15

M

MagMod gear
 flash grids, 66, 115
 gel kits, 116
 MagSphere diffuser, 125, 182, 184,
 186
 snoot, 159
Manfrotto gear
 flash shoe, 142
 light stands, 134
 Magic Arm, 139, 142
 spring clamps, 138, 142
manual camera mode, 46
Manual flash mode, 22–23
 reasons for using, 22
 specifics for setting, 23
 workflows indicating, 168, 175
McNally, Joe, 9, 12, 159
metal grids, 66
meters
 flash, 40
 in-camera, 89
modeling light, 35
monopods, 122, 137, 176

motion
 blurring, 149, 157
 freezing, 42, 149, 157
mounting your flash, 134–143
 boom light poles for, 137
 foot stand for, 136
 Joby Flash Clamp for, 139
 light stands for, 134
 Manfrotto Magic Arm for, 142
 monopods for, 137
 multiple-flash brackets for, 143
 Platypod Ultra for, 141
 RapidMount options for, 140
 spring clamps for, 138
 tilt brackets for, 135
Multi flash mode, 158
multiple-flash brackets, 143

N

Nikon flashes
 Manual mode on, 23
 power settings on, 20
 Wireless Remote Adapter Set for, 13
Nikon SD-9 Battery Pack, 41

O

Oben Aluminum Monopod, 137
off-camera flash, 58, 166, 176
on-camera flash
 bounce flash and, 77, 123
 problems with using, 11
 wedding receptions and, 124, 186
one-flash setup
 for backgrounds, 102
 for bridal portraits, 122, 183
 for group formals, 128, 185
on-location photography, 84–99
 clean backgrounds in, 98
 darkening the scene for, 90, 174
 exposure settings for, 93, 173
 fill light used in, 96
 flash settings for, 93, 175
 gels used for, 84–85, 92, 94, 177

 metering subjects for, 89
 positioning subjects for, 88, 172
 positioning your flash for, 91, 179
 real estate shots as, 99
 reflectors as second light in, 95
 soft backgrounds in, 97
 steps in process of, 88–94
 See also outdoor portrait workflow
optical wireless flash, 15
orange gels, 84, 85, 92, 177
outdoor portrait workflow, 172–181
 balancing the light, 181
 darkening the scene, 174
 exposure settings, 173
 flash settings, 175
 off-camera flash, 176
 orange gels used in, 177
 positioning subjects, 172
 positioning your flash, 179
 softening the light, 178
 taking a test shot, 180
 See also on-location photography

P

painted backdrops, 106
pan blur and freeze effect, 157
Panasonic Eneloop batteries, 25
Photoshop
 fixing ground spill in photos using, 154
 removing gear from photos using, 147
Phottix flashes
 Laso transmitter on, 16
 Manual mode on, 23, 168, 175
 power settings on, 20
Phottix US-A3 Umbrella Swivel, 63, 135
plate frames, 147
Platypod Ultra flash mount, 141
PocketWizard gear, 16
pop-up flash, 11, 12
portrait photography, 58–81
 bounce flash for, 77
 bridal shots as, 122, 183
 closeness of flash in, 75, 79
 diffusers used in, 62

dramatic profile portraits in, 160
fall-off created in, 79–80
feathered light in, 73
grids used in, 65–66
indoor portrait workflow, 166–171
light stands for, 63
off-camera flash for, 58
outdoor portrait workflow, 172–181
positioning flash for, 71, 74, 75, 169
reflectors used in, 70
second flash used in, 78
shadows used in, 72
short lighting in, 76
softboxes for, 61, 64, 68, 75
softening light for, 59, 73
three-flash setup for, 81
umbrellas for, 67, 69
positioning
 flash for portraits, 71, 73, 74, 91, 169
 subjects on location, 88, 172
power settings, 18–21
 camera settings and, 33
 explanation of, 18
 fine-tuning, 19
 f-stop and, 33, 48
 how to change, 20
 multi or repeating mode, 158
 starting place for, 21, 52
product lighting setup, 163
profile portraits, 160
props, flashes used as, 153
pulse-of-light systems, 12

R

radio (RF) wireless flash, 14, 15, 16
RapidMount SLX with RapidStrips, 140
real estate photography, 99
receptions, wedding. *See* wedding
 photography
rechargeable batteries, 25
reflections, removing from glasses, 162
reflectors
 instant headshots using, 70
 product lighting using, 163

spill light prevention using, 113
used as second light, 95
wedding reception photos using, 124
refresh time for flash, 24, 41
removing
 gear from photos, 147
 reflections from glasses, 162
Repeating Flash mode, 158
Rogue gear
 3-in-1 Flash Grid Starter Kit, 66, 115
 FlashBender 2 Reflector, 113, 124
 Gel Filter Kits, 116
room light
 gels for correcting, 85
 ISO setting and, 49
 matching with gels, 131
 shutter speed and, 47, 51

S

sand bags, 176
Savage 36″ Transparent Umbrella, 67
seamless paper
 black, 117, 118, 160
 gray, 117, 118
 white, 104–105, 118
second flashes
 gear for mounting, 138–142
 reflectors used as, 95
 See also two-flash setup
shadows
 portraits with facial, 72
 reflector for filling in, 70
 showing on backgrounds, 152
short lighting, 76
shutter speed
 blurring motion using, 149, 157
 freezing motion using, 42
 High-Speed Sync feature and, 43
 indoor portraits and, 170
 room light and, 47, 51
 situations for changing, 51
 slowing for wedding receptions, 124
 suggested setting for, 50
Slave mode, 32

snoots, 159
soft backgrounds, 43, 97
softboxes
 big light from, 68
 closeness of subjects to, 75, 79
 feathering light from, 73
 group formal shots using, 128, 185
 lighting backgrounds with, 102
 outdoor portraits using, 178
 placing in front of flash, 167
 recommended, 61, 64
 strip bank, 64, 163
softening light, 59
 diffusers for, 60, 62
 softboxes for, 61, 64, 68, 73, 178
 two factors essential to, 74
 umbrellas for, 67, 69
solid-white backgrounds, 110–111
Sony flashes
 Manual mode on, 23
 power settings on, 20
special effects gels, 155
Speedlights, 2
spill light prevention, 112–113
split back lighting effect, 161
sports photography, 157
spotlight effect
 on backgrounds, 108, 115, 119
 metal grids for creating, 66
spring clamp, 138
strip bank softboxes, 64, 163
stroboscopic effect, 158
studio portrait look, 146
sunglass reflection removal, 162
sunsets
 gels used for shooting, 94
 trick for achieving look of, 148

T

test flashes, 21, 171, 180
Tether Tools RapidMount SLX, 140
thinning subjects with lighting, 76
three-flash setup
 for portrait photography, 81
 for two-color split back lighting, 161

tilt brackets, 135, 166
top-of-camera flash, 11
tricks and techniques. *See* flash tricks and
 techniques
triggers, wireless, 14
tripod use, 147
troubleshooting flash, 17
TTL metering, 9
tungsten lights, 85
two-color split back lighting, 161
two-flash setup
 for portrait photography, 78
 for product photography, 163
 for wedding photography, 126, 187
 See also second flashes

U

umbrellas
 portrait photography using, 67, 69
 wedding group shots using, 128
underexposing subjects, 90, 174

V

Vello gear
 compact shoe stand, 136
 diffusion caps, 36
 shoe mount, 141
video tutorials, 2, 147, 154

W

wedding photography, 122–131
 backup flash for, 131
 bounce flash used in, 123, 129
 bridal portraits, 122, 130, 183
 bride getting-ready shots, 123, 182
 ceremony shots, 184
 flash-behind-the-bride look, 130
 flash-in-the-frame technique, 127
 gels for matching room light in, 131
 group formal shots, 128, 185
 lighting the room for, 126, 187

MagSphere diffuser for, 125, 182, 184, 186

on-camera flash for, 124, 125, 186

reception shots, 124–127, 186–187

workflow for, 182–187

Westcott gear

5-in-1 Reflector Disc, 148

Adjustable Shoe Mount Umbrella Bracket, 135

Apollo Orb softbox, 185

Collapsible 1-stop Diffuser, 62

Mega JS Apollo softbox, 68, 73, 102, 128, 167, 185

Parabolic Umbrella, 69, 128

Rapid Box Duo Speedlite Modifier, 167

Rapid Box Octa softbox, 61, 167, 178

Rapid Box Strip softbox, 64

Triple Threat Speedlite Bracket, 143

white backgrounds, 110–111

white balance settings

on-location photography and, 92

using as a second color, 156

white bounce cards, 39, 96, 124

white seamless paper, 104–105, 118

wide-angle diffusers, 38

wireless flash, 13–17

channels for, 31

controllers for, 13, 16

optical vs. radio, 15

triggers for, 14

troubleshooting, 17

workflows. *See* flash workflows

Y

Yongnuo flashes

controllers for, 13, 16

Manual mode on, 23

power settings on, 20

Z

Ziser, David, 151

Zoom control settings, 34

CONTINUE YOUR PHOTOGRAPHY TRAINING—ONLINE

with more courses
from Scott Kelby,
and other top instructors
in the industry

Why Become a KelbyOne Member?

Your annual membership gives you unlimited access to over 600 step-by-step
full-length courses and over 10,000 topic-specific video lessons, wherever you are,
whenever you want. We have exclusive classes and amazing instructors you
won't find anywhere else and we release a new full-length online class almost
every single week. Whatever your goals are, we have classes on every topic,
and special tracks for beginner, intermediate and advanced users.

The Benefits of Membership

 One-On-One Help Desk

2 Monthly Digital Magazines

The Creative Toolkit

The KelbyOne Community

 Member-Only Discounts

Interactive Webcasts

Learning Tracks

The KelbyOne Insider Blog